THE
PHOTOSHOP
WORKBOOK

Professional Retouching and Compositing
Tips, Tricks, and Techniques

Glyn Dewis

**Peachpit
Press**

The Photoshop Workbook:
Professional Retouching and Compositing Tips, Tricks, and Techniques

Glyn Dewis

Peachpit Press
www.peachpit.com

To report errors, please send a note to errata@peachpit.com
Peachpit Press is a division of Pearson Education

Acquisitions Editor: Ted Waitt
Senior Editor: Susan Rimerman
Production Editor: David Van Ness
Technical Editor: Scott Martin
Development/Copyeditor: Scout Festa
Proofreader: Heather Howard
Indexer: James Minkin
Composition: WolfsonDesign
Cover Design: Dave Clayton
Interior Design: WolfsonDesign
Cover Image: Glyn Dewis

ISBN 13: 978-0-134-00846-2
ISBN 10: 0-134-00846-4

9 8 7 6 5 4 3 2

Printed and bound in the United States of America

This book is dedicated to my dear friend Todd Mills, who leaves a huge void in many people's hearts having been taken from this World and us all far too soon.

Without his welcome, friendship, and support, I could easily have been walking along a very different path.

Miss you, Brother!

ACKNOWLEDGMENTS

A lot has happened since I first started using Photoshop: friendships and opportunities I never would have dreamed possible.

Anne: This book doesn't contain enough pages for me to write how I feel about you. Your love, support, trust, understanding, and encouragement is overwhelming. You give my life purpose. You are the reason I will never live with a "that will do" attitude; you deserve everything good that life has to offer. I'm an incredibly blessed man to have you as my wife; you and Posey are my world. I love you.

Morris Cat: My beautiful boy, my number one critic, my buddy—life isn't and never will be the same without you.

Scott Kelby: Blimey, where do I start? I find myself thanking you so often I just wish I knew a word that truly expressed how grateful I am to you for everything. From that first mention on your blog to the never-ending advice, support, and friendship, I owe more to you than I could ever repay.

Dave "The Editor" Clayton and Aaron Blaise: We've all said it before, but there are people you meet in life that just fit; people you instantly click with and feel you've known all your days—and that's exactly how I feel about you both. You're my brothers from other mothers, and I have this incredible creative industry to thank for bringing us together. Good times ahead!

Alan Hess: If Dave and Aaron are my brothers, then you're my cousin. Spending time with you is always such a blast. Thanks so much for your friendship.

Matt Kloskowski, Corey Barker, Pete Collins, and RC: Having you guys as friends is something I'll always treasure. Matt, we'll never forget your kindness for sending over that wonderful lighthouse picture of yours for Anne. Corey, you're a top fella and I'm convinced you really are a T1000. Pete, you truly are a great guy with a huge heart. And RC, well…everyone needs an RC in their lives!

Dave Cross: You've influenced what I do more than you'll ever know.

Joe McNally, Joel Grimes, Peter Hurley, Bert Monroy, Moose Peterson, Joe Glyda, Frank Doorhof, and all the other incredible KelbyOne Instructors: Your talent and love of what you do is a constant source of inspiration. I'm truly honored to share the stage and teach amongst you.

Barry Payne: Mate, you've been there from day one with your boundless enthusiasm and willingness to help. You epitomize true friendship.

Scott Cowlin and Ted Waitt: For your encouragement and belief that I should write this book; thank you so much for this opportunity.

The book team at Peachpit: Susan Rimerman (Senior Acquisitions Editor), your patience, organization, and team co-ordination skills are quite simply legendary! Ted Waitt (Executive Editor), Scout Festa (Development Editor and Copyeditor), Scott Martin (Technical Editor), Heather Howard (Proofreader), David Van Ness (Production Editor), WolfsonDesign (Interior Design/Composition), and James Minkin (Indexer), your vision, attention to detail, professionalism, and instincts make you an unbeatable team!

Richard Curtis at Adobe: Thanks to Adobe for making such fantastic software and for their support, which ultimately enables me to do what I love. In particular, Richard Curtis (Adobe UK) for his help, advice, and friendship.

Nicole Wolfe Procunier, Brandon Ford, Steve "Get to the Chopper" Nicolai, Mia McCormick, Meredith Pack, Kathy Siler, and Stephen Bell: There's so much I could say about you all, but to sum it up in one word: Awesome!

Zack and Meghan Arias: Thank you for inviting me into your lives; your generosity has been life-changing!

Erik Bernskiöld: How one person can hold so much knowledge, ability, and wisdom and still be so young is unbelievable! My only wish is that I'd known you sooner—I may have retained a few more follicles.

Loxley Colour: Ian Loxley, Calum Thomson, Paul McKendrick, and Neil Wright: Thanks for such an incredible product and the continued support. You folks and the team around you are world class!

Paul Avins: Your ability to see the possibilities and opportunities where others can't never fails to motivate. Thank you for your constant guidance and vision.

Chris Fields (CHNO Technology), Brian Matiash (Google), Ben Brain (Future Publishing), Chris Whittle (Elinchrom and the Flash Centre), Alastair Jolly (Smugmug), Weston "Wes" Maggio (Wacom USA), Torsten Kieslich, Amber McCoy (TetherTools), Eric Yang (Topaz Labs), David MacKay (Headshot Photographer), and Sylights (www.sylights.com): Thank you so much for being there in so many ways. Whether it be your world-class equipment and products, your support, your promotion, or your expertise, you guys *rock!*

Gabor Richter, Calvin Hollywood, Uli Staiger, and Olaf Giermann: I thank each and every one of you for your influence and advice, and for the many laughs; I look forward to much more in the future.

The Curry Club: Noel Hannan, Brian Worley, David Kelly, Keith Hammond, David Lee, James Hole, Gareth Davies, Dave Clayton, and Chris Fields: Isn't it about time we arranged another shoot and meal? Always fun, and always gets the creative juices flowing.

And finally, a huge thank you to all the models and clients I've worked with to date; it's been a pleasure working with and photographing you. Quite simply, these pages would be blank without you!

ABOUT THE AUTHOR

Glyn Dewis

Originally from Staffordshire, England, Glyn was introduced to Photoshop in 2005, and his life took a completely different path. With a somewhat tenacious personality and a hunger to learn, he attended his first Photoshop World Conference and Expo in Las Vegas in 2006. The trip had a profound effect on Glyn because he was exposed to a completely new world—the world of creativity and expression, where the only limitations are those placed on you by yourself.

Fast-forward a few years and Glyn is now an established photographer, retoucher, and trainer, with clients ranging from the BBC, Sky TV, and Air New Zealand to physique athletes and musicians. He attributes it all to a combination of hard work, the guidance of incredibly talented and generous friends, and a mind set of always wanting to improve and learn.

Photoshop and photography is very much an equal partnership in Glyn's work, and in addition to working with clients he now travels internationally, teaching his own series of workshops, as well as coaching, speaking, and instructing at conferences. He writes for several Photoshop magazines across Europe and the USA, including *Photoshop User* and *Practical Photoshop*. In 2013, he was featured in the *New York Times*. One of the highlights of his career was becoming a Member of the Photoshop World Dream Team of Instructors.

Teaching and standing in front of large audiences came naturally to Glyn, having attended drama school for a short time as a child. Until 2008, Glyn was also a competitive bodybuilder. He lives just outside Oxford, England, with his wife, Anne, and his cat, Posey.

Glyn regularly updates his blog with news, reviews, behind the scenes information, tutorials, and much more. To see more of Glyn's work, keep up with him on social media, and learn from his tutorial videos, check out these links:

Blog: www.glyndewis.com

YouTube: www.youtube.com/glyndewis

Facebook: www.facebook.com/glyndewis

Twitter: www.twitter.com/glyndewis

Google+: www.gplusglyn.com

CONTENTS

PART 1 TECHNIQUES 1

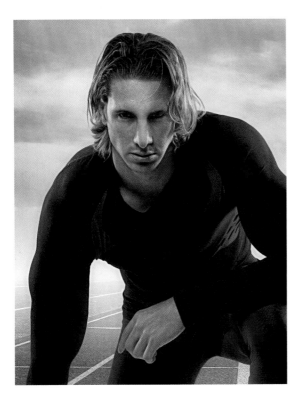

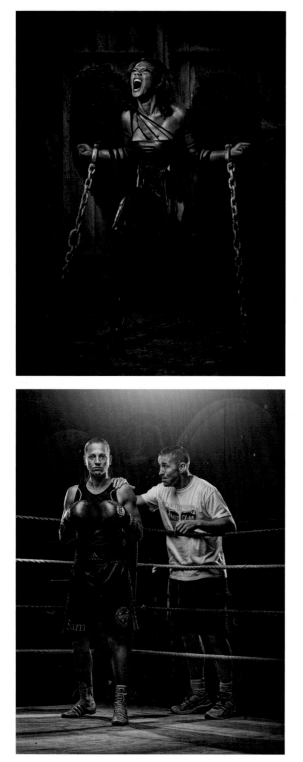

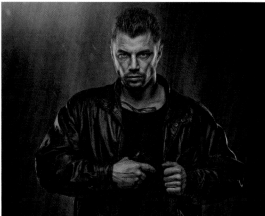

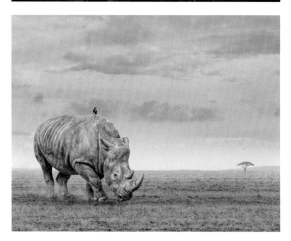

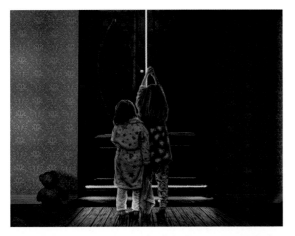

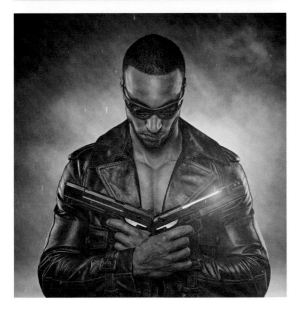

FOREWORD

I wear a lot of hats at my day job, where since 1999 I lead a company dedicated to teaching people Photoshop, Lightroom, and photography. One of my roles there (and one I particularly enjoy) is my role as Conference Technical Chair for the Photoshop World Conference & Expo. That's a fancy-sounding name for "the guy who gets to choose who speaks at the conference." It's a job I take very seriously.

People from all over the world come to this three-day conference and we had decided from the very beginning that if this truly was going to be a world-class event, we had to hire nothing but absolutely the very best instructors on earth—the thing that would make our conference so unique. If you come to Photoshop World as an attendee, you know for certain that you're learning from the very best.

Sure, there are some very obvious choices for instructors out there, but I don't need just 10 or 12 instructors. With well over 100 classes to fill during the conference and I need to put together a team or 35 to 40 flat-out amazing teachers. They can't be just "fairly good" or "pretty solid." They have to be literally the world's best at what they do. That's quite a small list.

Of course, I can't use the same instructors every single year—you have to keep things fresh for the attendees who come year after year. So an important part of my Technical Chair job is to find the next generation of Photoshop gurus—teachers whose skill and passion have started getting them worldwide acclaim. I was delighted to see that a photographer/Photoshop guru I met a few years ago on a vacation trip to London with my wife turned out to be just that.

After spending the day shooting (and laughing) our way around London (with our dear friend, designer Dave Clayton), I started following Glyn's tutorials online and son of a gun not only did he have some very clever stuff, I was learning new techniques from him on a regular basis. His retouching techniques and special effects were just really clever and he was covering and creating some of the most popular "looks" out there today.

So, when two years later I came to London with my "Light it, Shoot it, Retouch it" full-day seminar, I invited Glyn to be my "guest retoucher" to come on stage for 30-minutes and do a start-to-finish retouch of an image I had just lit and photographed of a boxer in a boxing ring. I left the stage, sat in the audience, and took notes along with everyone else. As expected, he absolutely crushed it!

I knew from the audience's reaction that Glyn had been a huge hit, but when I read the hundreds of written evaluation forms completed at the end of the day, I realized that what he did on stage that day wasn't just a really good session on retouching. What he did was something really special. He connected with the audience in a way that a few people in this entire industry can. Whatever that "thing" is that makes someone go from a really good teacher to a world-class instructor, he had it in spades. I knew right then I had to ask him to join our "Instructor Dream Team" at the Photoshop World Conference & Expo.

From his first time speaking at Photoshop World, he was a hit. He captivated rooms full of serious Photoshop users with his knowledge, passion, and gift for communicating with wit and wisdom throughout. But it was his heartfelt presentation at the closing ceremony that year in front of literally thousands of Photoshop users gathered from around the world, where he shared his personal story, his journey, his struggles, and his triumphs, that made him who he is today and that made us fall in love with the man behind the training.

He shared some wonderful insights into his life, which brought into perspective his willingness to pass on what he's learned to others (even if he learned it the hard way). He does it all in a way that really makes it stick. Glyn's teaching has helped so many people around the world achieve their dreams in Photoshop, and in doing that, they've helped him achieve his dreams as well. And you're holding a culmination of all of that in your hands right now.

I've learned so much from Glyn over the years, and I'm so excited that you'll now have the opportunity to learn from him as well as you join him on this journey. I'm so proud of Glyn for what he's done here in his debut book—the first of many to come—and one that I know will have you creating the type of images you've always dreamed of.

Glyn has a lot to share, and he doesn't hold back. He gives you everything he's got (as he does in everything). I know as you go through this book and start creating these types of images that there will be times where you'll have that same silly smile on as I did when sitting in that audience in London watching Glyn teach. You'll have that moment when Glyn teaches one of his amazing techniques and you think to yourself (just like I did), "*Ah ah*—so *that's* how you do it!"

You are *really* in for a treat.

All my best,

Scott Kelby
Publisher, *Photoshop User* magazine

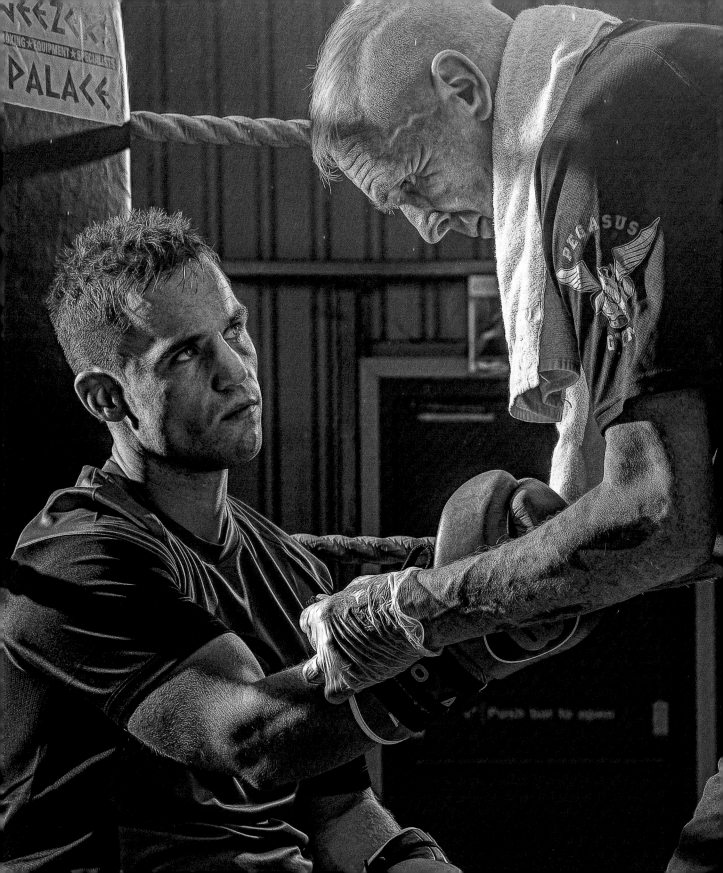

INTRODUCTION

Adobe Photoshop is a truly incredible piece of software, limited only by the skill and creativity of the person using it. From my perspective, there are no advanced users. There's no such thing as advanced—there are just those who have put it to use, practiced more, and have a working knowledge of the tools and techniques. Most importantly, though, they understand *how* and *when* to use the tools and techniques to get the results they want again and again.

So who is this book for? Well, to be perfectly honest, it's for anyone who already uses Adobe Photoshop, has a basic knowledge of the tools and features, and wants to improve and realize their own creative potential—it's that simple!

In *The Photoshop Workbook,* I lead you through the compositing and retouching techniques that I use every day to create images for my portfolio and for clients, who range from the BBC and Sky TV to athletes, musicians, and other professionals.

ABOUT THIS BOOK

This book is split into two distinct sections. In the first section, we start off by going through selections and cutouts. Having taught thousands of Photoshop users around the world, I know that making great selections and cutouts is the area that causes the most frustration. So, I've purposely dedicated Chapter 1 to this and placed it right at the start of the book. I'll show you how to achieve the very best results using a range of tools and techniques to get the job done, so you can carry on doing what you really want to be doing: being creative.

The tools we have available to us are incredible, but despite this there's no single tool or technique that will work on every image. I'll show you how to master the tools and the techniques, and even show you some tricks of the trade for making the perfect selections. Your knowledge and confidence will quickly build, so you can then laugh in the face of a tricky cutout—well, you know what I mean.

We then move on to look at the many creative uses of gray in Chapter 2. I'll show you a super-fast way to create composite images, how to creatively use textures, and will explain a nondestructive dodging and burning technique for adding depth and dimension to your images. I'll also share how to completely transform a location using gray, how to create a lens flare, how to add fake damage and dents, and even how to give anyone a perfect abs six-pack (well, almost anyone!).

Adding lighting effects is a great way to change the look and feel of a picture, so Chapter 3 covers some of the most common techniques I use to do exactly that. I show you what I call "the world's simplest lighting effect" and how to create realistic shadows. These techniques are effective but also simple and quick to apply.

Chapter 4 is where we'll have great fun with special effects, but with the emphasis on realism. We'll look at how to add realistic rain and how to create the flying debris that we so often see in Hollywood action-movie photos. You'll also learn how to turn day into night and even how to create a snow scene.

In Chapter 5 I'll show you how to match the color when compositing, and how to add realistic shadows so that the viewer will totally believe that everything was there in the original photograph. In addition, I show you some clever uses of brushes in compositing and how to add a horizon line so that the lighting in a scene is totally believable.

In the second section of the book, everything comes together and we put all the learning into practice as I take you step by step through six complete retouching projects.

Anyone can learn Photoshop techniques, but the real skill is in knowing how and when to apply them, and that's exactly what we do here as we work through a character portrait, a themed composite using gray, an animal project composite creating a unique landscape from a number of different pictures, a fairytale-themed composite using miniature and life-size elements, and a landscape retouch. By working through the projects you'll learn not only how to apply the techniques we covered in part one of the book, but also how to combine them to make your own creative images.

To help you with the learning process, I've made all the image files for each project available for you to download. To access the files, you must first register your book at Peachpit.com. If you don't already have an account, create one (it's free!) at peachpit.com/register. After you have created your account or logged in, register your book. Enter the book's ISBN number, 9780134008462, and click Submit. Look for the book under the Registered Product tab on your Account page. Then select Access Bonus Content. From there, you can download the image asset files.

HOW TO USE THIS BOOK

The first part of the book was written so that you can dive in, learn a technique, and then use it. I recommend that you work your way from start to finish of Chapter 1. Selections and cutouts can cause a lot of frustration, so spend some time here going through the tools and techniques, and try them out on your own images.

When it comes to Photoshop, there is no right or wrong way to do something—there are just good and bad results! Throughout this book you'll see many tips, tricks, and techniques that I use in my work, but there will always be countless other ways to achieve similar results. The key, however, is to continually build a knowledge base and add to your Photoshop tool bag.

Sharing knowledge and seeing someone's joy when they can do something that previously eluded them is a wonderful feeling. My hope is that the content of this book not only helps you develop your skills, but also inspires and pushes you to create images you never thought possible. Realize that with knowledge and plenty of practice, you can do it!

—Glyn Dewis

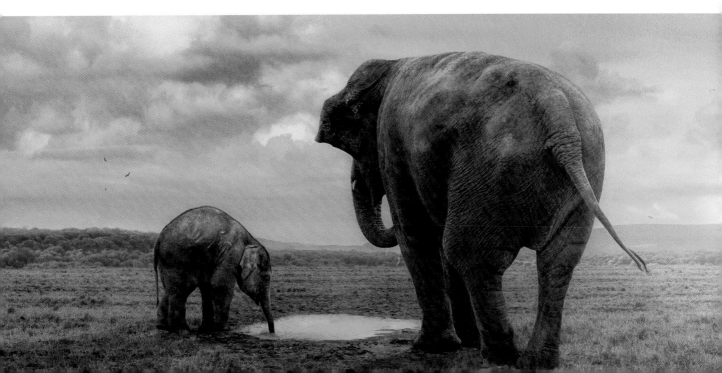

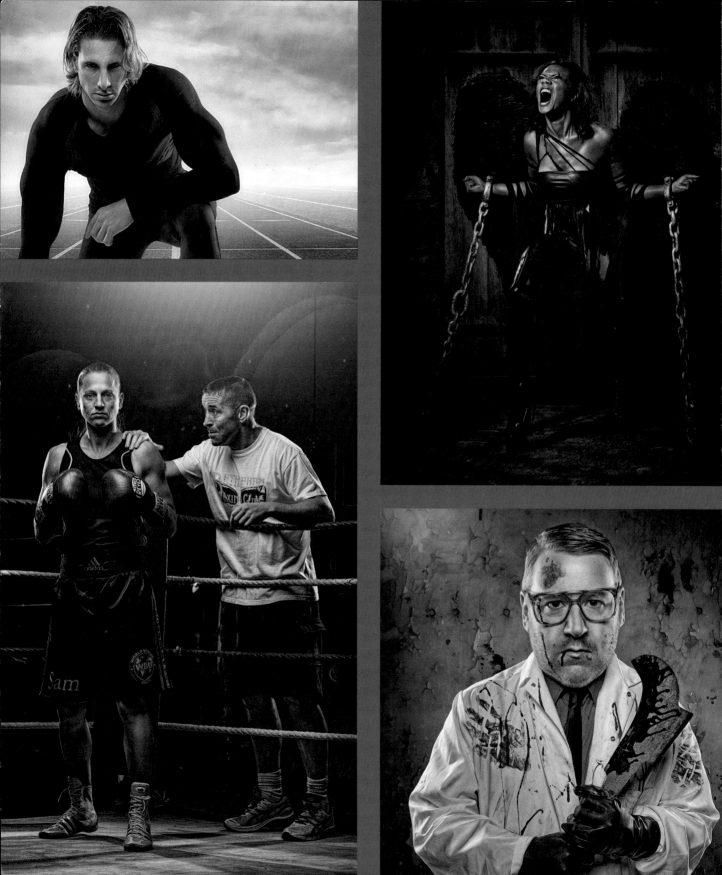

TECHNIQUES

SELECTIONS AND CUTOUTS

Let's kick off by going through a number of techniques for making selections and cutouts. As always with Photoshop, there are countless ways to achieve the same or similar results. In this chapter I take you through the techniques I use most often in my own workflow.

Making selections can be frustrating. I'm sure you'd much rather spend your time being creative than making selections, but there are times that they're unavoidable, especially when compositing. But with a little knowledge and a little practice, you'll soon find that they don't take much time at all.

QUICK SELECTION TOOL AND REFINE EDGE

When the Quick Selection tool was introduced, it seemed everyone I spoke to was achieving incredible results; for me, though, it was quite a different story.

Sure, simple selections were no problem, but when it came to getting a great selection of both body and hair, I ran into issues.

The solution I found was to use the Quick Selection tool to make two selections—one of the body, one of the hair—and then combine them.

1. With a suitable image open (that is, one in which the cutout includes fly-away hair), choose the Quick Selection tool from the toolbar (**Figure 1.1**), and in the options at the top of the screen make sure that the Add to Selection icon is turned on (middle option) and that the Auto Enhance checkbox is selected (**Figure 1.2**).

2. Click the photo, and drag only around the body area (leave the head until later) to select it (**Figure 1.3**).

 NOTE *As you drag, more and more of the image will be selected. If you select too much, Option/Alt-drag the areas you want to remove.*

3. Choose Select > Save Selection, name the selection **body** (**Figure 1.4**), leaving the other settings at their default as in **Figure 1.4,** and click OK.

4. Choose Select > Deselect, and use the Quick Selection tool to drag over the hair and face, selecting them.

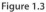

Figure 1.1

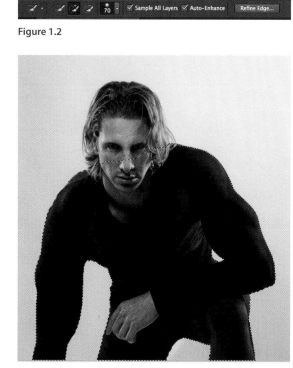

Figure 1.2

Figure 1.3

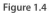

Figure 1.4

NOTE *When selecting the hair it's important that you don't include any areas where you can see through to the background (Figure 1.5). This is very important and a key part of making a great selection using the Quick Selection tool. Option/Alt-drag over any areas in which you can see the background to remove them from the selection (Figure 1.6).*

5. We can now go into Refine Edge to pick up all of those fine flyaway hairs. Click the Refine Edge button at the top of the screen in the Quick Selection options (Figure 1.7).

6. Now you'll choose how you would prefer to see the image when working on your cutout. When I'm working on a cutout that will eventually be placed in a bright scene like this one, I tend to favor On White, which can be found in the View drop-down menu (Figure 1.8). Conversely, when the background scene is going to contain lots of dark areas, I favor On Black.

continues

Figure 1.5 Incorrect selection of head and hair

Figure 1.6 Correct selection of head and hair with none of the background included

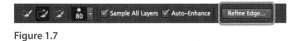

Figure 1.7

Figure 1.8

7. Next increase the Radius slider to start adding the remaining hair into the selection. If too high a pixel amount is used, the cutout can get a little funky as in **Figure 1.9**, so it's best to bring it up gradually. For this example, a Radius of 25px worked well as in **Figure 1.10**.

8. Select the Smart Radius checkbox to see if it enhances your selection. Then with the Refine Radius tool (**Figure 1.11**), paint around the entire outside of the head to pick up all the hair not yet included.

 TIP *I find that I get best results with the Refine Radius tool when I paint around the head with it just touching the hair, as opposed to using a large brush and painting all over the head and background area.*

9. Selecting Black & White from the View menu will show how the selection is now looking (**Figure 1.12**). Gray areas indicate where the selection is not so good and will likely be including some of the background area. In this example increasing the Contrast slider to 25% helped to reduce the gray.

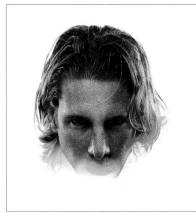

Figure 1.9 Example of using a too high Radius setting

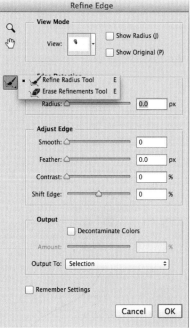

Figure 1.11

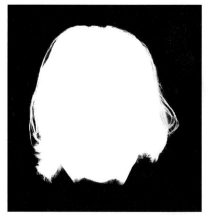

Figure 1.10

Figure 1.12

10. In the Output To menu, choose Selection and click OK. Choose Select > Save Selection, name this selection **head** (**Figure 1.13**), leaving the other settings at their default and click OK.

11. Now that we have made selections of the body and head, we need to combine them into one selection for cutting out. Click the Channels tab. Click the thumbnail of the body channel to view it and then hold down the Command/Ctrl key, and click the thumbnail of the head channel to load it as a selection (**Figure 1.14**). Fill this with white by going to Edit > Fill > Contents > White. Click OK. Choose Select > Deselect, or you could use the keyboard shortcut Command/Ctrl+D.

12. Drag the head channel into the trash at the bottom of the Channels panel. Click the body channel thumbnail (Alpha channel).

13. It looks good, except for an area on the right where some of the hair hasn't been completely selected (**Figure 1.15**). To add this to the selection, paint with a white brush over that area.

14. There's also an area where some of the white has gone onto the black, and between some of the hairs, making it look gray. Paint it with a brush in the Overlay blend mode. This allows you to paint in white or black and not affect the opposite color, as it only affects the gray.

> **TIP** *When using the Overlay blend mode to tidy up, you'll get the best results when you build up to an effect as opposed to going in with settings that are too high. I tend to use about 20% opacity and paint over it several times (**Figure 1.16**).*

continues

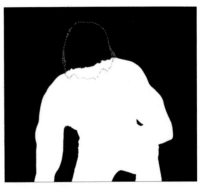

Figure 1.13

Figure 1.14

Figure 1.15

Figure 1.16

15. Click the RGB channel thumbnail to return the athlete to full color, and then click the Layers panel. To cut out the athlete and place him into a new scene, go to Select > Load Selection, choose body from the Channel menu, and click OK. This loads the complete selection of the athlete.

16. Click the Layer Mask icon at the bottom of the Layers panel and now the athlete has been cut from the background. Choose the Move tool (V), and drag the now cutout athlete into the new background by clicking within the image area and dragging onto the new background tab (**Figures 1.17** and **1.18**).

NOTE *When dragging on top of the new background tab, wait for the image to open, continue to drag into the image area, and then release.*

Now that the athlete is cut out and in position with a new background, in the following section I'll show you how to improve the cutout further with a layer style.

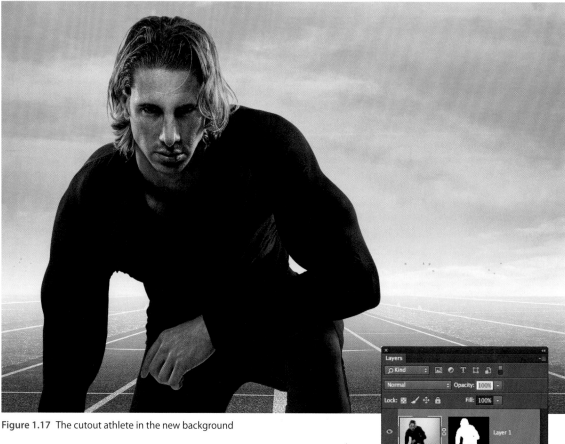

Figure 1.17 The cutout athlete in the new background

Figure 1.18 The cutout layer of the athlete including the layer mask

IMPROVING CUTOUTS WITH LAYER STYLES

Here's a great little trick you can use to show more of those fine fly-away hairs and make your cutout look even better.

This technique uses a layer style, which is normally attached to a layer, but I'll show you how to make it more user friendly.

1. Staying with the athlete image and making sure that the cutout is the active layer, click the fx icon at the bottom of the Layers panel and choose Inner Shadow (**Figure 1.19**).

2. Change the Angle setting to 90. This determines the direction that the inner shadow is coming from, and since we want to pick up fine hairs on both sides of the athlete's head, a setting of 90 makes the shadow come from directly above his head (**Figure 1.20**).

3. At the moment the shadow on the hair is black, but we can improve the look further by making the shadow the same color as the athlete's hair, adding to the realism. Click the color swatch in the Structure section to bring up the Color Picker. Then place your cursor, which is now a color sampler, on the athlete picture and click an outer part of his hair. This replaces the black color of the shadow with the color of the hair you just sampled. Click OK to close the Color Picker.

4. Before closing the Layer Style properties, deselect the Preview checkbox, and then select it again. Do this a few times, and you'll notice that the inner shadow we've applied does a great job showing even more hair, but the inner shadow has also been applied around the whole of the athlete's body.

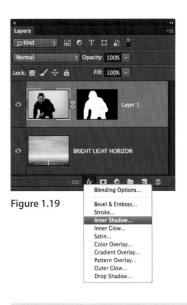

Figure 1.19

Figure 1.20

continues

5. To reveal the inner shadow layer style only on the hair, click OK to close the Layer Style properties, and then choose Layer > Layer Style > Create Layer (**Figure 1.21**).

6. Click this new layer in the Layers panel to make it active. Option/Alt-click the Layer Mask icon at the bottom of the Layers panel to add a black layer mask and completely hide the result of the Inner Shadow layer style.

7. Choose a soft-edged white brush (making sure to put the brush back into the normal blend mode in the options at the top of the screen) at 100% opacity and click on the black layer mask. Then paint over the athlete's hair to reveal the result of the original Inner Shadow layer style (**Figure 1.22**).

Figure 1.21

Figure 1.22

HOW TO REMOVE THE ANNOYING OUTLINE

It's very common when making selections and cutouts to end up with a thin outline around the person or object, as in Figure 1.23.

This outline is part of the original background. Removing it is very straightforward when you have a layer mask, as you'll see in the following steps.

1. Click the layer mask attached to the layer containing the cutout of the athlete to make it active. With the Lasso tool, make a rough selection around the athlete's body, but leave out his head (**Figure 1.24**).

2. Go to Filter > Blur > Gaussian Blur, add a Radius of 1 pixel, and click OK.

3. Choose Image > Adjustments > Levels, and gradually drag the black point in toward the center of the histogram (**Figure 1.25**) until the outline around the athlete disappears. Click OK, and then deselect the rough selection by pressing Command/Ctrl+D.

 NOTE *When you use a Levels adjustment to remove the outline, you're actually increasing the amount of black in the layer mask, which in turn shrinks the white area (the cutout). Adding a small amount of Gaussian Blur stops the cutout from having a sharp and defined outline, and so helps it blend into the scene more realistically.*

Figure 1.23

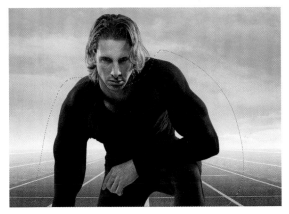

Figure 1.24

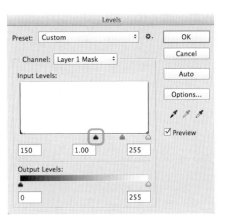

Figure 1.25

QUICK MASK

Whenever I make selections I regularly use Quick Mask to check how accurate my selection is, and to add to it or take away from it if necessary. Quick Mask is a great way to clearly see exactly what has been selected and a quick way to make alterations.

1. With an image open, double-click the Quick Mask icon at the bottom of the toolbar (**Figure 1.26**).

2. With the Quick Mask properties open, make sure that the Selected Areas checkbox is selected and click OK (**Figure 1.27**).

 NOTE *The default setting for Quick Mask is Masked Areas, meaning that what isn't included in the selection is covered in a red overlay. But from now on, when you enter Quick Mask mode, whatever is selected will be covered in the red overlay. I find this makes it easier when adding to or taking away from a selection. To change the color of the overlay, double-click the Quick Mask icon to open the properties and click the red color swatch.*

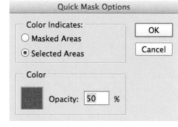

Figure 1.27

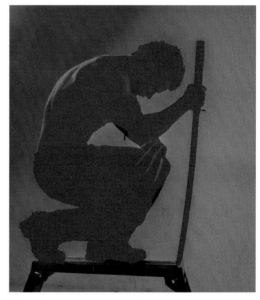

Figure 1.26

3. Having made a selection, go into Quick Mask mode by pressing Q or by clicking the Quick Mask icon in the toolbar. The red overlay appears, indicating the selection (**Figure 1.28**).

4. With the red overlay it's easy to see what is missing from the selection, such as the underside of the arm and part of the pants. To include these areas in the selection, paint over them with a black brush at around 75% hardness; to remove areas that should not be part of the selection, paint with a white brush at 75% hardness.

5. Press Q or click the Quick Mask icon in the toolbar.

 TIP *If the red overlay is too bright and is preventing you from seeing the image, double-click the Quick Mask icon in the toolbar and reduce its opacity from within the Quick Mask properties (**Figure 1.29**).*

Figure 1.28

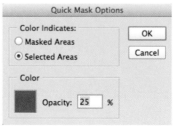

Figure 1.29

FAKING CUTOUTS: PART 1

Sometimes an image's background is too busy or too similar in tone and contrast to what you're trying to select and cut out. The Pen tool is great in situations like these, but if what you're trying to cut out includes hair or fur, then you can turn to brushes.

Brushes are incredibly powerful, and you can use them to fake the look of hair or fur—saving time and frustration.

Figure 1.30 shows the image we'll be working with.

1. With the image open in Photoshop, use the Quick Selection tool to make a rough selection of the chimpanzee (**Figures 1.31** and **1.32**).

2. Press Q or click the Quick Mask icon in the toolbar. The red overlay is a little too bright to be able to see what needs to be added to or removed from the selection of the feet, so double-click the Quick Mask icon to bring up the properties. Lower the opacity to 15% and click OK (**Figure 1.33**).

3. Press Q or click the Quick Mask icon in the toolbar to turn it back on. Use a white or black medium soft-edged brush to improve the selection of the feet.

continues

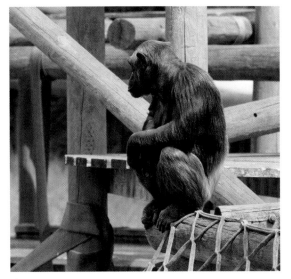

Figure 1.30

Figure 1.31 **Figure 1.32**

Figure 1.33

4. Press Q or click the Quick Mask icon in the toolbar to turn it off. Click the Layer Mask icon at the bottom of the Layers panel; this shows the chimpanzee on a transparent background. Command/Ctrl-click the New Layer icon to add a layer below the chimpanzee. Choose Edit > Fill > Contents > White, and click OK (**Figures 1.34** and **1.35**).

5. Click the layer mask icon at the bottom of the Layers panel, and choose a hard-edged brush with a black foreground color. Zoom in and paint along the outline of the chimpanzee to remove the hair from along his back, shoulders, arm, and head (**Figure 1.36**).

6. Now the brushes do their magic as we paint back the areas we've just removed, but this time in the shape of fur so that it looks as though we made a perfect selection.

7. In the options bar at the top of the screen, click the Brush Preset Picker icon and choose number 112, which looks like a single blade of grass (**Figure 1.37**).

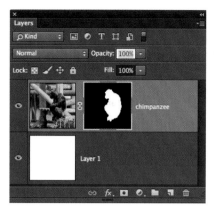

Figure 1.34

Figure 1.35

Figure 1.36

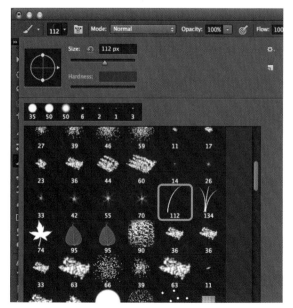

Figure 1.37

8. Click the Brush Panel icon at the top of the screen in the Options bar (**Figure** 1.38) so that we can change the settings of the brush to make it look like hair. Click Shape Dynamics, and set Size Jitter to 15% and Angle Jitter to 4%, so as to vary the shape and angle of the brush with each new stroke (**Figure** 1.39).

9. Click Scattering, set Scatter to 50%, and select the Both Axis checkbox. Set Count to 4, turn off any other brush panel settings, and click Brush Tip Shape. Change Angle to –95 degrees, and set Size to 45 pixels (**Figure** 1.40).

Figure 1.38

continues

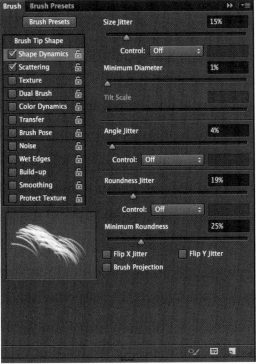

Figure 1.39

Figure 1.40

10. Set the foreground color in the toolbar to white. With the layer mask active, paint along the outline of the chimpanzee to bring back the hair that we removed earlier; this time it is revealed in the shape of the brush we just created (**Figures 1.41** and **1.42**).

> **TIP** *When painting along the outline, continually change the angle of the brush head by altering the Angle setting in the Brush panel. Select the Flip X or Flip Y checkbox to flip the brush head horizontally or vertically, respectively (**Figure 1.43**).*

Figure 1.41 Faking the look of the fur using brush 112

Figure 1.42 Revealing parts of the layer mask in the shape of brush 112

Figure 1.43

FAKING CUTOUTS: PART 2

Most of the time brushes do a great job with cutouts. But one technique doesn't necessarily work for every picture or situation. In this example the challenge was to select the fine hair of the lion's mane from the background and make it look believable.

So here's a great technique I learned from friend, and insanely gifted artist and animator, Aaron Blaise. First we need to create a brush:

1. Go to File > New, and create a document that's 2000 pixels square at 240ppi (**Figure 1.44**).

Figure 1.44

2. Choose a hard-edged brush with a black foreground color and paint random dots on the new document (**Figure 1.45**). These dots will form the individual hair strands.

3. To turn the dots into a brush, go to Edit > Define Brush Preset, name it **hair**, and click OK (**Figure 1.46**). We no longer need the document we used to make the brush, so choose File > Close and don't save.

 Figure 1.47 shows the image we'll work with.

4. Use the Quick Selection tool and Refine Edge to select the lion. Choose Selection as the Output To method in Refine Edge (as we did earlier with the athlete cutout), click OK and add a layer mask to cut the lion from the background. Create a copy of this layer by going to Layer > New > Layer via Copy, and then choose Layer > Layer Mask > Apply (**Figure 1.48**). (This keeps the original safe in case you make a mistake.)

continues

Figure 1.45

Figure 1.46

Figure 1.47

Figure 1.48

6. Choose the Smudge tool from the toolbar (**Figure 1.49**). Go to the Brush Picker and choose the **hair** brush we just created (**Figure 1.50**).

7. In the options at the top of the screen, set Mode to Normal, set Strength to 75%, and make sure that the Sample All Layers and Finger Painting checkboxes are unselected (**Figure 1.51**).

8. Use the Smudge tool to apply brush strokes around the outside of the mane and drag out the hair that is already there. This creates the look of extra hair strands (**Figure 1.52**).

 TIP *To clearly see the new hair you are painting/smudging in, add a blank layer, fill it with white (Edit > Fill, and choose white from the Use menu), and drag it beneath the layer containing the cutout; just as in the earlier example faking the cutout of the chimpanzee.*

 TIP *Vary the Strength and Size settings of the Smudge tool as you work around the hair to create a more random and believable effect. You could also create several more brushes and use them in combination to enhance the result.*

Figure 1.50

Figure 1.51

Figure 1.52

ADVANCED BLENDING

The Blend If sliders can do more than I have space in this book to explain. I tend to use them for controlling how color appears within the highlight and shadow areas of a picture, and also for extracting colored liquid.

Here's how they can be used to extract colored liquid, in this case coffee, from its original background. **Figure 1.53** shows the final image.

NOTE *The overflowing coffee was photographed much lower down and in a controlled manner against a gray seamless background, so as to prevent unnecessary mess in the studio and make it easier to extract.*

continues

Figure 1.53

1. With the coffee image open in Photoshop, use the Lasso tool to make a rough selection around the overflowing coffee (**Figure 1.54**). Go to Edit > Copy.

2. With the picture open that you want to add the liquid into, go to Edit > Paste and then Edit > Free Transform to resize the liquid so that it fits into the scene (**Figure 1.55**).

3. Click the fx icon at the bottom of the Layers panel, and then click Blending Options.

4. Within the Blending Options are the Blend If sliders. From the Blend If menu, choose Red. Drag the black marker in the This Layer gradient bar to the right (**Figure 1.56**).

 You'll see the gray background and blue cup begin to disappear, but the coffee remains (**Figure 1.57**).

 NOTE *In this example choosing Red from the Blend If drop-down menu worked but this will vary depending on the image you use.*

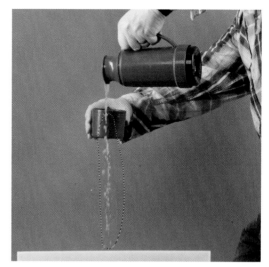

Figure 1.54

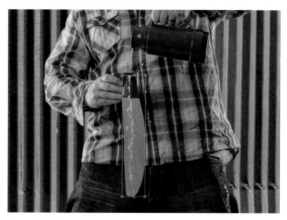

Figure 1.55

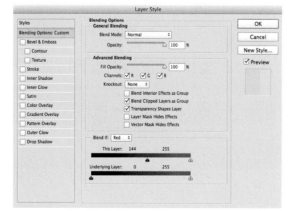

Figure 1.56

Figure 1.57

5. At the moment the coffee cutout looks harsh around the edges. To soften this and help the cutout blend into the scene, Option/Alt-click the black marker in the gradient bar. Doing so splits it into two so you can move each part independently. Moving them to 147/198 worked great (**Figures 1.58** and **1.59**).

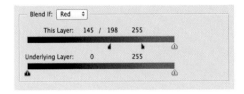

Figure 1.58

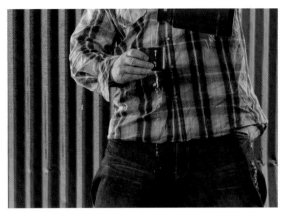

Figure 1.59

COLOR RANGE

Color Range is a great way to make selections based on, well, color.

Figure 1.60 shows a cheese board I photographed against a gray background; during retouching I will add texture to make the background look more like a wall. First I need to make a selection that will include all of the background, including the small visible areas among the parts of the food.

1. With the image open in Photoshop, go to Select > Color Range.

2. Click the Eyedropper tool that has the + symbol on it, then drag around the background area of the image to add to the selection (**Figure 1.61**).

 NOTE *In the Color Range properties, the preview pane shows in real time what is being added to or taken away from the selection. Areas in white are being selected; areas in black are not.*

continues

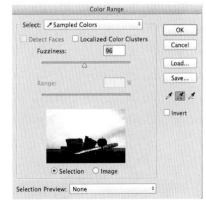

Figure 1.60

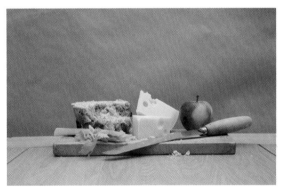

Figure 1.61

3. Think of the Fuzziness slider as range: the more you move it to the right, the more areas will be selected. In this case I've left it at 30. In **Figure 1.62** we can see that parts of the knife are included in the selection, but we will sort that out in the next step. Click OK.

4. Press Q to enter Quick Mask, and with a white foreground color, paint over the knife with a normal round brush to remove the overlay.

5. Press Q to exit Quick Mask mode. Go to Select > Save Selection, name the selection **wall**, click OK, and go to Select > Deselect.

6. Now that there's a saved selection of the background, textures can be added very easily using blend modes. (I'll cover this in more detail in Chapter 2.) Go to File > Place Embedded (File > Place in earlier versions of Photoshop), navigate to a texture that you wish to use, and click OK. This places the texture at the top of the layer stack. Resize the layer by dragging the transform handles, and press Return/Enter. The layer is added as a Smart Object layer.

7. So that the layer is only on the gray paper, go to Select > Load Selection, choose **wall** from the Channel menu, and click OK (**Figure 1.63**).

8. Click the Layer Mask icon at the bottom of the Layers panel, and change the blend mode of the texture to Soft Light. **Figure 1.64** shows the result with the added texture and a color effect.

Figure 1.62

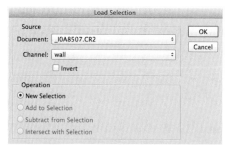

Figure 1.63

Figure 1.64

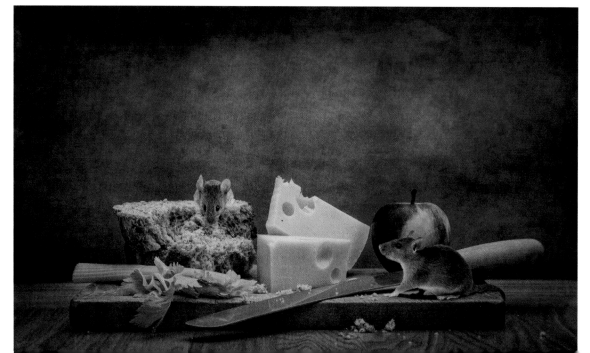

Color Range is great for selecting areas that contain a color, as the name would suggest. Another way that I use it is to change the color of clothing, as you can see in **Figures 1.65** and **1.66**. In this example the clothing has been selected and then the color changed, using a Hue/Saturation adjustment layer.

Figure 1.65

Figure 1.66

THE PEN TOOL

Without a doubt, using the Pen tool is the best way to make clean, sharp selections and cutouts.

I'm not talking about selecting hair, because there are other methods more suited for that, but when you want to select something with straight lines and curves, nothing beats the Pen tool. But it's also the tool that most frustrates new users of Photoshop.

In this short section I give you a few pointers to help you get the most out of the Pen tool. With a little practice, the tool is actually very simple to use.

1. Choose the Pen tool in the toolbar, and make sure that the Path option is selected in the options bar (**Figures 1.67** and **1.68**).

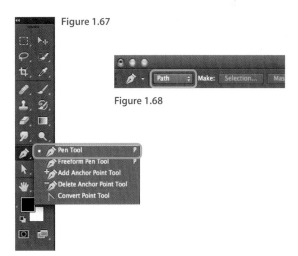

Figure 1.67

Figure 1.68

continues

2. Go to File > New, create a new document 1000 pixels by 800 pixels at 240ppi, and click OK. (We're just using this new document to practice.)

3. Curves are the hardest thing to create with the Pen tool. Choose the Path Selection tool (**Figure 1.69**), and in the options at the top of the screen ensure that the Constrain Path Dragging checkbox is selected (**Figure 1.70**). (Depending on your version of Photoshop, you may notice that it is turned off by default.)

4. Grab the Pen Tool 'P'. Now click down in the document to add a point. Then add another point in the document a little distance away from the first, but before releasing drag a little in the direction that you wish to head (**Figure 1.71**).

5. To make this a curve, Command/Ctrl-click the line and drag upward (**Figure 1.72**). As you drag up or down on the line, you'll see that the handles increase in length.

6. To make a sharp corner without a curve, use the Option/Alt key. Once you have clicked to lay down a point, hold down the Option/Alt key and click directly on it. Now you have told Photoshop that the next point you create should be joined with a straight line as opposed to a curve. This is how to draw a path, and an eventual selection, around objects where there is no curve (**Figure 1.73**).

 TIP *The Command/Ctrl key is extremely useful when working with the Pen tool. For example, hold it down and click any point to drag it to a new position. Or hold it down, click any handle, and drag to change the angle and length of a curve.*

7. Once you have traced whatever you want to select with the Pen tool, the path can now be found in the Paths panel. To turn this path into a regular selection, click the Load Path as a Selection icon at the bottom of the Layers panel (**Figure 1.74**) and save it.

 TIP *The Rubber Band option allows you to see exactly where each line will be when you click to add points. To turn it on, select its checkbox in the options bar (**Figure 1.75**).*

 NOTE *You can always use the Edit > Step Backwards command to go back a few steps if you find that things start to go wrong; this is extremely useful and quickly gets you back on track.*

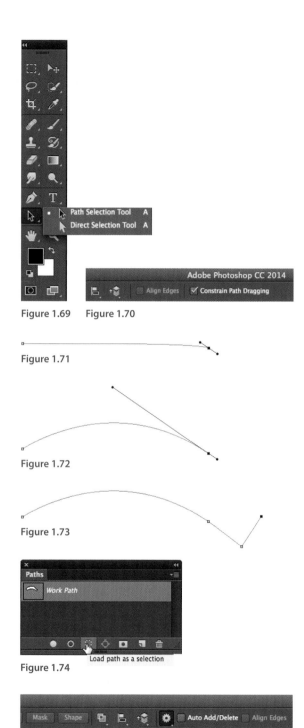

Figure 1.69 **Figure 1.70**

Figure 1.71

Figure 1.72

Figure 1.73

Figure 1.74

Figure 1.75 The Rubber Band option shows you exactly where each new line will be.

CHANNELS FOR SELECTIONS

Channels are a great way to make selections, but I tend to use them in combination with other methods to get the best possible result.

Here I'll show you how I use channels to select the tail hair on the giraffe in **Figure 1.76.** I've already used the Pen tool to select the head, neck, body, and legs, and I used Refine Edge to pick up all the hair on the mane. These selections have been saved, so all that remains is to select the hair on the giraffe's tail.

1. In the Channels panel, click the Red, Green, and Blue channels in turn. I am looking for the channel that gives the most contrast between the tail hair and the background; in this case, it's the Green channel (**Figure** 1.77 and **1.78**).

continues

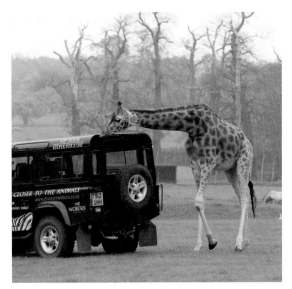

Figure 1.76

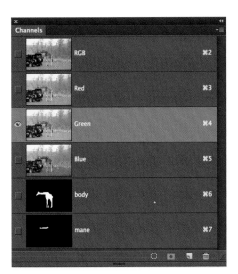

Figure 1.77

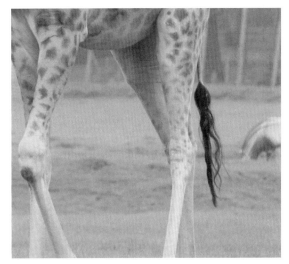

Figure 1.78 The Green Channel gives the most contrast between the giraffe's tail and the background.

2. Create a copy of the Green channel by dragging it over the New Channel icon at the bottom of the Channels panel, and name it **Green copy (tail)** (Figure 1.79).

3. With the Lasso tool, make a rough selection around the tail hair. Then go to Select > Inverse so that everything but the tail hair is selected. Then go to Edit > Fill and choose White from the Contents menu. Click OK, and then choose Select > Deselect.

4. Choose Image > Adjustments > Levels. With the White Point Eyedropper, click an area of the background around the tail hair; with the Black Point Eyedropper, click the hair.

5. There remain a few gray areas around the hair (Figure 1.80). Set the foreground color to white. Choose a medium soft-edged brush and in the options bar choose the Overlay blend mode, set Opacity to 50%, and apply a few paint strokes over the gray areas.

NOTE *Painting with a brush in the Overlay blend mode means that it affects only the gray areas. This allows us to paint in white and get close to the black areas without affecting them, but I find I have more control when I use an opacity lower than 100%.*

6. Go to Image > Adjustments > Invert.

Now we'll combine the body, mane, and tail selections into one complete selection that we can use to cut the giraffe from its original background.

7. Drag the Body channel onto the New Channel icon at the bottom of the Channels panel to create a duplicate; rename it **Giraffe**.

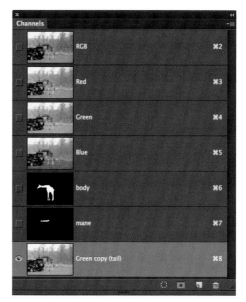

Figure 1.79

Figure 1.80 Gray areas remain around the hair.

Figure 1.81 A brush in the Overlay blend mode removed the gray and enhanced the selection.

8. With the Giraffe channel active, Command/Ctrl-click the Mane channel thumbnail to load it as a selection; fill it with white by going to Edit > Fill and choosing White from the Contents menu. Command/Ctrl-click the Tail channel thumbnail to load it as a selection, and fill that with white also (**Figures 1.82** and **1.83**).

9. Click the RGB channel to return to the normal full-color view. Go to Select > Load Selection, choose Giraffe from the Channel menu, apply a layer mask, and then add it into a composite (**Figure 1.84**).

 NOTE *It's always advisable to save selections just in case you need to make changes later on. Save images as Photoshop (.psd) files or TIFF (.tif) files.*

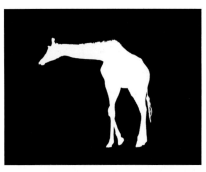

Figure 1.82

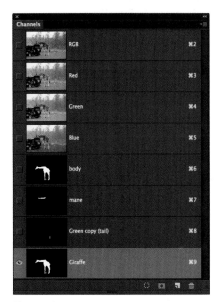

Figure 1.83

Figure 1.84

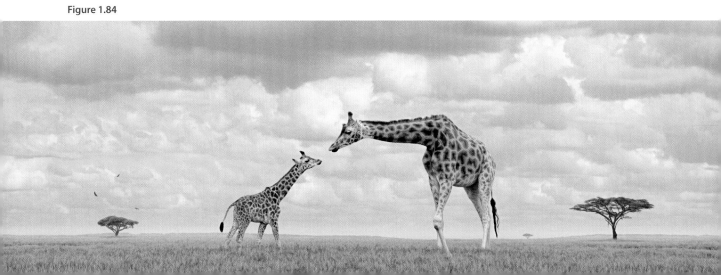

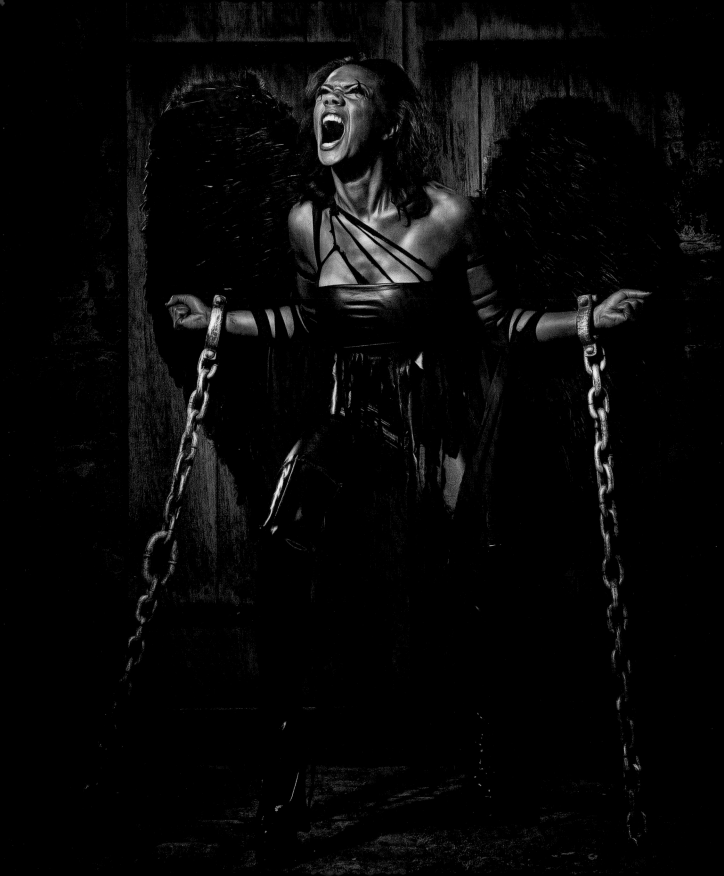

THE POWER OF GRAY

It seems that every time I work on a new picture there's another great reason to make use of 50% gray in some way, be it for creating a special effect or for simply helping me to work nondestructively. It's no understatement when I say that once I'd discovered how 50% gray can be used to create composite images, my portfolio was transformed!

In this chapter I take you through some of my favorite ways to use 50% gray in retouching. I cover techniques such as blend mode compositing, textures, dodging and burning, lens flares, and how to fake damage or dents.

BLEND MODE COMPOSITING

Compositing is becoming increasingly popular among photographers and retouchers as a way of creating images that range from the real to the surreal.

I became interested in creating composite images initially because of poor weather. Many times I would have a photo shoot organized, but on the day it was supposed to happen all plans would need to be changed because of rain. So I began photographing models in the nice warm studio and then using Photoshop to add them into new locations.

Here's a technique that can give you instant composite images. You just photograph your model against a gray background and Photoshop helps with the rest, leaving you to concentrate on the creative side of retouching: lighting effects, color, special effects, and so on.

Studio Lighting

First of all let's look at the lighting used when photographing the model. For this picture the idea was to make it seem as if our model had been captured, and was being kept under lock and key in a dungeon.

Figure 2.1 shows the lighting diagram I used. To make it appear as though two fire torches were on the walls on either side of the model, I used two spotlights fitted with a sheet of orange gel on each. To the front there was a 1-meter (100cm) square soft box fitted with a grid but with the outer diffusion panel removed; this gave a really interesting shadow effect on the floor area, almost looking like bars in the dungeon door (**Figure 2.2**).

> **NOTE** *You can see in Figure 2.2 that the gray paper background isn't evenly lit. Having dark and light areas and interesting shadows helps produce interesting pictures.*

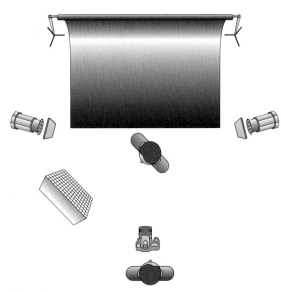

Figure 2.1

Figure 2.2

The Background

This blend mode compositing technique is used when adding solid backgrounds, such as walls and doors, as opposed to something like an outdoor scene.

A key element of a successful composite is perspective; the angle at which the background was photographed should match the angle at which the model was photographed. Getting this right is actually easier than you might think; it just requires that you be consistent.

TIP *Generally when I shoot a full-length photograph of a model in the studio I am down on one knee and using my go-to lens, a 70–200mm (**Figure 2.3**). Because I know that this is the position I use when photographing a full-length shot, when I'm out and about and see what I think would make a great background I adopt the same position, using the same lens with roughly the same focal length.*

Doing this means that the perspective of the background (**Figure 2.4**) and model will match closely, and blend seamlessly when combined in the composite.

Figure 2.3

Figure 2.4 The background photographed from the same perspective as the model

The Compositing

1. In Photoshop, go to File > Open and open a file that contains a model photographed on gray seamless paper. Then go to File > Place Embedded (File > Place in earlier versions of Photoshop), navigate to the file that you want to use as the new background, and click OK.

2. This places the file we wish to use as the background at the top of the layer stack and above the studio photograph of the model. Shift-Option/Alt-click any outer transform handle, and drag outward until the picture fills the layer. Press Return/Enter.

3. Rename this layer **Scene**, and then to create the composite change its blend mode from Normal to Overlay (**Figure 2.5**).

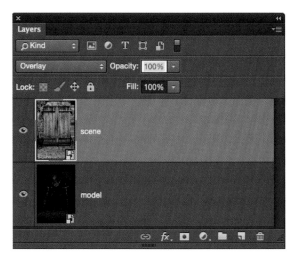

Figure 2.5 Layer stack with new scene placed above the model on gray paper

4. The new background scene has been added (**Figure 2.6**), but when you look closer you may notice that some darker parts of the background are showing through the lighter areas of the layer containing the model (**Figure 2.7**). This is easily fixed with a layer mask.

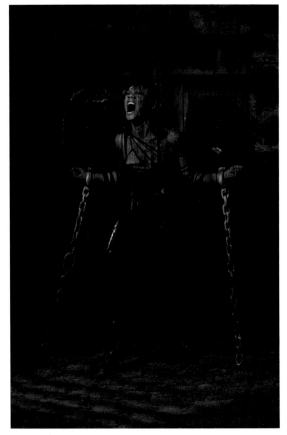

Figure 2.6

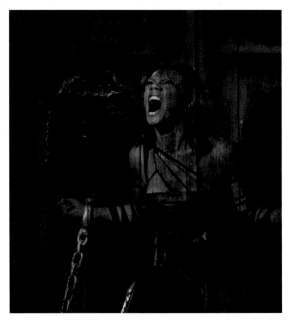

Figure 2.7

5. With the scene layer active, click the layer mask icon at the bottom of the Layers panel. Then with a normal medium soft-edged brush and a black foreground color, paint over areas of the image where the background is showing through (**Figure** 2.8).

 TIP *Don't use a brush that is totally soft (0% hardness), because when you get near the edges your brush strokes will spill over and remove more than you want to.*

 The fantastic thing about creating composites with this technique is how every single fine hair is included simply by changing the blend mode. You can clearly see this in **Figure** 2.9.

continues

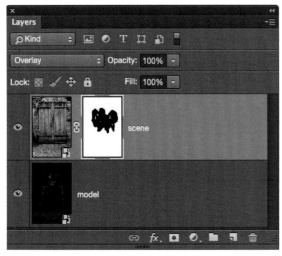

Figure 2.8 Add a layer mask and paint with a black brush to hide areas where the background shows through.

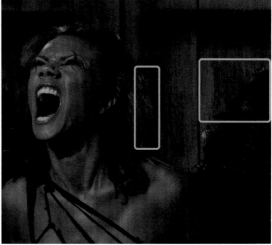

Figure 2.9

NOTE *You can use other blend modes when creating composite images in this way, but mainly Soft Light and Overlay are used. There is a slightly different result when using Soft Light rather than Overlay—the final look is a lot softer and lower in contrast. **Figure 2.10** shows Soft Light; **Figure 2.11**, using the Overlay blend mode, slightly darker and with increased contrast.*

Once you have composited your model and background, it's time to start working on the fun stuff: enhancing details, adding lighting effects, and so on. I'll cover these techniques in the coming chapters (**Figure 2.12**).

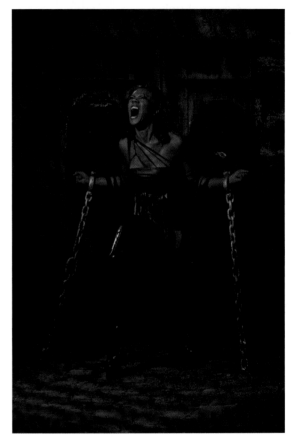

Figure 2.10

Figure 2.11

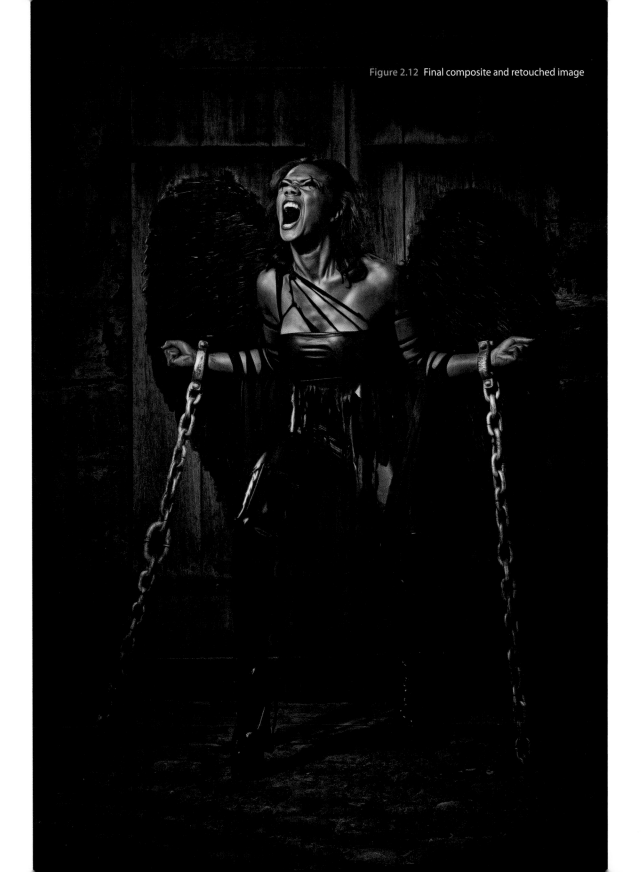

Figure 2.12 Final composite and retouched image

TEXTURES, TEXTURES, TEXTURES

With blend mode compositing you can also use textures instead of photographs. In fact, textures can be added to the gray paper to make it appear as though it was a solid brick wall.

TIP *Textures are everywhere. I collect them all the time by taking photographs of walls, floors, old flaking paint, rust, and so on. All around there are limitless textures to photograph, and you can even use your mobile phone so that you're constantly adding to your collection for future use.*

TIP *Adobe Exchange (www.adobeexchange.com) is a wonderful resource for textures. Search for "flypaper" and you'll find many free and paid textures (Figure 2.13) that you can use in your own images.*

Figure 2.13

In **Figure 2.14**, the flowers have been photographed using available light, with gray paper attached to a piece of cardboard for the background.

1. With the flower arrangement photograph open in Photoshop, go to File > Place Embedded (File > Place in earlier versions of Photoshop) and navigate to a texture file that you have stored on your hard drive. (Using the Place command means that the file will now open directly into the document we are working on, and saves opening and dragging it across.) In this example I'm using the texture in **Figure 2.15**, the Adobe Exchange Flypaper add-on. Click OK to add it to the top of the layer stack, and change the blend mode to Overlay (**Figure 2.16**).

continues

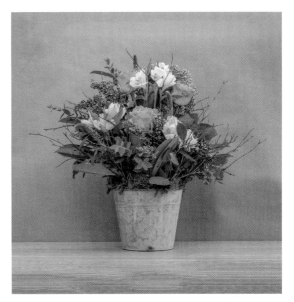

Figure 2.14

Figure 2.15

Figure 2.16

Changing the blend mode of this texture layer to Overlay attaches it to the gray paper but also to the flowers and the table top (**Figure 2.17**). There's no need to worry about that at this stage, but if you don't want to use the color in the texture, then you can desaturate it.

2. Go to Image > Adjustments > Desaturate (**Figure 2.18**), and you'll see that the Desaturate command is grayed out and unavailable. This is because we used the Place command to add the texture, adding it as a Smart Object.

3. Go to Layer > Rasterize > Smart Object (**Figure 2.19**), then to Image > Desaturate. Lower the opacity of the layer to 50%.

4. Repeat this process, adding as many textures as you like and trying other blend modes, such as Soft Light or Hard Light, to create a completely bespoke background. Then click the uppermost texture layer and Shift-click the last texture layer so that they are all highlighted (**Figure 2.20**). Then go to Layer > New > Group from Layers, name the group **textures**, and click OK.

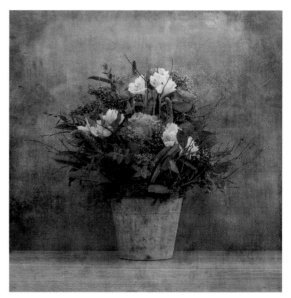

Figure 2.17

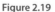

Figure 2.18

Figure 2.19

Figure 2.20

5. Add a layer mask to the textures group by clicking the layer mask icon at the bottom of the Layers panel. With a normal medium soft-edged brush and a black foreground color, paint over the table and the flowers to remove the texture, leaving it visible only on the gray paper (**Figure 2.21**).

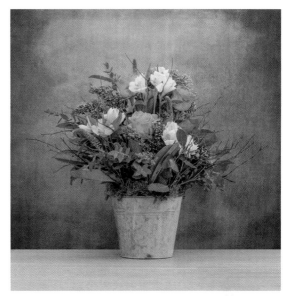

Figure 2.21 Paint in black to remove the texture from unwanted areas.

Figure 2.22 Out of camera image

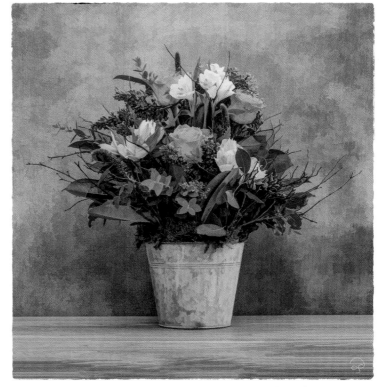

Figure 2.23 Final retouched image with textures added onto the background

SMART DODGING AND BURNING

Dodging and burning means to add dimension, depth, and direction by brightening and darkening specific areas of a photograph.

Ordinarily we might use the dodge and burn tools directly on our pictures. But if we go too far with the dodging and burning, as is very easily done, removing or reducing the effect means undoing and then redoing lots of work.

Here is a smarter way to dodge and burn that uses a 50% gray layer and allows us to work nondestructively.

1. Open a portrait image in Photoshop (**Figure 2.24**), and then go to Layer > New > Layer. In the New Layer dialog that appears, name the layer **dodge & burn**. Choose Soft Light from the Mode menu. Select the Fill with Soft-Light-neutral color (50% Gray) checkbox (**Figure 2.25**) and click OK.

2. Set the foreground and background colors to their default of black and white by pressing D. Click the foreground color in the toolbar.

3. In the Color Picker, set H (Hue) to 0, S (Saturation) to 0, and B (Brightness) to 50 (**Figure 2.26**). This gives you 50% gray. Click OK.

Figure 2.24

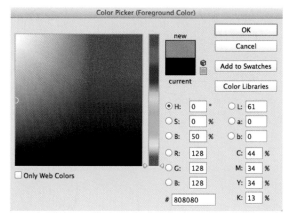

Figure 2.25

Figure 2.26

4. Choose the Dodge tool from the toolbar, and in the tool options at the top of the screen, choose Midtones from the Range menu, set Exposure to 10%, and select the Protect Tones checkbox (**Figure 2.27**).

> **TIP** *It's very easy to overdo dodging and burning, so always use a low Exposure amount so that it can be applied gradually and with more control.*

5. With the Dodge & Burn layer active, use the Dodge tool to brighten areas of the picture; to switch to the Burn tool and darken areas, hold down the Option/Alt key while using the Dodge tool.

6. Option/Alt-click the eye icon of the dodge & burn layer to make it the only layer visible (**Figure 2.28**).

7. A common mistake with dodging and burning is having both the brightened and darkened areas very defined and not blending into each other. But because we are on a 50% gray layer we can do something about this. Use the Lasso tool to select an area of dodging and burning that you want to blend together (**Figure 2.29**), and then go to Filter > Blur > Gaussian Blur. Now increase Radius to whatever amount you think softens the blend between the dodging and burning the best (**Figure 2.30**), and click OK.

You may also find that there are areas of the dodging and burning where you want to reduce the strength, or even remove it completely; this is where we use the 50% foreground color that we prepared in step 3.

continues

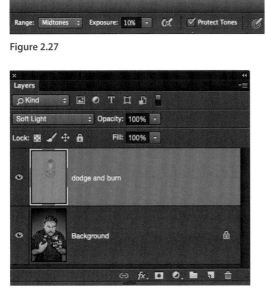

Figure 2.27

Figure 2.28

Figure 2.29

Figure 2.30

8. With a normal soft edged brush and the 50% gray fore-
ground color, paint over areas of the dodge and burn
layer to remove or reduce the dodging and burning.
To remove it completely, paint at 100%; to reduce the
dodging and burning by 50%, change the opacity of
the brush to 50%.

NOTE *In **Figure 2.31** you can see the original dodging
and burning, which was a little too much. **Figure 2.32**
used the 50% gray brush, and you can see that it has been
reduced. This is only possible when dodging and burning
on a new layer, as opposed to dodging and burning directly
on top of the picture.*

9. To return to the original image view, Option/Alt-click to
reveal the eye icon of the dodge & burn layer.

Figure 2.31

Figure 2.32

TRANSFORMING A LOCATION

Sometimes the location you are shooting in doesn't quite match what you had anticipated. At times like this, a little knowledge of gray can come in handy.

In this example I'd been hired to photograph and then retouch promotional material for an upcoming theater production. Unable to visit the location until the day of the shoot, I was assured it was perfect for what was needed: an old building with internal stone walls and the feel of an old castle. The reality, however, was quite the opposite, so it was down to the lighting and Photoshop to transform a modern hotel bedroom into an ancient castle chamber.

1. With the out-of-camera file open in Photoshop, use the Quick Selection tool to make a selection of the walls behind our two characters (**Figure 2.33**).

2. Save the selection for future use, as covered in Chapter 1, by going to Select > Save Selection. Name the selection **cutout**, and click OK.

3. We now need to remove elements from the back wall. We'll use the Clone Stamp tool to do this. To prevent us from accidentally cloning over other areas, load the **cutout** selection by going to Select > Load Selection. From the channel menu, choose **cutout** (**Figure 2.34**).

continues

Figure 2.33

Figure 2.34

4. Add a new blank layer to the top of the layer stack, name it **clone** (**Figure 2.35**), and choose the Clone Stamp tool from the toolbar (**Figure 2.36**).

5. In the options at the top of the screen, use the following settings: Mode: Normal; Opacity: 100%; Flow: 100%; Sample: Current & Below (**Figure 2.37**).

With the cutout selection visible, use the Clone Stamp tool to remove unwanted areas of the background (**Figure 2.38**).

> **NOTE** *When cloning away areas of the background, you don't have to create a perfectly cloned area. Having uneven areas, as you can see in **Figure 2.38**, makes for a more interesting background when the new wall texture is added in, much like the lighting in the blend mode technique.*

Figure 2.35

Figure 2.36 **Figure 2.37**

Figure 2.38

6. Keep the cutout selection visible and add a Hue/Saturation adjustment layer (**Figure 2.39**). Set Saturation to −100 to completely desaturate the back wall, which gives us our gray background (**Figure** 2.40).

7. We can now begin adding textures to transform the location. In this example I wanted to make the back wall appear like an old brick wall in a castle. Go to File > Open, and open the file in Photoshop. Go to Select > All, and then to Edit > Copy.

continues

Figure 2.39 With the selection active, add a Hue/Saturation adjustment layer.

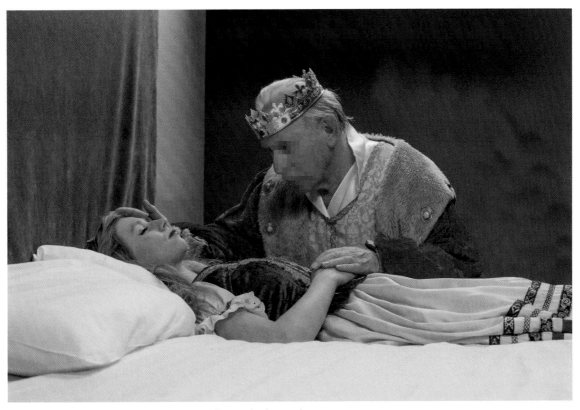

Figure 2.40 Setting Saturation to −100 gives us the gray background.

8. Now click the tab to return to the start image (**Figure 2.41**), go to Select > Load Selection, and choose **cutout** from the Channel menu. With the **cutout** selection active, go to Edit > Paste Special > Paste Into.

 This places the texture in the selection area as opposed to directly on top of our picture.

9. If you need to resize the texture, go to Edit > Free Transform and drag out the transform handles until the texture fills the area within the selection (**Figure 2.42**). Press Return/Enter.

10. To attach the new texture to our gray background so that it looks more realistic, change the blend mode of the texture layer to Soft Light or Overlay, depending on the look you prefer. (**Figure 2.43**). Rename this layer **wall texture**.

Figure 2.41 Each tab represents an open image.

Figure 2.42

Figure 2.43 The new wall texture added with the Overlay blend mode

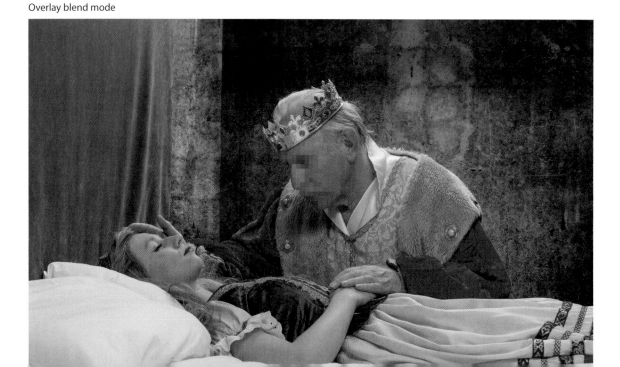

Adding a Window

This is a good example of why the lighting in the original picture is so important. Adding a window means that light from outside would be entering the room, adding high-lights onto the subjects. To mimic this, I used a large softbox behind the king that represented the window light. On the opposite side of the bed a strip box was used to add a little extra light into the shadow areas (**Figure 2.44**).

1. Go to File > Open and open a suitable window image in Photoshop. Go to Edit > Copy, then to Select > All, and click the tab to go back to the original image.

2. Go to Select > Load Selection and choose **cutout** from the Channel menu. Go to Edit > Paste Special > Paste Into. Go to Edit > Free Transform to resize the window. Press Return/Enter. Use the Move tool (V) to position the window. Rename the layer **window**.

3. Click the thumbnail of the window in the Layers panel, and then go to Image > Adjustments > Desaturate. Then click the layer mask attached to the window layer (**Figure 2.45**). With a normal medium soft-edged brush and a black foreground color, paint around the window to hide any unwanted areas (**Figure 2.46**).

continues

Figure 2.44 Lighting diagram showing the set up on location

Figure 2.45

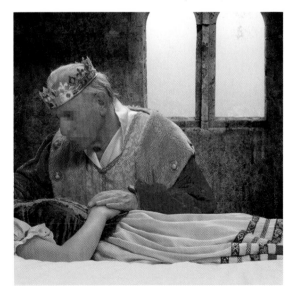

Figure 2.46 Window desaturated and then blended into scene with a layer mask

4. To add an outdoor scene into the windows, start off by making a selection of the windows using the Quick Selection tool (**Figure 2.47**).

5. Go to File > Open, and open a suitable outdoor image. Then go to Select > All, and then to Edit > Copy. Click the tab to return to the original image being retouched.

6. With the selection of the windows active, go to Edit > Paste Special > Paste Into, and then to Edit > Free Transform to resize the outdoor scene so that it fills the windows, creating a realistic view (**Figure 2.48**).

7. Once the new wall, windows, and scene had been added, the lighting on the subjects made sense. I continued to retouch the image using techniques I cover throughout the book (**Figure 2.49**).

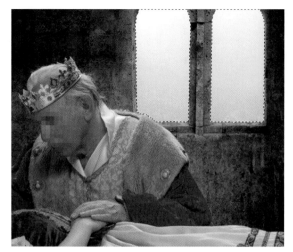

Figure 2.47

Figure 2.48 Windows and a new outdoor scene added into place

Figure 2.49 Final retouched image

ADDING DENTS AND DAMAGE

In this section I show you how to put dents and damage into your pictures; a special effect that is great for adding signs of battle damage to an action scene.

In the out-of-camera shot (**Figure 2.50**), the body armor looked too clean for it to be composited into a scene where there were explosions going off and debris flying around. In **Figure 2.51** you can see how I used this technique to add battle damage in a number of places, such as the chest and head.

Figure 2.50 Out-of-camera shot

Figure 2.51 Final retouched image complete with battle damage

Here I'll show you the steps for this technique by making it appear as though a beautiful Aston Martin (**Figure 2.52**) has some damage to the wheel arch.

For this technique you'll need a photograph that already contains damage. (It doesn't matter what color the dent is, because we will be completely desaturating it at some point.) If you don't have a photograph of a dent already, there are many available from stock sites such as istock-photo.com; just search for "car dent" or something similar.

1. Go to File > Open and open an image that you want to add some dents to. Then go File > Open and navigate to the file containing the dents you will use in this technique.

2. With the Lasso tool, make a selection around the dent (**Figure 2.53**), and then go to Edit > Copy.

3. Click the tab (**Figure 2.54**) to show the picture that we are going to add the dent onto, and go Edit > Paste. Double-click the layer name, and rename it **dent**.

continues

Figure 2.52

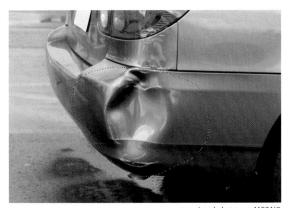

Figure 2.53

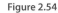
www.istockphoto.com MCCAIG

Figure 2.54

4. You may need to resize the dent for it to fit, so go to Edit > Free Transform (**Figure 2.55**) and resize it in proportion by Shift-Option/Alt-dragging any corner transform handle. Press Return/Enter, and use the Move tool (V) to drag it into position.

5. Remove all the color from the dent by going to Image > Adjustments > Desaturate (**Figure 2.56**). Because we will be using a filter, go to Filter > Convert for Smart Filters (**Figure 2.57**) so that any settings we apply aren't permanent and can be adjusted.

6. Click the layer mask icon at the bottom of the Layers panel (**Figure 2.58**) to add a white layer mask. Then with a normal soft-edged brush and a black foreground color, paint over areas you wish to remove or conceal.

7. Change the blend mode of the dent layer to Overlay, and then click once on the thumbnail of the dent in the Layers panel so that it is active (**Figure 2.59**).

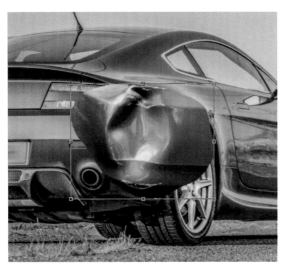

Figure 2.55

Figure 2.56 Desaturate so that any color dent can be used.

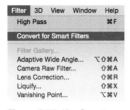

Figure 2.57 Use Smart Filters so that settings can be adjusted at any stage.

Figure 2.58 The layer Mask icon in the layers panel

Figure 2.59 The frame around the thumbnail means that it's active.

8. Go to Filter > Other > High Pass, and drag the Radius slider all the way to the left (the minimum setting of 0.1 pixels). You'll notice that the dent on the car is no longer visible (**Figure** 2.60).

9. Now, begin to increase the High Pass filter setting by dragging the point to the right (**Figure** 2.61) and increasing the radius. The higher the radius, the more dent is revealed (**Figure** 2.62). Click OK.

Because we used High Pass as a Smart Filter, this means that at any stage we can double-click the filter name in the Layers panel and make adjustments to the settings to show more or less of the dent.

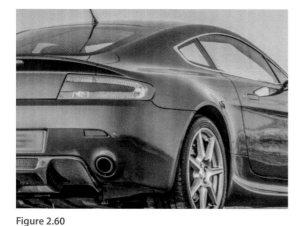

Figure 2.60

Figure 2.61 Increasing the High Pass filter settings reveals more of the dent.

Figure 2.62

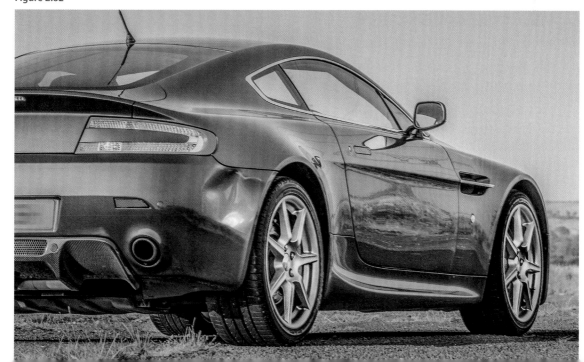

INSTANT SIX-PACK

If ever you find yourself retouching physique portraits, you could also use the dents technique to add or enhance a six-pack.

1. **Figure 2.63** is the image that I want to enhance the six-pack on. So, I can make a selection of a six-pack in another picture (**Figure 2.64**) and use the dents technique to quickly produce the result in **Figure 2.65**.

2. You can have a lot of fun with this technique, but it also has a very practical application. With a little bit of work it can enhance a physique to produce the look that the model or client asks for.

Figure 2.63

Figure 2.64

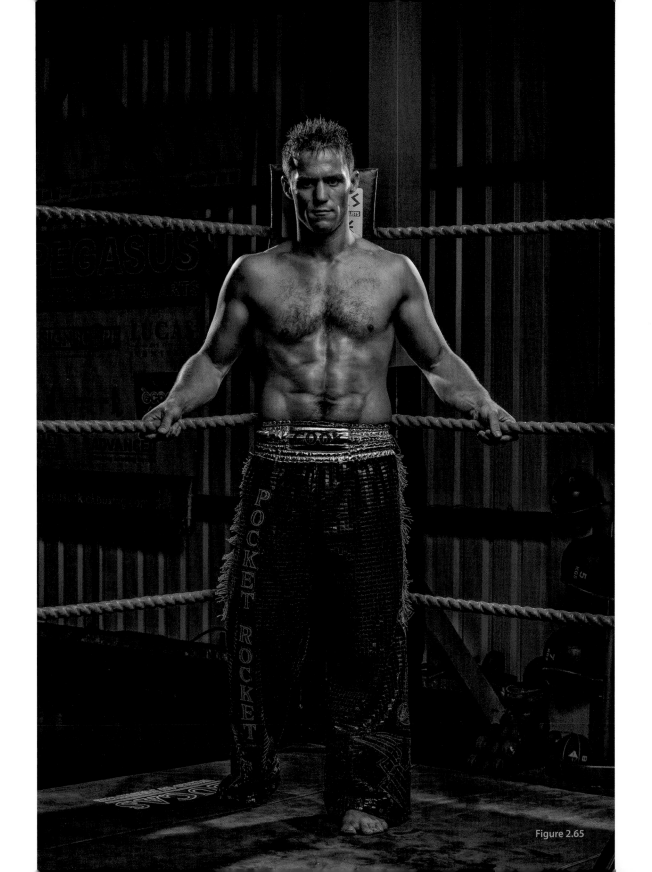

Figure 2.65

PHOTOSHOP LENS FLARES

A lot of folks tend to avoid Photoshop's Lens Flare filter because its results can have that "done in Photoshop" look. But as with most Photoshop tools and filters, just because it's there doesn't mean you have to use it in the way it was intended. This technique shows how a simple use of 50% gray can give you much more flexibility.

1. I want to add a lens flare onto the metal part of the gun (**Figure 2.66**). So with the image open in Photoshop, go to Filter > Render > Lens Flare.

2. From the choice of lens flares, for this effect I'm going to use the 105mm Prime. In the small preview window, drag to position the flare where you would like it. This can be challenging due to the size of the preview, but don't worry about being entirely accurate (**Figure 2.67**).

3. Adjust Brightness to 70% and click OK.

 Now in Photoshop we can see that the lens flare has been added, but we can also see the additional Photoshop flares (**Figure 2.68**). Depending on the look you are after, you may not like to see these, but using 50% gray we are able to remove them.

Figure 2.66

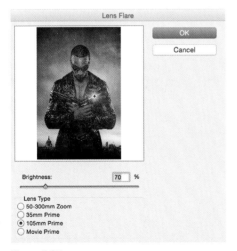

Figure 2.67

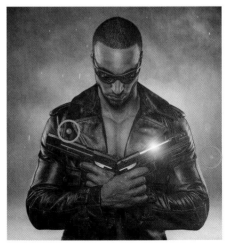

Figure 2.68 Traces of lens flare you may not want in your picture

4. Go to Edit > Step Backwards to remove the lens flare. Now add a new blank layer to the top of the layer stack by going to Layer > New > Layer. Name the layer **lens flare**, set the mode to Hard Light, select the Fill with Hard-Light-neutral color (50% Gray) checkbox, and click OK (**Figure 2.69**).

 NOTE *This process might seem a little strange, but each time you use the Lens Flare filter, the settings remain.*

5. Go to Filter > Convert for Smart Filters, then to Filter > Render > Lens Flare, and click OK. Reposition the lens flare with the Move tool (V).

6. To remove the extra Photoshop flares, change the blend mode of the lens flare layer to Normal to reveal the gray layer (**Figure 2.70**).

7. Press D to set the foreground and background colors in the toolbar to their default of black and white. Click the black foreground color to open the Color Picker, and set H to 0, S to 0, and B to 50. Setting B (Brightness) to 50 gives us 50% gray (**Figure 2.71**).

8. Choose a normal soft-edged brush and paint directly onto the gray layer to remove the unwanted Photoshop lens flares (**Figure 2.72**).

9. Change the blend mode of the lens flare layer to Normal. Return to the color picture and see that the additional lens flares have been removed.

Figure 2.69

Figure 2.70

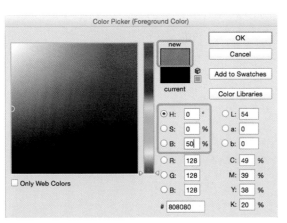

Figure 2.71

Figure 2.72 Painting with the 50% gray brush removes the unwanted lens flares.

MAKE EYES POP

This is great for times when your subject has very dark eyes or when the lighting didn't reveal the detail and texture of the eyes (**Figure 2.73**).

1. With the image open in Photoshop where you want to enhance the eyes, add a new blank layer, and name it **eye detail**. With the Elliptical Marquee tool (**Figure 2.74**), hold down the Shift key and drag out a perfect circle around the iris (**Figure 2.75**).

2. Fill this circular selection with 50% gray by going to Edit > Fill > Contents > 50% Gray, and click OK.

3. Keeping the selection visible, go to Filter > Noise > Add Noise. Set Amount to 400%, choose Gaussian, select the Monochromatic checkbox, and click OK (**Figure 2.76**).

 NOTE *The resolution of the image you are using will determine the amount of noise you add. High-resolution images are good at 400%, whereas lower-resolution images (e.g., 120ppi) would be best around 200%.*

Figure 2.73 The dark lighting doesn't show the eye texture and color.

Figure 2.74 **Figure 2.75** **Figure 2.76**

4. With the selection visible, go to Filter > Blur > Radial Blur. Set Amount to 30, choose Blur Method: Zoom and Quality: Best (**Figure 2.77**), and click OK.

5. Cancel the selection by going to Select > Deselect. Add a white layer mask to the eye detail layer by clicking the layer mask icon at the bottom of the Layers panel.

6. With a normal medium soft-edged brush and a black foreground color, making sure the layer mask is active (**Figure 2.78**), paint on top of the image to remove areas of the circle that are outside the iris (**Figure 2.79**). Also paint in black to reveal the pupil and around the outside of the circle to soften and blend in.

7. Change the blend mode of the eye detail layer to Hard Light, and lower the opacity to taste. In this example I lowered the opacity to 50% (**Figure 2.80**).

continues

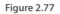

Figure 2.77

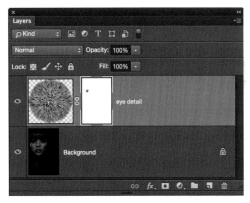

Figure 2.78

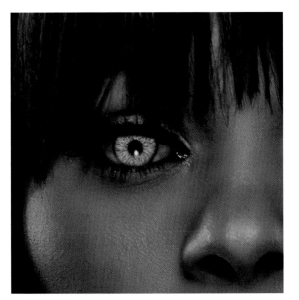

Figure 2.79 Paint in black on a white layer mask to remove unwanted areas and reveal the pupil.

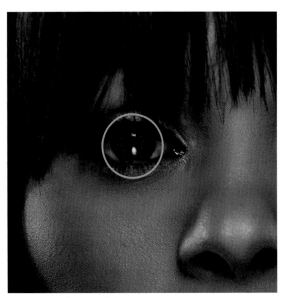

Figure 2.80

8. Now we'll add some color into the eye. Click the Hue/Saturation Adjustment layer (**Figure 2.81**), and then in the Hue/Saturation properties select the Colorize checkbox (**Figure 2.82**).

9. To restrict the color so that it affects only the eye, click the Clipping Mask icon (**Figure 2.83**) in the Hue/Saturation properties. Then adjust the Hue slider to choose a color for the eye. Also adjust the opacity of the Hue/Saturation adjustment layer until you achieve the look you're after.

Figure 2.81

Figure 2.82

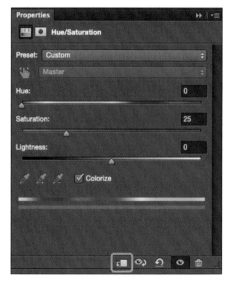

Figure 2.83

10. With one eye now enhanced (**Figure 2.84**), click the Hue/Saturation adjustment layer in the Layers panel and Shift-click the eye detail layer so that both are selected (**Figure 2.85**).

11. Go to Layer > New > Group from Layers, name the group **eye**, and then press Command/Ctrl+J to create a copy (**Figure 2.86**). Then simply use the Move tool (V) and drag within the image area to reposition the eye copy layer over the remaining eye.

Figure 2.84

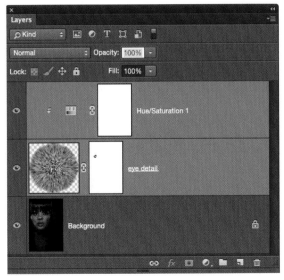

Figure 2.85

Figure 2.86

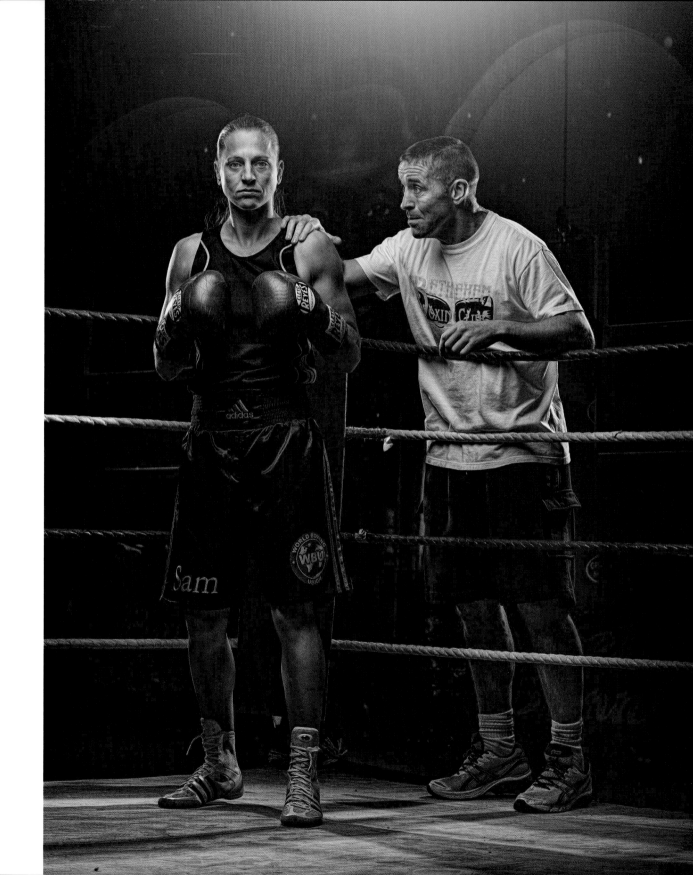

LIGHTING EFFECTS

The light in our pictures determines the mood and directs the viewer's attention. And when it comes to retouching techniques, creating and adding lighting effects is one of my favorite things to do.

Without a doubt the best way to learn about light (how it looks and how it interacts with elements) is to just get out and observe. I have folders full of snapshots that I've taken purely for reference. Photographs of clouds, street lighting, shadows, reflections, and so on, and I'm continually adding to it. Why? Because when I'm adding lighting effects in Photoshop I have something that I can refer to rather than merely guessing how it should look. This alone has saved me hours of head scratching and time trying to make something look right.

In this chapter I take you step by step through lighting effects that I use regularly in my own work. I use some to enhance areas of a picture and some for special effects, but they are all effective and quick and easy to create.

THE WORLD'S SIMPLEST LIGHTING EFFECT

This has to be the world's simplest lighting effect. When you see how it's done you'll say, "Really—is that all?"

This technique is used to mimic what we see when the outer areas of a light source are visible in a picture, as opposed to seeing the bright center point. You can see the effect and how it has been added in the opening image of this chapter. The light is coming from the top, suggesting that a light source is above the two people in the boxing ring.

1. With the image file open (**Figure 3.1**) add a new blank layer to the top of the layer stack, and name it **light**.

2. With your foreground color set to white, choose a soft-edged brush and size it to about 250px. (Make sure there are no settings or effects applied to the brush.)

3. With the light layer active, click once in the center of the image. Zoom out and then choose Edit > Free Transform. Hold down the Option/Alt and Shift keys and then click and drag any of the corner transform handles, and resize the white soft-edged circle much, much larger so that it goes beyond the bounds of the image borders. (Note: Holding down both the Option/Alt and Shift keys when resizing the light does so in the same proportions.) Then press Return/Enter (**Figure 3.2**).

Figure 3.1

Figure 3.2

4. Zoom in, and select the Move tool. Drag the light to the top of the picture so that only the bottom feathered edge remains in view. There you have it—instant light source (**Figure 3.3**).

 Of course you can always do something extra to take the effect to another level, and that's what we're going to do here by adding in dust specks, just like you get around a light source.

 To do this I'm going to make use of something I call "thingys." To create a file like **Figure 3.4**, point your camera to the sky at night and take a photograph of rain, using on-camera flash.

5. Place your thingys layer into the open image by choosing File > Place Embedded (File > Place in earlier versions of Photoshop), and make sure it's positioned at the top of the layer stack. Resize it to fill the layer by using Edit > Free Transform.

 NOTE *The Place command opens the file directly into the image you're working on and adds it to the layer stack. The Open command simply opens the image.*

6. Change the blend mode of the thingys layer from Normal to Screen, which will make only the lighter parts of the layer visible.

continues

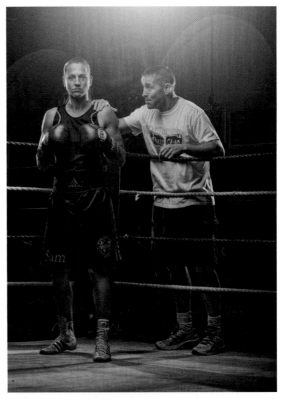

Figure 3.3

Figure 3.4

7. Add a white layer mask to the thingys layer, and with the foreground color set to black, choose the Gradient tool from the toolbar.

8. Click directly on the gradient in the top left of the screen and choose the Foreground To Transparent Gradient from the Gradient Picker.

9. Click OK, and drag multiple gradients over the image to remove the thingys from the lower area of the picture (**Figures 3.5** and **3.6**).

I owe the thingys technique to my friend Olaf Giermann, an incredible digital artist from Germany.

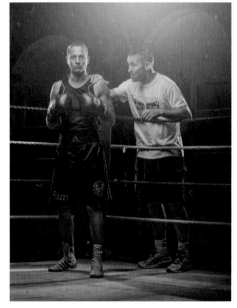

Figure 3.5

Figure 3.6

Figure 3.7 The result of using the world's simplest lighting effect and thingys, with the final coloring applied using a cross processing effect from within the Nik Color Efex Pro.

THE NEVER-ENDING LIGHTING RIG

This technique has saved me more times than I care to remember. It's so called because I can add more lights into a scene without actually having them there with me during the photo shoot.

I'm not suggesting you use this technique instead of capturing the light in camera, but there are times during shoots when for one reason or another (usually time constraints) it's not possible.

At times like these my priority is to light what's most important, and then later in Photoshop I can use my never-ending lighting rig to do the rest.

Figure 3.8 shows the image I'll be using this technique on. You can see straight away that the lighting needs to be improved, as it's a struggle to see detail in the paintings on the back wall.

1. With the image file open add a new blank layer to the top of the layer stack, and name it **light**.

2. Then with the foreground color set to white, choose a soft-edged white brush, size it to 250 pixels, and place a single dot in the center of the picture. Change the blend mode of the light layer from Normal to Overlay.

3. If you don't see the light right away, you can move it around using the Move tool, or you can choose Edit > Free Transform and resize the spotlight by holding down the Shift and Option/Alt keys and then dragging one of the corner transform handles (**Figure 3.9**).

continues

Figure 3.8

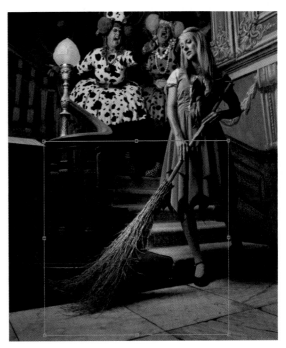

Figure 3.9

4. To make the light source brighter, duplicate the light layer by holding down the Command/Ctrl key and pressing J, or by dragging the light layer over the New Layer icon at the bottom of the layer stack.

5. Put both layers (light and light copy) into a group by Shift-clicking both to make them active and then choosing New Group from Layers from the Layers fly-out menu (**Figure 3.10**).

6. Name this group **light 1**, and close the group by clicking the arrow next to the folder icon in the Layers panel. With the Move tool, drag within the image to reposition the now brighter light source.

7. Now that the light and light copy layers are in a group, use Free Transform to resize the now brighter light source, and use the Opacity slider to control the strength (brightness) (**Figure 3.11**).

 TIP *If you want to add more light sources, simply duplicate the light 2 group by holding down Command/Ctrl+J. You can then reposition that duplicated group using the Move tool, resize it using Free Transform, and control the brightness with the Opacity slider.*

Figure 3.10

Figure 3.11

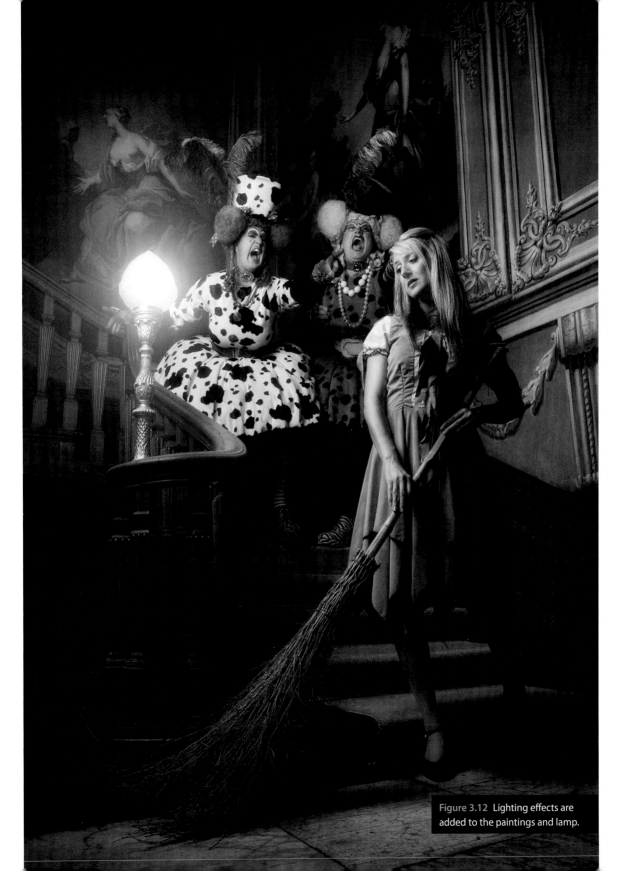

Figure 3.12 Lighting effects are added to the paintings and lamp.

GRADIENT LIGHTING: PART 1

This technique creates a lighting effect that goes through a transition, either from one color to another or fading to transparent.

It's a great technique for mimicking the look of street lighting, because it goes from warm (nearest the light source) to cool (farther away), as in **Figure 3.13**.

This gradient lighting effect has been used to add warm street light coming in from the right; it becomes cooler toward the lower left, as it would do in reality.

1. Open an image in Photoshop and choose Layer > New Fill Layer > Gradient and click OK.

2. In the dialog that appears, rename the layer **light** and choose Soft Light from the Mode menu.

 The Gradient Fill dialog appears (**Figure 3.14**).

3. Click the gradient within the Gradient Fill dialog, and the Gradient Editor dialog appears.

4. From here you can choose a gradient as a starting point for the effect you want to create. It doesn't matter which one, because you can change the colors very easily, but a good one for this effect is Violet, Orange (**Figure 3.15**).

5. The orange will work great, but we need to change the violet to a cool blue. Click the far left marker underneath the gradient bar (**Figure 3.16**), and then click the color swatch to open the Color Picker. Choose a suitable blue, something like R: 107, G: 150, B: 164. But don't worry about getting it exactly right because you can always modify it later.

6. Click OK to close the Color Picker, and then click OK again to close the Gradient Editor. At this stage the lighting effect is going from top to bottom, with the warm light at the top and the cool blue light at the bottom, but we need it to come in at an angle from the side.

7. To do this, rotate the Angle disc from within the Gradient Fill dialog (it should still be open). In this case I set the angle to 35 degrees (**Figure 3.17**).

8. You can also move the light farther in or out of the picture by dragging your cursor directly over the top of the picture with the Gradient Fill dialog still open. Once the light is where you prefer, click OK.

 TIP *Because this effect is on its own layer, you can use the Opacity slider to control how strong or weak the effect is. Should you wish to modify the position or color of the lighting effect, simply double-click the gradient thumbnail in the Layers panel and open the dialogs as before.*

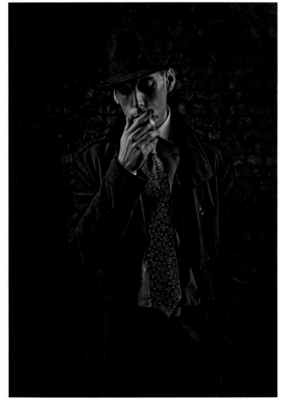

Figure 3.13

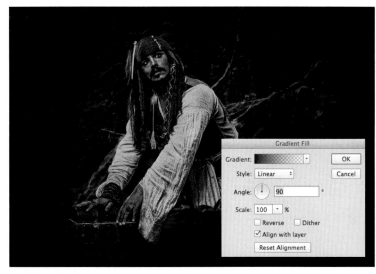

Figure 3.14

Figure 3.15

Figure 3.16

Figure 3.17

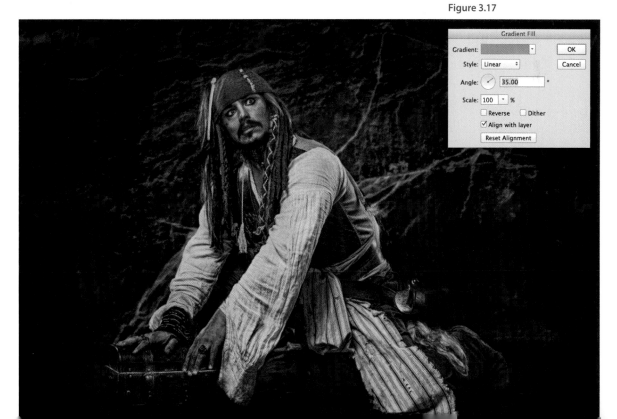

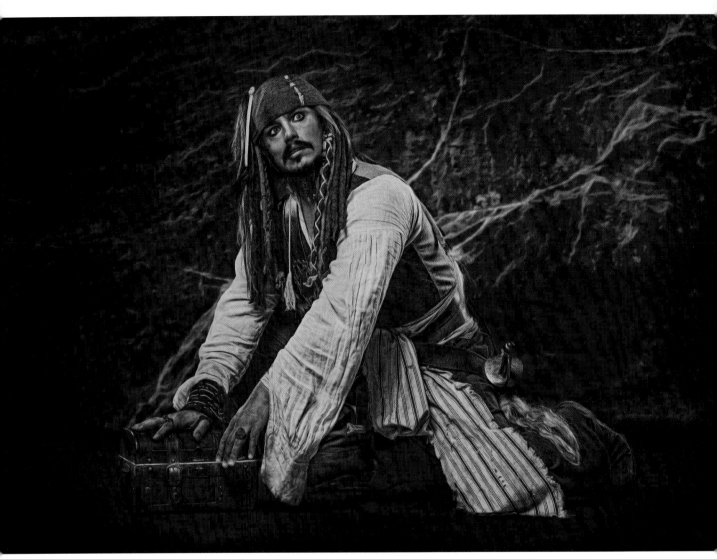

Figure 3.18 The gradient light effect has been used to mimic the look and feel of the fire torch light coming in from the right and cooling down as it spreads.

GRADIENT LIGHTING: PART 2

A great thing about Photoshop is that there's always more than one way to apply the same technique.

As is always the case, the lighting at the time of the photo shoot is vital, but what do you do if you want to alter it or add to it during retouching?

In this section I show you how to do exactly that using the same gradient lighting technique, but instead of an overall lighting effect we'll use it to change the lighting on a person.

In **Figure 3.19** you can see that the lighting on the tunnel and the lighting on our model don't match. This is because he has rim light on either side. So we need to remove or reduce it.

1. With the image file open, set the foreground and background colors to their default of black and white by pressing D on the keyboard, and click on the layer containing the cut out of the Special Agent. Then click the fx icon at the bottom of the Layers panel and choose Gradient Overlay.

2. In the Gradient Overlay dialog, click the gradient to open the Gradient Editor, and choose the second gradient on the top row (Foreground to Transparent).

3. Click OK, and in the Layer Style properties change the Angle to 0 degrees, which will make the lighting effect go from dark on the left, and fade to transparent. (Note: You can choose any angle, but 0 degrees works best in this picture so that we can darken one side of our model.)

4. With the Gradient Overlay Layer Style dialog open, place your cursor on top of the image, then click and drag left or right to position the lighting effect exactly where you would like it. Click OK to accept the changes (**Figure 3.20**).

5. You may want to remove or reduce the light effect in certain areas. Our model's face has gone too much into shadow, so to remove it from that area and keep it everywhere else, right-click the name of the layer style (Gradient Overlay) in the Layers panel and from the menu that appears choose Create Layer (**Figure 3.21**).

continues

Figure 3.19

Figure 3.20

Figure 3.21

6. This has now turned the layer style into a new layer to which we can add a layer mask (**Figure 3.22**). With a black, soft-edged brush, paint away (reduce) the lighting effect. In this case I set the brush to 20% opacity and reduced the effect on the left side of the model's face.

Figure 3.22

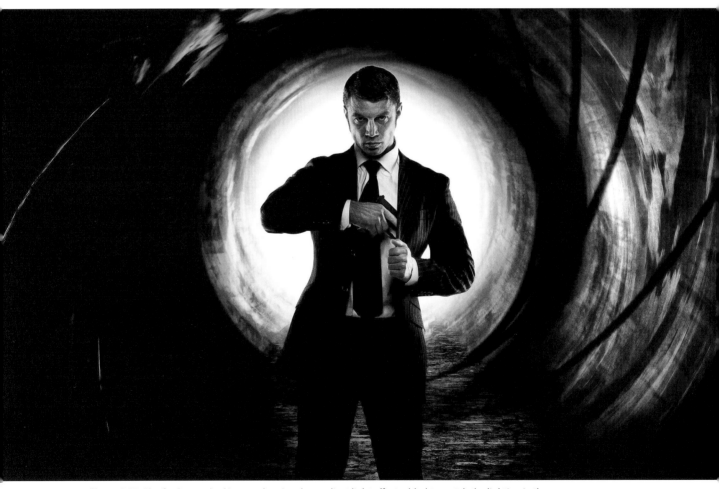

Figure 3.23 The final retouched image, showing the gradient light effect added to match the lighting in the scene.

LIGHT BEAMS

On sunny days I love it when beams of light break through the clouds, and this was an effect I really wanted to create and add into my pictures.

It's actually very simple to replicate with Photoshop, but it can be made to look even more realistic when it's added to a scene that has a bright area within the clouds, as this will always be where the beams appear from.

The best way to learn how to create this effect realistically is by getting out, observing, and taking plenty of reference photographs.

1. With the image file open, choose Layer > New Fill Layer > Gradient, rename the layer **Light Beams** and click OK (**Figure 3.24**).

2. In the Gradient Fill dialog that now appears, change the Style from Linear to Angle (**Figure 3.25**) and then click the gradient to open the Gradient Editor.

3. Change the Gradient Type to Noise, creating a multi-colored starburst effect. We need to remove the color but keep the starburst.

continues

Figure 3.24

Figure 3.25

4. To desaturate the color, change the Color Model setting from RGB to HSB (Hue, Saturation, Brightness) and then drag the S (Saturation) slider to the far left (**Figure 3.26**).

5. At this stage the effect you see onscreen may not look too much like light beams, so click the Randomize button (**Figure 3.27**) until you get the look you're after. (Note: Each click will give a different result.)

 NOTE *If you want the light beams to stand out more, drag the Roughness slider to the right (50% is the default setting).*

6. Once you're happy with how the light beam pattern looks, click OK to close the Gradient Editor, then click OK again to close the Gradient Fill dialog. In the Layers panel, change the blend mode to Soft Light.

 At this stage the light beams are in the center of the picture (**Figure 3.28**). We want them to come from the bright area in the clouds.

Figure 3.26

Figure 3.27

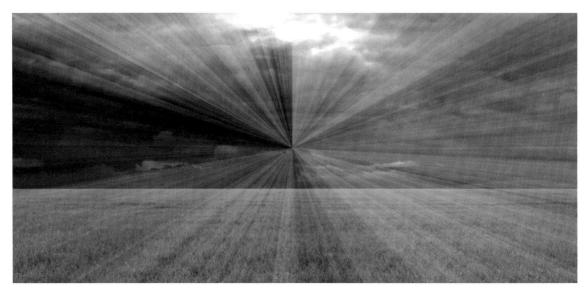

Figure 3.28

7. To reposition the light beams, double-click the thumbnail of the gradient in the Layers panel to re-open the Gradient Fill dialog. Put your cursor directly on the photo and drag the light beams over the bright area in the clouds. Click OK to close the Gradient Editor.

8. With a large, soft-edged brush and a foreground color of black, paint on the layer mask to hide the effect in the areas you don't want it; in this case, the upper-left and -right corners, and the lower part of the picture (**Figure 3.29**).

Figure 3.29

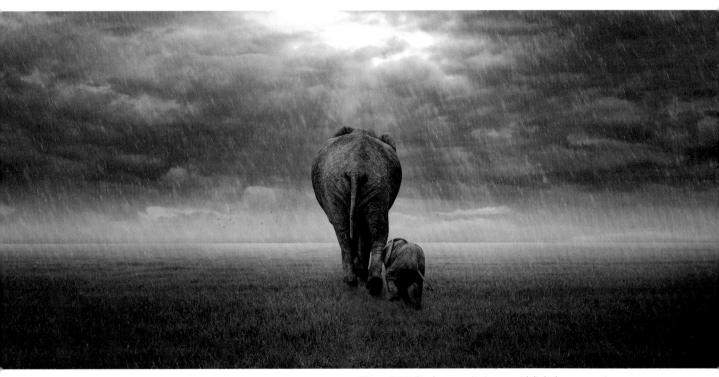

Figure 3.30 Final composite image with light beams coming from the sun behind the clouds.

HORIZON LIGHT

This technique is great for adding bright light on the horizon to create depth and distance.

I use this technique mainly when I'm working on composite images in which the model being added to the scene has rim lighting on either side of their body. Adding a bright light source on the horizon behind the model helps all the elements blend well so the lighting makes sense.

Figure 3.31 shows the background that our model will eventually be composited into. With the image file open, add a new blank layer to the top of the layer stack and name it **horizon light**.

1. Press D on the keyboard to set the foreground and background colors to their default of black and white. Then press X to swap them around making white the foreground color. Next choose the Gradient tool from the toolbar (G), and click the gradient (**Figure 3.32**) to bring up the Gradient Editor. Choose the Foreground to Transparent gradient by clicking its thumbnail (top row, second from the left). Click OK.

2. In the options bar at the top of the screen, choose the fourth gradient from the left, the Reflected gradient. In option/settings make sure that Reverse is unchecked, and that Dither and Transparency are checked (**Figure 3.33**).

Figure 3.31

Figure 3.32

Figure 3.33

3. With your cursor in the image area, click the horizon line, hold down the Shift key, drag in a straight line upward about a third of the way into the sky, and release (**Figure 3.34**).

Now you have a light along the horizon. If it's not quite right, simply step back and re-do it. If it's too bright, reduce the opacity on that layer. In **Figure 3.35**, I've added an athlete and some text to the image.

Figure 3.34

Figure 3.35 Bright horizon light on the horizon behind our model.

FAKE RIM LIGHTING

Using the same image file above, I'll now show you how I enhanced the rim lighting on the athlete.

This effect is great for adding or enhancing rim lighting, is easily applied, and best of all it looks entirely realistic.

1. With the layer containing the cutout of the athlete active, click the fx icon at the bottom of the Layers panel and choose Inner Glow from the menu that appears.

 TIP *To access the Layer Style dialog quickly, double-click to the right of a layer name in the Layers panel. This also applies to layers containing layer masks.*

2. Click the color swatch in the Structure section of the Layer Style dialog (**Figure 3.36**) to open the Color Picker, choose white, and click OK. A white outline appears around the athlete.

3. In the Elements section of the Layer Style dialog, make sure that Technique is set to Softer and that Source is set to Edge.

4. Increase the Size to approximately 50 pixels to enhance and soften the look of the rim light.

 NOTE *Experiment with the Size setting to see what works best for your image. Also try adjusting the Stroke to see what effect it has.*

5. The rim light effect now appears around the entire athlete (**Figure 3.37**), but we really only want it on either side of him. To hide the effect in specific areas, we'll first convert the Inner Glow layer style into a layer.

6. Click OK to close the Layer Style dialog. In the Layers panel, position your cursor over the name of the layer style or the fx icon we just applied, Inner Glow.

7. Right-click, and from the pop-up menu that appears choose Create Layer (**Figure 3.38**).

Figure 3.36

Figure 3.37

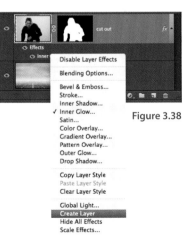

Figure 3.38

8. The Inner Glow layer style now appears on its own layer at the top of the layer stack. With this layer active, hold down Option/Alt and click the layer mask icon at the bottom of the layer panel. This adds a black layer mask (**Figure 3.39**).

9. Set the foreground color to white. With a soft-edged brush, paint on the layer mask to reveal the effect where you want it. Now you can experiment with the Opacity setting, or perhaps soften the effect further by adding a small amount of Gaussian Blur.

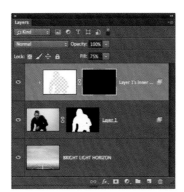

Figure 3.39

REFLECTED LIGHT

In this technique I show you how to create realistic reflected light.

This is a lighting effect I use a lot to add realism into a scene where other lighting effects have been used. It has many uses and, in fact, a wedding photographer friend of mine even uses this technique to enhance photographs of brides' hands by adding light that reflects off the stone in the ring.

1. **Figure 3.40** shows the original image. The intention here is to add a blue light coming from the center of his chest. I start by adding a new blank layer to the top of the layer stack and naming it **blue light**.

2. To choose a suitable blue, I click the foreground color in the toolbar to open the Color Picker, and I set the RGB values to R: 11; G: 53; B: 74. Click OK.

 NOTE *We need to choose a darker color than what we expect to see in the final image. This is because of how the blend mode we'll be using affects the result.*

3. With a soft-edged brush, paint on your image where you want the reflected light to appear.

continues

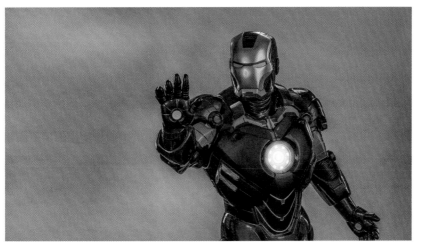

Figure 3.40

4. Change the blend mode of the blue light layer to Color Dodge.

5. Press Command/Ctrl+J to create copy of the blue light layer, and do this several more times until you have multiple copies in the layer stack (**Figure 3.41**). This brightens the blue light considerably (**Figure 3.42**).

6. To refine the edge a little by controlling exactly where it appears, Shift-click each blue light layer so that they are all highlighted and selected, and from the Layers panel fly-out menu choose New Group From Layers. Name the group **blue chest**.

7. Add a white layer mask to the blue chest group by clicking the layer mask icon at the bottom of the layers panel. With a black, soft-edged brush, paint on the image to conceal the light in areas you don't wish it to appear (**Figure 3.43**).

> **TIP** *Painting with a larger brush removes the light much more realistically. The smaller the brush, the more obvious the brush strokes. Also, control the brightness of the effect by using the Opacity setting on the blue chest group.*

In **Figure 3.44**, you can see the final image with the background added, and how this technique has been used to add the blue light onto our superhero's chest and hands. It's also been used to add the yellow/orange reflected light on his lower body from the explosion. To add the light flare effect coming from the center of his hands, a reflective gradient was used just as in the technique for adding a Horizon Light earlier in this chapter.

Figure 3.41

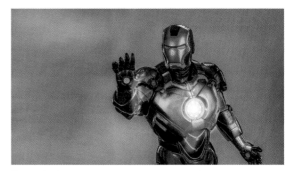

Figure 3.42

Figure 3.43

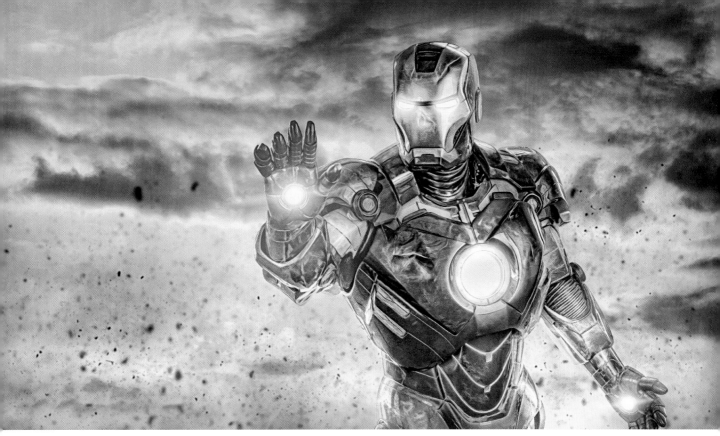

Figure 3.44

SHADOWS

It's the combination of highlights and shadows that makes flat and uninteresting photos into moody and atmospheric ones. In this technique, we'll take away light and create shadows.

Figure 3.45 is not the most exciting image, but it's perfect for our purposes. We're going to imagine that sunlight is coming from the horizon, meaning that the wall and grass in the foreground would be in shadow.

1. To first add a darkening effect, we'll add a Levels adjustment layer.

 TIP *You may be tempted to use the Midtones slider to darken the image, but this also saturates the colors, giving an unrealistic result. Instead, we'll make use of the Output Levels setting.*

Figure 3.45

continues

2. Change the Output Levels setting of the whites to 160. You can do this by typing in the amount or by dragging the control point toward the center of the gradient (**Figure 3.46**).

3. The whole picture is now darkened, but we only want to darken the wall and grass in the foreground. So invert the layer mask attached to the levels adjustment by choosing Image > Adjustments > Invert.

4. With the foreground color set to white, choose a hard-edged brush (making sure no settings are applied in the brush presets), and paint over the wall and grass in the foreground to reveal the darkening in that area and give the illusion of shadow (**Figure 3.47**).

 If we'd applied this effect to an image where the floor was concrete, this would be sufficient. However since this is grass, we need to take it a step further to add to the realism.

5. Still with a white foreground color, grab the Brush Tool and choose brush number 134 which looks like three blades of grass (**Figure 3.48**).

Figure 3.46

Figure 3.47

Figure 3.48

6. Then click on the Brush Panel icon in the options bar at the top of the screen. In the Brush Tip Shape, rotate the Angle to -40 degrees and set the Spacing to 35% (**Figure 3.49**).

7. Turn on Shape Dynamics and set the Size Jitter to 15% and Angle to 5%. Leave all other settings at their default.

8. Next turn on Scattering and set the Scatter to 35%, Count to 2 and Count Jitter to 100%. No other brush settings should be checked or on.

9. With all the settings in place, click on the Levels Adjustment Layer Mask and paint along the straight edge that goes from the bottom right of the wall to the bottom edge of the picture. Doing so reveals the darkness of the levels adjustment layer and gives the effect of the shadow across the grass, as it would appear in the *real world*. You can see the effect it has on the layer mask in **Figure 3.50**.

10. Of course this picture is used to demonstrate the shadow effect, but if you wanted to take it a step further and add in the sunset you could firstly add a Photo Filter Adjustment Layer. Choose Warming Filter (81) from the drop-down menu and increase the Density to 80%.

Figure 3.49

Figure 3.50

CHAPTER 4

SPECIAL EFFECTS

In this chapter I share some special effects that I regularly use in my own pictures.

I'm often asked how I create these effects and whether they come from using third-party plug-ins. The great thing is that they're all created within Photoshop, and each one is quick and easy to produce.

Over the next few pages I'll show you techniques I use for turning day into night, creating a cartoon/painterly effect, and making your own dust, debris, snow, and rain brushes. Plus, I show a quick and easy black and white conversion technique, and how to fake the wet look.

TURNING DAY INTO NIGHT

Techniques for turning a day scene into a night scene open up a whole new world of creative possibilities.

Here's a really simple way to do exactly this, and how to add realistic street lighting by using the Camera Raw filter and a layer mask.

1. With an image file open in Photoshop (**Figure 4.1**), create a copy by going to Layer > New > Layer via Copy (Command/Ctrl+J). Name this layer **night**.

2. Because we're going to make use of a filter for this effect, we want to use it as a Smart Filter, so go to Filter > Convert for Smart Filters, and then to Filter > Camera Raw.

3. To create the nighttime look, move the Temperature slider to –55 so that we introduce much more blue into the picture. Then darken the picture by moving the Exposure slider to –3.00 (**Figure 4.2**), and click OK.

 Now that we have the beginnings of our nighttime scene (**Figure 4.3**), we'll move on to adding the street lighting.

Figure 4.1

Figure 4.2

Figure 4.3

4. Click the original background layer at the bottom of the layer stack, and create a copy by pressing Command/Ctrl+J. Rename it **light**, drag it to the top of the layer stack, and go Filter > Convert for Smart Filters (**Figure 4.4**).

5. Go to Filter > Camera Raw, increase Temperature to +100 and Vibrance to +100, and click OK.

6. Click the triangular icon to the right of the night and light layers (**Figure 4.5**) to hide the layer masks that are attached to the Smart Filter, and to prevent the layer stack from becoming too long.

7. Click the uppermost layer (light), and Option/Alt-click the layer mask icon at the bottom of the Layers panel. This adds a black mask and hides the contents of the light layer.

8. Press D to set the foreground and background colors to their default, and then with a white foreground color and a normal soft-edged brush at 25% opacity, paint around the wall light and down to the ground and pavement (**Figure 4.6**).

TIP *Releasing and pressing down with the brush increases the opacity of the light layer showing through the black layer mask.*

continues

Figure 4.4

Figure 4.5

Figure 4.6

9. Let's take this a step further and make it appear as though there's a light inside the doorway that is spilling out onto the road surface. With the same white brush, change the hardness to 90% and, with the layer mask selected in the Layers panel, paint inside the doorway and onto the road (**Figure 4.7**).

 NOTE *Option/Alt-click the layer mask to see that the area around the door and road surface is pure white (Figure 4.8), meaning that the full color of the light layer is showing through. To reduce this, we need to make the white area not quite so white. We can do that with the output levels. Option/Alt-click the layer mask to go back to the picture.*

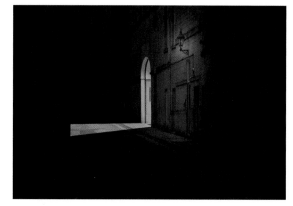

Figure 4.7

10. Option/Alt-click the layer mask to go back to the picture. Use the Lasso tool to make a rough selection around the doorway and the light on the road surface (**Figure 4.9**). Then go to Image > Adjustments > Levels and drag the White Output Levels mark to 170 (**Figure 4.10**). Click OK, and then choose Select > Deselect (Command/Ctrl+D). This makes the light in the doorway and on the road surface not quite so bright.

 NOTE *Option/Alt-click the layer mask and you can see that the area of the door and road surface has gone from pure white to a light shade of gray.*

Figure 4.8

Figure 4.9

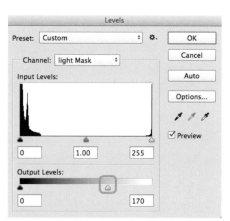

Figure 4.10

THE CARTOON OR PAINTERLY EFFECT

Contrary to what most people believe, this effect isn't created by using a third-party plug-in but instead makes use of two filters built into Photoshop: Reduce Noise and High Pass.

It creates a wonderful textured feel and seems to add more dimension to a picture—as if it's coming out of the screen or off the print a little. It works especially well when used on pictures with a fun element.

1. Create a merged layer at the top of the layer stack by going to Select > All, then to Edit > Copy Merged, and then to Edit > Paste (Shift+Command/Ctrl+ Option/ Alt+E). Rename the layer **painterly**.

2. Create a copy of this new layer by pressing Command/ Ctrl+J. Name this layer **sharpness** (**Figure 4.11**).

3. Turn off the sharpness layer by clicking the eye icon to the left of the layer. Click the painterly layer, and go to Filter > Convert for Smart Filters and then to Filter > Noise > Reduce Noise.

4. With the Reduce Noise properties open, set Strength to 10, set all other sliders to 0 (**Figure 4.12**), and click OK.

 TIP *If you place your cursor within the preview inside the Reduce Noise filter, and then click and release, you will see the before and after views.*

5. Most times I apply this effect twice, but the second time I use a slightly lower strength. Go to Filter > Noise > Reduce Noise, and this time set Strength to 5 and click OK.

 Applying this effect tends to reduce the sharpness in areas like the eyes, hair, and so on. To bring some of this sharpness back but maintain the painterly effect, we can use the High Pass filter.

continues

Figure 4.11

Figure 4.12

6. Click the sharpness layer and click to turn the eye icon on so that the layer is visible. Then go to Filter > Other > High Pass, add a Radius of 1 pixel, and click OK. Then change the blend mode of the sharpness layer to Overlay (**Figure 4.13**).

A radius of just 1 pixel is enough to bring back sharpness for most pictures; very rarely would you want to use an amount of 2 pixels or beyond. Also, applying this effect using Smart Filters means that you can very easily and quickly increase or decrease the final result.

Figure 4.13 The result of adding the cartoon/painterly effect

DEBRIS AND DUST

Debris and dust are something you often see in movie posters when there's a lot of action and explosions. As always with Photoshop, there are countless ways to create this debris and dust effect.

Creating the Brush

1. Create a new document: go to File > New, make the dimensions 1500px width and 1500px height, set the resolution to 240ppi, and for Background Contents choose anything other than Transparent. Click OK.

2. Then go to Filter > Noise > Add Noise, set Amount to 400%, set Distribution to Gaussian, and select the Monochromatic checkbox (**Figure 4.14**).

3. For this effect to work we need to make the noise bigger. Choose the Rectangular Marquee tool, Shift-click, and drag out a square in the center of the document (**Figure 4.15**).

4. Copy this selection onto its own layer by pressing Command/Ctrl+J. Then go to Edit > Free Transform, Shift+Option/Alt-click any corner transform handle and drag outward so that the square fills the document. As a result, the size of the noise has been increased. Flatten the layers by going Layer > Flatten Image.

continues

Figure 4.14

Figure 4.15

5. Go to Filter > Filter Gallery, and then to Stylize > Glowing Edges. Here is where you can experiment with the Edge Width, Edge Brightness, and Smoothness settings to create random shapes that will pass as being debris. In this example I found that setting Edge Width to 14, Edge Brightness to 20, and Smoothness to 1 worked great (**Figures 4.16** and **4.17**).

6. Click OK to close the Filter Gallery, and then press D to set the foreground and background colors to their default of black and white. Press X so that white becomes the foreground color. Choose the Gradient tool from the toolbar and, in the options at the top of the screen, select the Foreground to Transparent from the Gradient Picker, and the Linear gradient as in **Figure 4.18**.

Figure 4.16

Figure 4.17

Figure 4.18

7. Drag inward from each side (left, right, top, and bottom) and from the corner of the document several times. This will cover the debris that is too close to the edge and ensure that there are no straight lines (**Figure** 4.19). Then go to Image > Adjustments > Levels, click the Black Point sampler icon (**Figure** 4.20). Zoom in on the document and click any of the debris shapes (this darkens them all so that they stand out more). Click OK to close the Levels Adjustment dialog.

 NOTE *When you're defining (creating) a brush, Photoshop makes the darkest areas opaque and the gray areas semitransparent. White areas are completely ignored.*

8. Choose Edit > Define Brush Preset, name the brush **Debris**, and click OK. Choose the Brush tool (B), and in the options at the top of the screen click to open the Brush Preset Picker. The brush we just created will appear as the very last in the list. Click this new brush to select it, click the gear icon in the top right of the Brush Preset Picker properties to open a menu (**Figure** 4.21), and choose Save Brushes.

continues

Figure 4.19 The result of using several gradients to remove the debris from the edges and to remove any straight lines

Figure 4.20

Figure 4.21

9. Name the brush set **Particles**, and click OK.

The Particles brush set, which contains the Debris brush, is now stored for future use and will appear in the Brush Preset Picker's list of brushes (**Figure 4.22**), meaning you can share it and export it. (Brush sets are a great way to keep similar brushes together.)

Figure 4.22
The Particles brush set is now stored in Photoshop for future use.

Saving Brush Presets

Now we can make some adjustments in the Brush panel to make the Particles brush look and behave as we want it to.

1. Choose the Brush tool (B), and from the Brush Preset Picker choose the Particles brush. Click the Brush panel icon (**Figure 4.23**).

2. In Brush Tip Shape, set Spacing to 60%. In Shape Dynamics, set Size Jitter to 5% and Angle Jitter to 100% (**Figure 4.24**). In Scattering, set Scatter to 25% and Count to 1. In Transfer, set Opacity Jitter to 65%.

3. To save these settings as a preset, click the fly out menu in the top right of the Brush panel properties and choose New Brush Preset (**Figure 4.25**). Name the preset **Debris/Dust**, and click OK.

Figure 4.23

Figure 4.24 Making changes in the Brush panel

Figure 4.25 Saving brush settings as a preset for future use

Using the Debris Brush

We'll now add depth using several layers.

4. With an image open in Photoshop that you want to add debris to, add a new blank layer to the top of the layer stack and name it **debris 1**.

5. Use the Debris brush with a black foreground color to paint the debris. Debris in the distance would be small because it is farthest from the camera, so to make it appear out of focus go to Filter > Convert for Smart Filters and then to Filter > Blur > Gaussian Blur. I used a blur amount of 20 pixels (**Figure 4.26**). Then click OK.

6. Add another blank layer and name it **debris 2**. Increase the size of the brush a little because the debris nearer to the camera would be larger, and then apply a few brush strokes. Go to Filter > Convert for Smart Filters, and then to Filter > Blur > Gaussian Blur and apply less blur than in the previous step. I applied a blur amount of 15 pixels. Click OK.

continues

Figure 4.26

7. Add another blank layer and name it **debris 3**. This debris should be slightly larger than the previous layer, so increase the size of the brush. Add a small amount of Gaussian Blur (5 pixels) so that it still has the look of movement. Click OK.

8. Add another blank layer and name it **debris 4**. This will be the debris nearest the camera. This debris needs to be largest of all, so increase the size of the brush to the maximum and apply a few brush strokes (if you want the debris to be even bigger, use Edit > Free Transform and resize the contents of the layer). Finally, go to Filter > Convert for Smart Filters, and then to Filter > Gaussian Blur and add a blur amount similar (if not slightly more) to the amount you used on the debris 1 layer.

NOTE *In **Figure 4.27**, you can see that adding layers of debris at varying sizes and with different amounts of blur creates the feeling of depth. You can add as many layers of debris as you like, but I recommend no less than three: farthest away, in line with the subject, and closest to the camera.*

Figure 4.27 Adding multiple debris layers to create depth

CREATING A SNOW SCENE

Here's a simple technique that I use for creating a realistic snow scene. When it's used on a picture in which there is little or no detail in the sky, it is incredibly effective, especially when falling snow is added .

1. With a suitable picture open in Photoshop (**Figure 4.28**), go to Select > Color Range. In the Color Range properties, choose Sampled Colors from the Select menu, choose the Selection option, and choose None from the Selection Preview menu (**Figure 4.29**).

2. Move your cursor on top of the open photo, and click once with the Eyedropper tool. You can see what is being selected from the white areas in the Color Range preview box. Now that you have sampled an area of the picture, move the Fuzziness slider left or right to add or take away from the selection. When you are happy that enough has been selected, click OK.

3. Add a new blank layer to the top of the layer stack by clicking the New Layer icon at the bottom of the Layers panel. Name the layer **snow** (**Figure 4.30**). Go to Edit > Fill, choose White from the Contents menu, and click OK.

Figure 4.28

continues

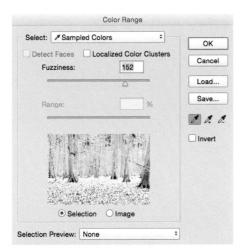

Figure 4.29

Figure 4.30

4. Go to Select > Deselect (or press Command/Ctrl+D). Add a small amount of blur, so that the snow has no sharp edges, by going to Filter > Blur > Gaussian Blur, adding a Radius of 2 pixels, and clicking OK (**Figure 4.31**).

> **NOTE** *You may need to make a few attempts and experiment with Color Range by clicking and sampling different areas of your picture before you get the result you're after. You can also duplicate the snow layer by pressing Command/Ctrl+J, which will increase the amount of snow cover.*

You can take it one step further by using the Particles brush to create falling snow. The technique is exactly the same as for debris, but use the brush with a white foreground color (**Figure 4.32**).

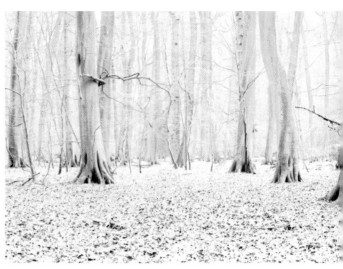

Figure 4.31

Figure 4.32

RAIN

Here's how to create rain using a few Photoshop filters, as well as how to turn it into a brush that you can keep and use in the future.

1. Press D to set the foreground and background colors to their default of black and white. Create a new document by going File > New. Set Width to 1200px, Height to 800px, and Resolution to 240ppi, and click OK (**Figure 4.33**). (It doesn't matter what color you set as Background Contents so long as you don't use Transparent.)

2. Go to Filter > Noise > Add Noise, set Amount to 400%, and choose Gaussian and Monochromatic (**Figure 4.34**). Click OK. Go to Filter > Blur > Motion Blur, and set Angle to –52 and Distance to 70 pixels (**Figure 4.35**).

continues

Figure 4.33

Figure 4.34

Figure 4.35

3. You may notice that the motion blur around the edges of the file don't look quite right (**Figure 4.36**). Go to Edit > Free Transform, Shift+Option/Alt-click a corner transform handle, and drag outward until the edges aren't visible. Press Return/Enter.

 NOTE *If you can't use Free Transform, then the layer you're working on may be locked. Simply click the padlock icon to the left of the layer to unlock it.*

4. Go to Image > Adjustments > Levels, choose the Black Point sampler, and then click within the image. This changes the look of the layer entirely, and you'll see lines appear that we'll be able to use as rain (**Figure 4.37**). Try clicking around different areas of the layer, which will create results with more or less rain. Once you have the look you're after, click OK.

5. To turn this rain effect into a brush, go to Image > Adjustments > Invert so that the rain effect is now black against a white background. Photoshop uses the dark and gray areas to form the brush, ignoring the white areas. Go to Edit > Define Brush preset, name the preset **rain**, and click OK.

 TIP *When adding rain to your pictures, stick to the principles covered earlier: Create a number of layers with rain of different sizes and blur strengths to add depth (Figure 4.38).*

Figure 4.36

Figure 4.37

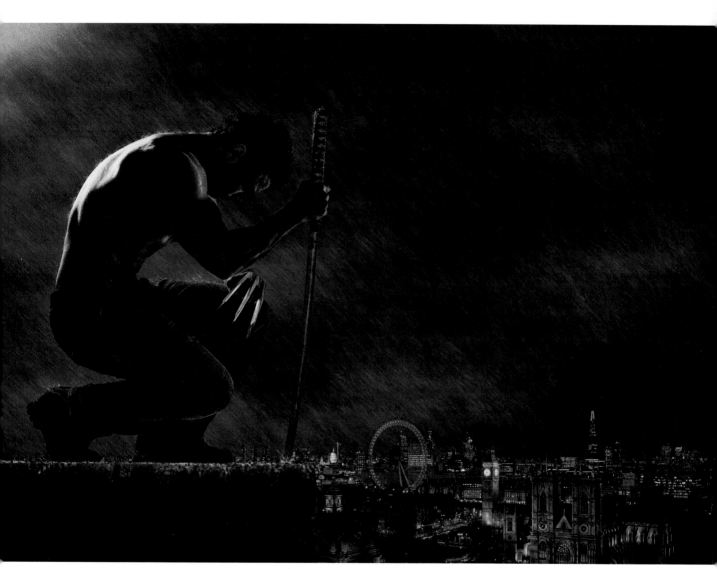

Figure 4.38

THE WET LOOK

Here's a simple technique you can use for making something look wet, which I applied to the model in the previous rain technique. Of course nothing beats the real thing, but this can give a great result.

1. Create a merged layer at the top of the layer stack by going to Select > All, then to Edit > Copy Merged, and then to then Edit > Paste (or press Shift+Command/Ctrl+Alt/Option+E). Name the merged layer **wet look**.

2. Go to Filter > Filter Gallery > Artistic > Plastic Wrap and experiment with the settings until you get the look you're after. I set Highlight Strength to 20, Detail to 5, and Smoothness to 15 (**Figures 4.39** and **4.40**).

3. Add a black layer mask to the wet look layer by Option/Alt-clicking the layer mask at the bottom of the Layers panel. Then with a normal white soft-edged brush at 20% opacity, paint over areas of the image to reveal the wet look. Apply several brush strokes to build up the opacity in areas where you want the wet look to be more visible.

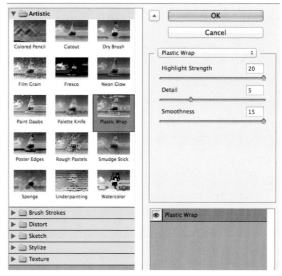

Figure 4.39

Figure 4.40

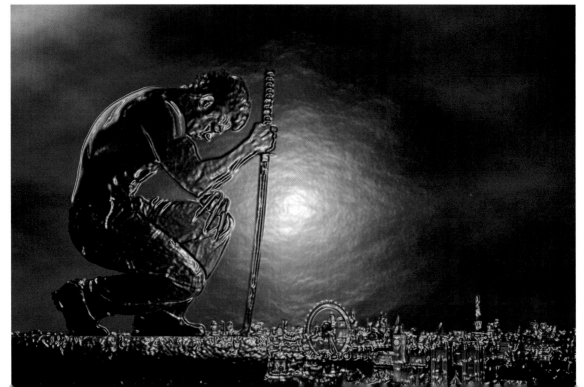

BLACK AND WHITE CONVERSION

I often use black and white conversions as a way to reduce the color in my pictures. In this example, I'll show you how I applied it to a physique photograph that I shot of UK-based natural bodybuilder Nigel St. Lewis.

1. With the image that you want to convert to black and white open in Photoshop, press D to set the foreground and background colors to their default of black and white. Then click the Gradient Map adjustment layer icon (**Figure 4.41**).

2. We can now make adjustments to get exactly the look we're after. Click the gradient bar in the Gradient Map properties (**Figure 4.42**).

3. Drag the Gradient Editor to one side so that you can see your picture. Drag the Black Output Levels marker and the White Output Levels marker (**Figure 4.43**) to make adjustments to the black and white conversion.

 A new icon appears under the gradient (**Figure 4.44**). This controls the transition from black to white.

4. Drag the new icon left or right until you get the look that you're after (**Figure 4.45** on the following page).

Figure 4.41

Figure 4.42

Figure 4.43

Figure 4.44

Figure 4.45

ADDING FAKE BLOOD

As photographers and retouchers, we don't always have the luxury of using a make-up artist at the time of a photo shoot to create effects such as cuts and bruises. But here is how you can create them in Photoshop.

The blood and scratches are added using a series of brushes, but rather than creating them we'll download them. Places like www.deviantart.com have an enormous database of brushes available for free, but be sure to read the terms of use (Figure 4.46).

Figure 4.46 Results from typing "blood spatter brushes" into deviantART's search

Installing the Blood Brushes

When you download brushes from the Internet, you'll generally be downloading a set containing brushes with different looks, giving you many creative possibilities. There's no particular set of brushes that I recommend; I suggest you download and try a variety. Once they're downloaded, they're easy to install.

1. With Photoshop open, choose the Brush tool (B) and then click to open the Brush Preset Picker from the options bar at the top of the screen. Click the cog icon in the upper-right corner, and choose Preset Manager (**Figure 4.47**).

 TIP *You can also choose the Preset Manager from the Brush Presets tool in the toolbar: click the small arrow in the upper-right corner of the panel.*

2. In the Preset Manager, click Load (**Figure 4.48**), navigate to the blood brushes you downloaded, and click OK.

 You'll see all the blood brushes in the list of brushes in the Preset Manager.

3. So that all the blood brushes are easy to find, organized, and available to use at a later date, it's good practice to create a set that contains them all. In the Preset Manager, click the first blood brush, Shift-click the last brush, and then click Save Set (**Figure 4.49**).

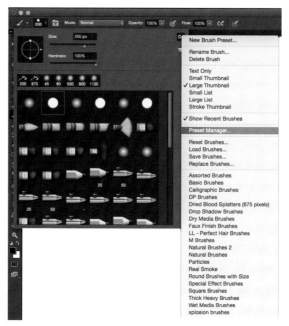

Figure 4.47

Figure 4.48

Figure 4.49

4. Name the set **Blood Brushes**, save the set onto your hard drive (Photoshop > Presets > Brushes), and click OK (**Figure 4.50**).

Using the Blood Brushes

First we need to get the color of the blood right. In the real world, blood isn't the color of tomato ketchup, as we see a lot, but is actually much darker.

1. Click the foreground color in the toolbar to open the Color Picker.

2. In the middle area we have a vertical line made up of different colors. To choose the initial color, move the pointer up or down (**Figure 4.51**).

3. Now that we've chosen the initial color, we can target a specific area. Click inside the large square, and drag the circular pointer. In **Figure 4.52** you can see what changes certain areas of the square make. You can see the color in real time in the preview box. Once you're happy with the color, click OK to close the Color Picker.

4. Add a new blank layer to the top of the layer stack, and name it **blood**.

Figure 4.50

continues

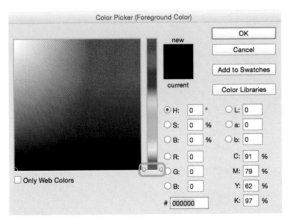

Figure 4.51

Figure 4.52

5. Choose one of the blood brushes from the Brush Preset Picker, and then click the Brush Panel icon (**Figure 4.53**) so you can make adjustments to how the brush behaves.

6. In Shape Dynamics, I set Size Jitter to 75% and Angle Jitter to 100% (**Figure 4.54**). In Transfer, I set Opacity Jitter to 100% (**Figure 4.55**).

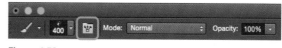

Figure 4.53

Figure 4.54

Figure 4.55

7. In **Figure** 4.56 the blood effect looks very two-dimensional. To remedy this, change the blend mode of the blood layer from Normal to Overlay and then adjust the opacity of the layer (**Figure** 4.57).

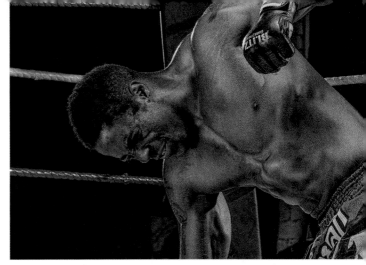

Figure 4.56 The blood painted on a layer in the Normal blend mode.

Figure 4.57 The blood looks much more realistic in the Overlay blend mode.

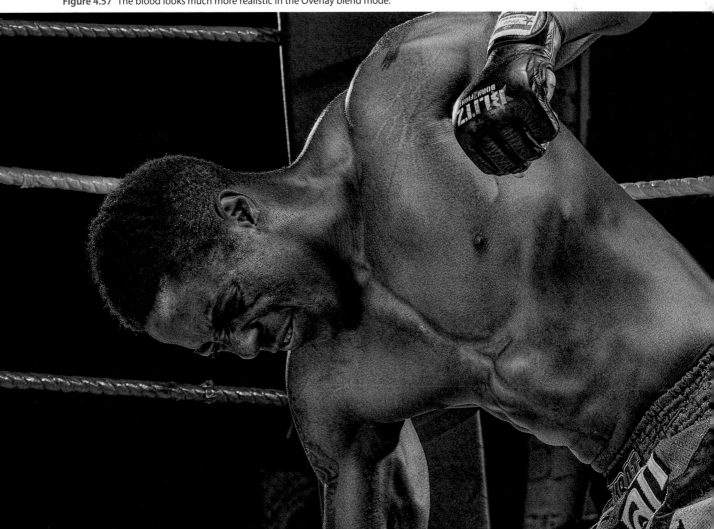

ADDING SWELLING

Here's how to use a couple of tools in the Liquify filter to make it appear as though the fighter has a swollen eye.

NOTE *In the more recent Photoshop updates we are able to use the Liquify filter as a Smart Object but if you don't have this option, simply duplicate the layer you are going to work on and then use Liquify; that way, your working copy is safe.*

1. With the layer containing your subject active, go to Filter > Convert for Smart Filters, and then to Filter > Liquify (**Figure 4.58**).

2. In the Liquify Filter properties, select the Advanced Mode checkbox (**Figure 4.59**) so that all of Liquify's tools are available.

3. Use the Zoom tool (Z) to zoom in on the area you wish to liquify.

Figure 4.58

Figure 4.59

4. I want the area around the fighter's eyebrow to be swollen, but I need to ensure that other areas aren't affected. I use the Freeze Mask tool for this (**Figure 4.60**). Make sure the Show Mask checkbox is selected (**Figure 4.61**), and paint over the areas you want to protect. In **Figure 4.62** I've painted an area in the middle of the fighter's eye.

> **NOTE** *If you paint over too much of an area with the Freeze Mask tool, you can remove some of the selection with the Thaw Mask tool, located directly underneath it in the toolbar.*

continues

Figure 4.60

Figure 4.61

Figure 4.62

5. Choose the Bloat tool (**Figure 4.63**), and set Size to 125, Density to 50, and Rate to 80 (**Figure 4.64**). (Experiment with the settings to suit yourself.)

6. With the Bloat tool, click several times around the area you want to swell.

7. Deselect the Show Mask checkbox, click Reconstruct (**Figure 4.65**), and move the Amount slider left and right to dial in exactly how much of the effect you wish to keep (**Figure 4.66**). Click OK.

Figure 4.63

Figure 4.64

Figure 4.65

Figure 4.66

THE DETAILS EFFECT

The gritty, detailed look is extremely popular in movie posters, and many retouchers like to add it to their own work.

There are three different techniques I use for adding or enhancing details. I'm a big believer in knowing a variety of techniques that you can call on to produce similar results. **Figure 4.67** shows the image we'll be using each technique on.

Details with Photoshop

This was a technique I first saw being demonstrated by the German digital artist Calvin Hollywood.

1. With the image file open in Photoshop, create two copies by pressing Command/Ctrl+J twice (**Figure 4.68**).

2. Click the uppermost layer, and Shift-click the layer below so that both copies are selected. Then go to Layer > New > Group from Layers. Name the group **details**, change Mode to Soft Light (**Figure 4.69**), and click OK.

continues

Figure 4.67

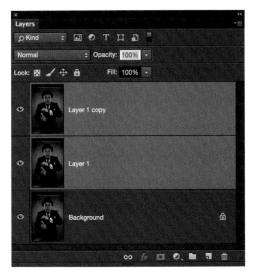

Figure 4.68

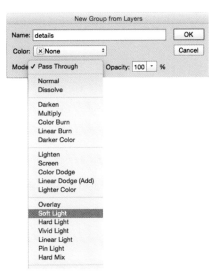

Figure 4.69

3. Click the triangle icon for this group to open it and reveal the two layers inside. Change the blend mode of the uppermost layer in the group to Vivid Light (**Figure 4.70**).

4. On the same layer, go to Image > Adjustments > Invert, which restores the picture to how it originally appeared; however, the image has now been set up to enhance details.

5. Convert the layer to a Smart Object by going to Filter > Convert for Smart Filters. Add the details by going to Filter > Blur > Surface Blur.

6. In the Surface Blur properties, set the Radius and Threshold settings to the same number. I find that settings not exceeding 30 produce the best results (**Figure 4.71**).

 NOTE *Don't set the amount too high in the Surface Blur filter, as it can introduce halos and artifacts into your pictures, especially if they have lots of shadow areas. You can see this just under the rim of the hat in **Figure 4.72**.*

7. To limit where and how strongly the details are applied, close the details group by clicking the triangle icon, as before, and Option/Alt-click the layer mask icon to add a black layer mask. Then with a white medium soft-edged brush, paint over the image to reveal the details. Use a lower opacity brush when painting over the skin as opposed to the clothing.

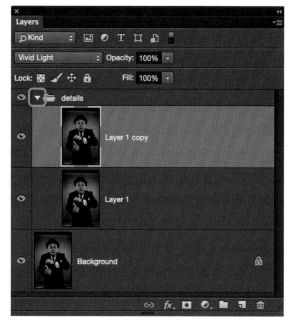

Figure 4.70

Figure 4.71

Figure 4.72

Details with the Nik Collection

I'm using the latest version of Nik Color Efex Pro 4, which includes a preset called Detail Extractor.

I'm a big fan of this plug-in not just because of the results but also because it allows me to work nondestructively.

1. Starting from the beginning, with no layers other than the original image, go to Filter > Convert for Smart Filters, and then to Filter > Nik Collection > Color Efex Pro 4.

2. From the Presets list, choose Detail Extractor. The default settings are immediately applied (**Figure 4.73**).

3. More often than not I'll use the default settings, but experiment with them to see what you prefer (**Figure 4.74**). Click OK.

continues

Figure 4.73 Nik Color Efex Pro 4

Figure 4.74

4. Because the details have been applied to the entire picture, click the white layer mask attached to the filter in the layer stack (**Figure 4.75**) and go to Image > Adjustments > Invert to change it to black.

5. With a white medium soft-edged brush, paint over the image area to reveal the details. Use a lower opacity brush when painting over the skin as opposed to the clothing.

 You can see that it enhances the details and information incredibly. Unlike the previous technique, it creates very few (if any) artifacts and halos.

 One side effect of using this preset for enhancing details is that it also brightens the image (**Figure 4.76**). In this particular picture that isn't what we want, because the model's suit needs to remain dark.

Figure 4.75

Figure 4.76 Enhancing details with the Detail Extractor plug-in

Details with Topaz Details

The final technique I turn to for enhancing details, depending on the image, is Topaz Details. The result it produces is quite different from the previous two techniques, and it also adds a slight textured effect. This plug-in gives great results but needs to be used sparingly on skin.

1. With the image open in Photoshop, go to Filter > Convert for Smart Filters, and then to Filter > Topaz Labs > Topaz Details 3.

2. In the Detail section, I adjust only the Small Details, Small Details Boost, Medium Details, and Medium Details Boost settings, with the uppermost slider increased to the right the most, and less for the three others, to produce an arc (**Figure 4.77**). Click OK.

 TIP *To see a true representation of how the plug-in is affecting the image, increase the magnification to 100% by clicking the magnifying glass in the upper-right corner (Figure 4.78).*

 For this particular image, this plug-in has produced the best result because it enhances detail and maintains the original darkness of the suit (**Figure 4.79**).

3. Because the details have been applied to the entire picture, click the white layer mask attached to the filter in the layer stack, and go to Image > Adjustments > Invert to change it to black. Then with a white medium soft-edged brush, paint over the image to reveal the details. Use a lower opacity brush when painting over the skin as opposed to the clothing.

Figure 4.77

Figure 4.78

Figure 4.79

Here is the before image with the model photographed against a plain gray background, allowing for textures to be added or for cutting out and compositing a new background.

After (facing page), final composited and retouched image.

COMPOSITING QUICK TIPS

The challenge with writing a book like this is knowing when to stop, because the more I use Photoshop the more techniques I discover.

So before we move on to working through projects from start to finish, I've included a handful of compositing techniques that I'm regularly asked about. These quick tips are helpful to know before tackling any project.

Techniques covered in this chapter include: how to create a realistic horizon line when making scenes from a number of different photographs; how to use brushes for compositing into grass; how to add realistic shadows (an unavoidable and essential compositing skill); and two techniques using color to seamlessly blend images together for a realistic composite.

CREATING A HORIZON LINE

You might think that a horizon line is perfectly straight, but when the ground is something like a field, the horizon line is made up of distant blades of grass of varying sizes and angles.

You can mimic this look very easily using brushes that are included with Photoshop, but rather than manually painting the horizon line we can make the process much quicker using the Pen tool.

Figure 5.1

1. With the grass (ground) layer already open in Photoshop, grab the Pen tool (P) and make sure that the Path option is selected from the options at the top of the screen (**Figure 5.1**).

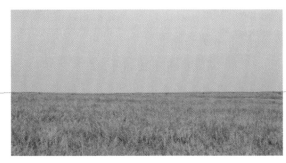

Figure 5.2

2. Starting from just outside the left side of the image and finishing just outside the right of the image, draw a path across the width of the grass just below the horizon line. Do this by adding numerous points and creating slight angles to join them so that the path isn't perfectly straight (**Figure 5.2**).

3. Grab the Brush tool. In the Brush Preset Picker, choose number 134, which looks like three blades of grass (**Figure 5.3**). Click the Brush panel icon (**Figure 5.4**) so that we can adjust some settings and make brush 134 perform how we need it to for a realistic horizon line.

Figure 5.3

Figure 5.4

4. In the Brush panel, click Brush Tip Shape, set Size to 50px, and set Spacing to 5% (**Figure 5.5**). Make sure that the Shape Dynamics and Scattering checkboxes are selected; all others should be unselected.

5. Click Shape Dynamics, and set Size Jitter to 30% and Angle Jitter to 5% so as to vary the size and angle of the grass a little, making it look more realistic (**Figure 5.6**). All other settings can remain at their default.

6. Click Scattering and set Scatter to 18% and Count to 2 (**Figure 5.7**). The settings used here aren't fixed in stone but do work well for this image. For your own images, experiment with settings to see what works best.

7. Now we need to add the sky. Go to File > Place Embedded (File > Place in earlier versions of Photoshop), choose your sky image, and click OK. Use the transform handles to resize your sky layer so that it fills the layer, and press Return/Enter to accept the transformation.

 NOTE *You could simply open the file and drag it across, but I prefer to use the Place Embedded or Place command because it allows me to automatically add the file into the image I'm working on.*

continues

Figure 5.5

Figure 5.6

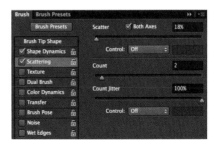

Figure 5.7

8. With the Move tool selected, use the up and down arrow keys to position the sky layer so that the horizon line is just slightly beneath it (**Figure** 5.8).

9. Add a layer mask to the Sky layer (**Figure** 5.9) and with the Brush tool selected, set the foreground color to black.

TIP *Press the D key to set the foreground and background colors to their default of black and white. You can also quickly swap the foreground and background colors by pressing the X key.*

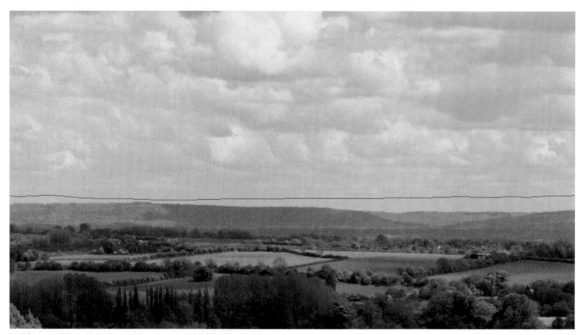

Figure 5.8

Figure 5.9

10. Click the Path panel; the path we created earlier is highlighted. Click the Stroke Path with Brush icon at the bottom of the Path panel (**Figure** 5.10).

The horizon line has been created and looks like distant blades of grass (**Figure** 5.11).

continues

Figure 5.10

Figure 5.11

11. Click underneath the work path in the Path panel to deactivate it (**Figure 5.12**). In the Layers panel, click the layer mask attached to the sky layer. With a normal medium soft-edged brush and a black foreground color, paint over the area below the horizon line to reveal the grass (**Figure 5.13**).

> **TIP** *For speed, rather than using a brush to paint in the area below the horizon line, you could make a selection of that area with the Rectangular Marquee tool and then choose Edit > Fill > Contents > Black. Any gaps could then be quickly filled with a medium soft-edged brush.*

Figure 5.12

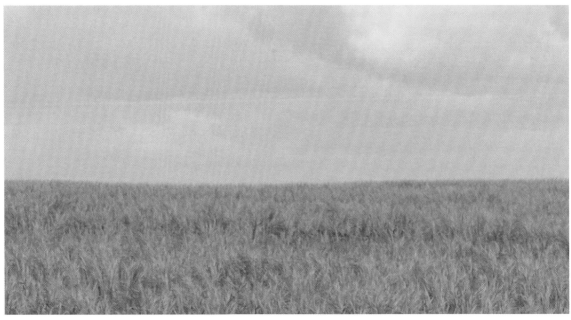

Figure 5.13 The realistic horizon line and the grass below are revealed.

COMPOSITING INTO GRASS

Now we'll put the giraffe that we cut out in Chapter 1 into the long grass. This is very easy to do using the same brush we just used to create the horizon line.

1. With the giraffe positioned above the layers that go into making the background, click the thumbnail of the layer containing the grass (**Figure 5.14**). Use the Lasso tool to make a rough selection of the area around the giraffe's hooves (**Figure 5.15**), and go Layer > New > Layer via Copy (or press Command/Ctrl+J).

2. Rename this new layer **grass on hooves** and drag it to the top of the layer stack. Add a black layer mask by Option/Alt-clicking the layer mask icon at the bottom of the Layers panel (**Figure 5.16**).

continues

Figure 5.14

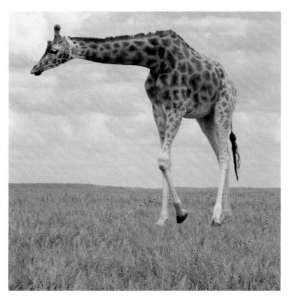

Figure 5.15

Figure 5.16

3. Choose the Brush tool (B), click the Brush Preset panel, and choose brush number 134. In the Shape Dynamics section, set Size Jitter to 25% and Angle Jitter to 8%; leave all other settings at their default (**Figure** 5.17).

4. In the Scattering section, set Scatter to 15%, Count to 2, and Count Jitter to 100% (**Figure** 5.18).

5. With a size of 30px, a foreground color of white, and the layer mask active, paint over the giraffe's hooves with the brush. This reveals parts of the layer that we cut out, but in the shape of our brush, faking the look of the giraffe standing in the long grass (**Figures** 5.19 and **5.20**).

NOTE *To see the layer mask view, as in Figure 5.20, Option/Alt-click the layer mask thumbnail in the Layers panel. Option/Alt-click again to return to the normal view.*

TIP *There may be times when you want to create composite images with surfaces like sand or snow. In situations like these, you can do a lot during the photo shoot that will help considerably when it comes to retouching. Buy some bags of sand or fake snow and spread it across the area where the model is standing during the photo shoot. Blending their feet realistically into the new scene will be much easier.*

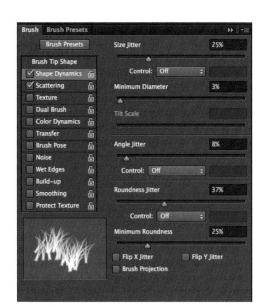

Figure 5.17

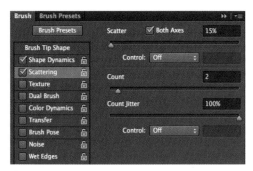

Figure 5.18

Figure 5.19

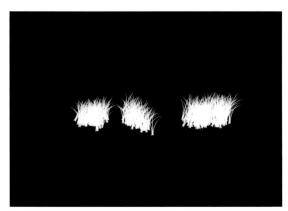

Figure 5.20

SHADOWS

If there's one thing that can make or break a composite image it's the shadows. I guess we've all seen pictures where it seems as if the person that has been added to a scene is levitating because the shadows just don't look right.

I've mentioned that observing real life can help tremendously with retouching, and this is especially true with shadows. Shadows in the real world seem to be made up of two parts: the contact shadow, where the person or object is in direct contact with a surface, and the shape shadow that appears because of the light.

There are many ways to add the shape shadow. A lot of times you can do this by creating a copy of the cutout, filling it with black, and then using Transform and opacity, but there are times when that won't work.

Here's an equally simple technique you can use, but getting it to look just right will take plenty of practice—but that's the same with everything you do in Photoshop.

1. Add a new blank layer (Layer > New > Layer), name it **contact shadow**, and click OK. Drag this layer below the cutout in the layer stack (**Figure 5.21**).

2. In the Layers panel, Command/Ctrl-click the layer mask used to create the cutout. In this example I clicked the layer mask in the children layer, which loads the cutout as a selection (**Figure 5.22**).

 NOTE *If you didn't create your cutout using a layer mask, Command/Ctrl-click the layer thumbnail.*

Figure 5.21

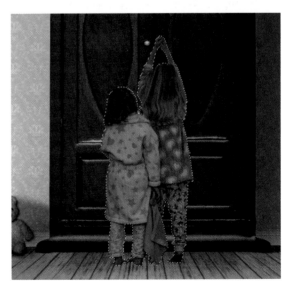

Figure 5.22

continues

3. With the selection active, go to Edit > Fill > Contents > Black, and click OK. This fills the selection of the children in black (**Figure 5.23**). Go to Select > Deselect, and with the Move tool (V) press the down arrow key on your keyboard twice—just enough so you can see the black outline appearing around the children's feet (**Figure 5.24**).

4. Soften the contact shadow a little by going to Filter > Blur > Gaussian Blur and adding a Radius of 1 pixel.

5. The contact shadow looks good around the feet, but you may also be able to see it in other areas around the children. Option/Alt-click the layer mask icon at the bottom of the Layers panel to add a black layer mask, and hide the contact shadow (**Figure 5.25**). Then with a normal soft-edged brush and a white foreground, brush on the layer mask to reveal the contact shadow where the feet and the floor meet.

6. Next is the shape shadow, so add a new blank layer above the contact shadow layer and name it **shape shadow**. Lower the opacity of this layer to 20% (we can alter this later), and with a normal round brush at 20% hardness, paint in the shadows. (I always paint in the shadows using these settings, and adjust the opacity or blur the hardness later if I want.) In this example, I will later add a bright light to the gap along the bottom of the wardrobe doors, meaning the shadows it creates will extend off the bottom of the picture (**Figure 5.26**).

NOTE *You don't have to be completely accurate with the shape you paint, as long as it resembles a shadow.*

Figure 5.23

Figure 5.25

Figure 5.24

Figure 5.26

MATCHING COLOR #1

Another make-or-break situation for composite images is when the color of the background scene and the color of the assets being added don't match.

For example, **Figure 5.27** shows the original studio shot of the model and **Figure 5.28** is where a new background has been added, using the Blend Mode compositing technique we covered in Chapter 2. The warm color of the model doesn't match the cool and desaturated color of the background, which means the composite doesn't work.

We could correct this in Photoshop using color adjustment layers, curves, and so on, but here's a quick and effective technique to match the color without any adjustments. It's a technique I use very often, and 99 percent of the time it will be all you need to do.

continues

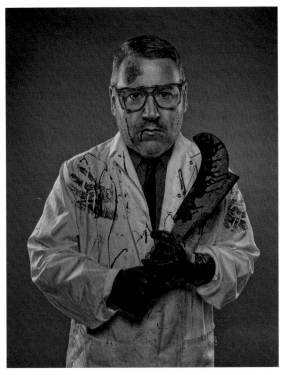

Figure 5.27 The model against a gray background

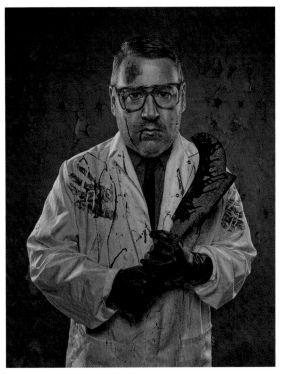

Figure 5.28 The color of the model and the background don't match.

1. No matter which technique you used to bring together the cutout and the new background, add a copy of the background scene to the top of the layer stack. In this example, I used the blend mode compositing technique to add a new background behind the model, added a copy of the textured background to the top of the layer stack, and named it **texture-color** (**Figure 5.29**).

2. Go to Filter > Blur > Average. No properties box will appear, and Photoshop will simply apply Average Blur to the texture-color layer. Because there are no properties, there is no need to apply Average Blur as a Smart Filter, because it does only one thing: mix all the colors of that layer together (**Figure 5.30**).

3. Now that we have a layer containing an average of all the colors that make up the background, add it onto the model by making a selection of the model and clicking the layer mask icon at the bottom of the Layers panel (**Figure 5.31**).

Figure 5.29

Figure 5.30

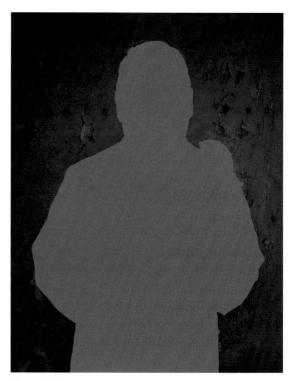

Figure 5.31

4. Change the blend mode of the texture-color layer to Color, and lower the opacity to 20% (**Figure 5.32**). Doing this adds the color of the environment onto the model and blends the two elements much more realistically.

Figures 5.33 and **5.34** clearly show how the Average Blur technique helps to match the color across the picture. The result is very subtle but just enough to make a difference.

> **TIP** *This technique can also be used on a scene or view. It's a good thing to do if you're going to add additional color effects, because the colors will be much more balanced and even.*

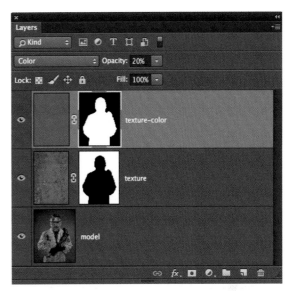

Figure 5.32

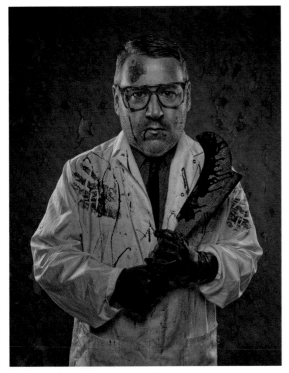

Figure 5.33 (above) Before, when the colors between the model and background didn't match.

Figure 5.34 (right) After, the colors match between the model and the background.

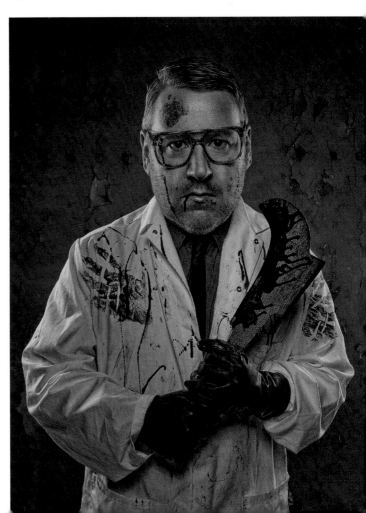

MATCHING COLOR #2

I learned this incredibly simple but effective technique from my friend Pete Collins of KelbyOne. It's another technique for subtly matching color in composites, but it's also great for adding a slight haze to distant objects, which is something we see in the real world.

Figure 5.35 is a composite picture of a rhino that I created; we'll also be working on it in the projects section of this book.

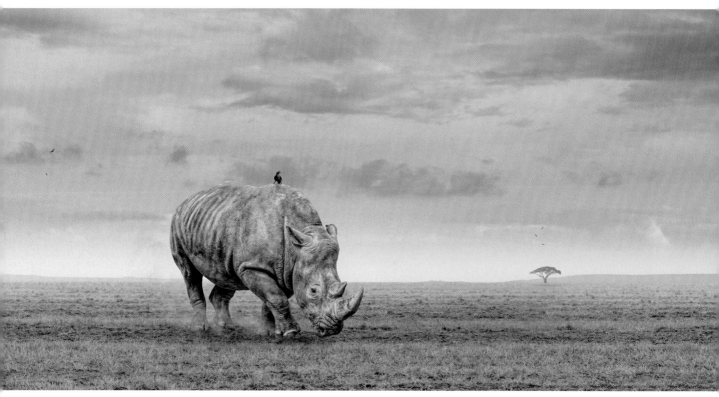

Figure 5.35

In **Figure 5.36** you can see the layer stack, including the cutout of the rhino. All you need to do for this technique is lower the opacity of the layer to no less than 90%. This introduces a little color from the background and adds a slightly hazy effect. You're done! Techniques don't get much simpler or quicker than this.

NOTE *If you go lower than 90%, you will start to see the background coming through the rhino.*

Figure 5.37 shows the "before" image. In **Figure 5.38**, the "after" image, you can see a little of the background color on the rhino, and the lowered opacity has given it a slight hazy effect—perfect for distant objects.

Figure 5.36

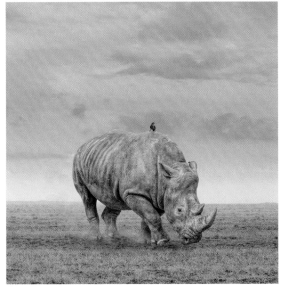

Figure 5.37

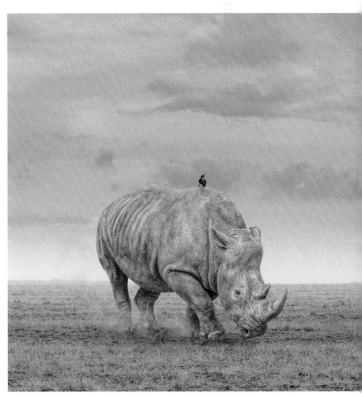

Figure 5.38

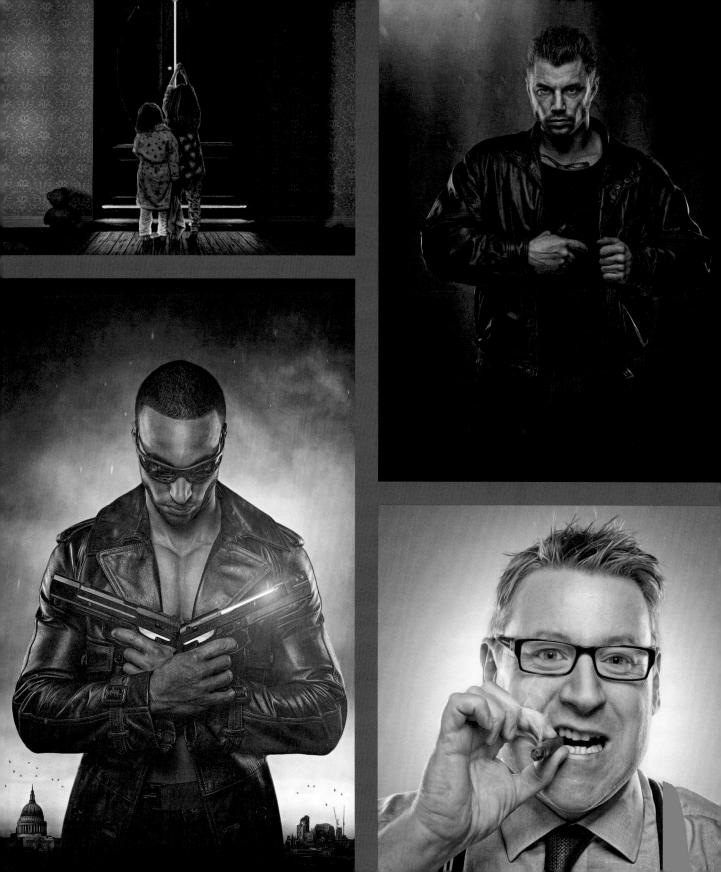

PROJECTS

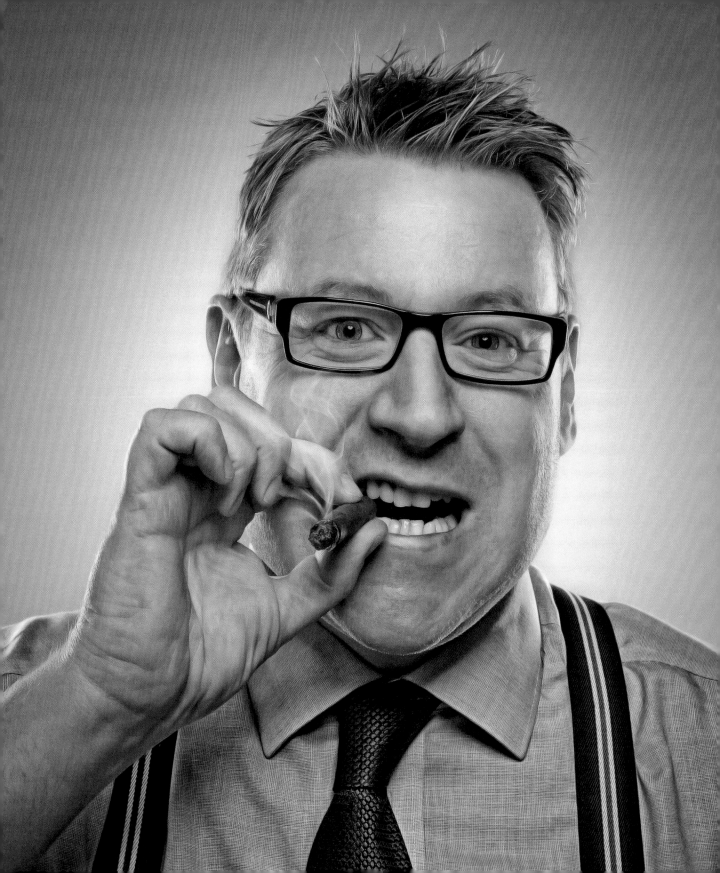

CHARACTER PORTRAIT

The photo we'll be going through in this chapter ranks as one of my all-time favorites. I took it during one of my Photoshop workshops, and my best friend and assistant, Dave Clayton, had to step in at the last minute and be the model for the attendees. A daunting task for someone who had never modeled before, but taking on a character completely transformed his confidence and enhanced the look of the photograph.

In this tutorial, we'll retouch a character portrait and add a new color and spotlight behind our model. We'll do it all nondestructively, meaning that the color and spotlight will be editable so that you can later change the color and resize or even remove the spotlight.

This look requires three lights: one on either side of the model (I prefer to use strip boxes) and one to the front (medium softbox or beauty dish) (**Figure 6.1**), with the side (rim) lights brighter than the light to the front by approximately one stop. The background is a gray seamless roll, giving us an even and neutral starting point to which we can add a color.

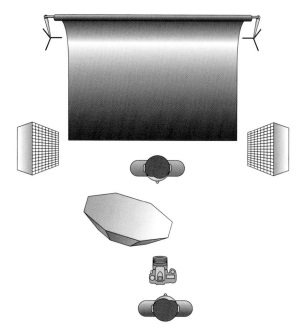

Figure 6.1 Three-light setup with gray seamless background

RAW CONVERSION AND RETOUCH

Starting in Camera Raw, we'll correct the color, enhance details, remove spots/blemishes, and retouch the eyes and teeth.

1. With the file open in Camera Raw, check the white balance by clicking the gray background to the side of the model's head with the White Balance tool (**Figure 6.2**).

Figure 6.2

2. The picture now looks a little on the cool side, so we'll warm it up by dragging the Temperature slider to the right to add some yellow. I've moved it from 5250 to 5640 (**Figure 6.3**).

3. To bring out more detail, move the Blacks slider to +95 and move the Shadows slider to +55.

4. To prevent the highlights from blowing out and losing detail, take the Highlights slider down to −30.

 NOTE *The amounts that the Blacks, Shadows, and Highlights Sliders need to be moved are unique to each picture, and dependent on your own taste.*

Figure 6.3

5. Enhancing the detail by adjusting the Blacks, Shadows, and Highlights sliders can flatten out the contrast in the image, so to add a little contrast back in, move the Clarity slider to +60 (**Figure 6.4**). Later on we'll be adding contrast to specific areas.

 NOTE *The Clarity Slider affects only the midtone contrast and gives a subtle and controlled result—unlike the Contrast slider, which is much stronger and affects all areas of the image.*

6. The skin tone looks a little on the red/orange side; to correct that, go to the HSL/Grayscale tab and move the Oranges slider to –18 and the Reds slider to –12 (**Figure 6.5**).

7. Now we need to clean up the gray background because later on we'll be attaching a new color to it, and any marks, scratches, or dust on it now will remain visible. Choose the Spot Removal tool, set it to Heal, and select the Visualize Spots checkbox at the bottom of the screen (**Figure 6.6**). Make the Healing Brush slightly bigger than the marks to be removed, and apply a brush stroke over the top of each (**Figure 6.7**). Deselect the Visualize Spots checkbox.

 TIP *Select and deselect the Visualize Spots checkbox before removing any marks to ensure that what is about to be removed is not an essential part of the picture.*

continues

Figure 6.4

Figure 6.5

Figure 6.6

Figure 6.7

8. With the Spot Removal tool in Heal mode, remove some of the spots and blemishes on the model's face. (These are very easy for Camera Raw to remove, but if the spots are more substantial you can remove them in Photoshop for more control.) To remove the food from the model's teeth, change the mode from Heal to Clone and paint over the area to be removed; drag the green pin to an area where there is a join between two teeth (**Figure 6.8**).

9. Change the mode back to Heal and deselect the Show Overlay checkbox.

 The food between the teeth has been realistically removed.

10. The eyes are looking a little dark and uninteresting at the moment, so zoom in and choose the Adjustment Brush. Make sure that all the sliders are at 0, except for Exposure at +0.50, and make sure that the Auto Mask, Show Overlay, and Mask checkboxes are selected (**Figure 6.9**). Paint over the center of each eye so that they are covered with the red overlay, and then use Erase to reveal the pupils (**Figure 6.10**).

 TIP *Turn off the Mask checkbox when erasing the overlay on the pupils.*

11. Deselect the Overlay and Mask checkboxes, and then bring out detail in the eyes by moving the Exposure slider to 1.20. Move the Temperature slider to –39 to give the eyes a blue coloring, move Clarity to +25 to add some contrast, and move Sharpening to +40.

 TIP *When you've finished retouching the eyes, zoom out to see the result. It gives you a much clearer view of what's been done.*

Figure 6.8

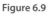

Figure 6.9

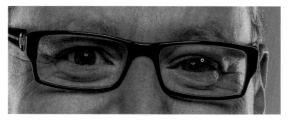

Figure 6.10

12. Double-click the Hand tool to come out of the Adjustment Brush and see the entire image. In the Detail tab, take the Sharpness up to 80. Then, so that the sharpness is applied only to our model and not to the background, hold down the Option/Alt key and move the Masking slider to 80 (**Figure 6.11**).

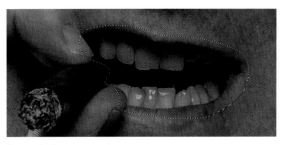

Figure 6.11

Holding down Option/Alt while moving the Masking slider restricts where sharpening is applied.

NONDESTRUCTIVE RETOUCHING IN PHOTOSHOP

A nondestructive workflow allows you to go back and make changes to a picture without redoing lots of steps.

1. With no more retouching to be done in Camera Raw, we need to open the image file in Photoshop as a Smart Object so that we can continue to work non-destructively. To do this, hold down the Shift key while clicking the Open Image button.

In Photoshop, we'll whiten up the teeth.

2. With the Lasso tool, make a very rough outline around the mouth (**Figure 6.12**).

3. With the selection active, add a Hue/Saturation adjust-ment layer. From the Master menu, choose Yellows (**Figure 6.13**).

4. Move the Lightness slider to +100. Rename this adjust-ment layer **Whiten Teeth**.

The next part of the retouching involves dodging and burning. For a refresher, see Chapter 2.

5. Add a new blank layer filled with 50% gray, change the layer's blend mode to Soft Light, and rename it **dodge & burn**.

continues

Figure 6.12

Figure 6.13

6. Grab the Dodge tool from the toolbar. In the options at the top of the screen, ensure that Range is Midtones and that Exposure is 10%. Make sure that the Protect Tones checkbox is selected. Dodge and burn the face and hand using the technique described in Chapter 2. You could also add another 50% gray layer and work on the shirt, dodging and burning to accentuate the creases and folds (**Figure 6.14**).

7. The nose has a bright highlight caused by the original studio lights, and I find it a little distracting. Click the bottom layer (editor), add a new blank layer above it, and rename it **nose shine**.

8. Choose the Healing Brush tool from the toolbar. In the settings at the top of the screen, set Mode to Darken, Source to Sampled, and Sample to Current and Below. Sample an area of skin on the cheek. Option/Alt-click and paint over the shiny area of the nose to remove it.

 NOTE *Setting the Healing Brush mode to Darken means that the brush will mainly affect areas brighter than that initially sampled.*

9. For realism, we need to keep a small amount of the highlight in this area. We can do that either by reducing the opacity of the layer to around 40% or by using the Fade command in the Edit menu. In this case, I faded the healing we just applied so that it was just 40% visible. This allowed some of the highlight to show through (**Figure 6.15**).

 The next few steps use a plug-in called Detail, by Topaz Labs. I love the effect this plug-in produces. You can get a 30-day free trial by visiting www.topazlabs.com/store; otherwise, skip to the following section.

10. Click the bottom layer in the Layers panel (the editor layer). Open the Detail plug-in by choosing Filter > Topaz Labs > Topaz Detail.

11. Zoom to 100% view. Make slight adjustments to the Small Details, Small Details Boost, and Medium Details sliders, as in **Figure 6.16**. Click OK to apply the effect and close the plug-in.

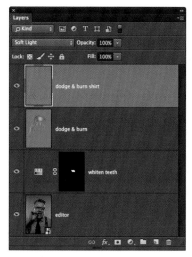

Figure 6.14

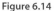

Figure 6.15

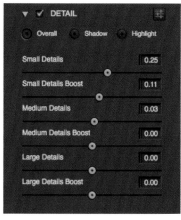

Figure 6.16 The Topaz Detail plug-in

12. Because we applied the plug-in to a Smart Object (the editor layer), the plug-in has been applied as a Smart Filter that has a layer mask attached. We want the effect of the plug-in applied only to the model and not the background, so hide the effect by converting the layer mask to black. Click the layer mask, then go to Image > Adjustments > Invert.

13. With a white foreground color, choose a brush with approximately 25% hardness and 100% opacity. Paint the layer mask over the model's shirt to reveal the effect of the Detail plug-in. Then, as the effect would be too strong at 100% on the skin, reduce the opacity of the brush to 40% and paint the layer mask over the rest of the model (hair, face, arm, and hand).

ADDING COLOR TO THE BACKGROUND

Before we add the colored background and the spotlight, we need to combine all the layers into a Smart Object. This is so that we have a layer containing all the retouching we've done to this point.

We could create a merged layer at the top of the layer stack, but we couldn't then go back to make further adjustments. It's smarter to combine the layers into a Smart Object.

1. Click the top layer so that it is active, then Shift-click the layer at the very bottom of the layer stack; this selects all the layers. Choose Convert to Smart Object from the menu in the upper-right corner of the Layers panel.

2. Rename the Smart Object **retouch**. Choose Layer > Smart Objects > New Smart Object via Copy (**Figure 6.17**).

The new layer is automatically named retouch copy.

3. With the retouch copy layer active, use the Quick Selection tool to make a selection of the model; do not include gaps in the hair where the background is showing through.

4. Check to see how accurate your selection is by clicking the Quick Mask icon in the toolbar or pressing Q. If any areas need selecting, paint over them with a black brush; if areas need to be deselected, paint over them with a white brush.

continues

Figure 6.17

5. Exit Quick Mask by clicking its icon in the toolbar. Click the Refine Edge button to go into the Refine Edge properties. Using the techniques you learned in Chapter 1, improve the selection and bring in all the fine hairs that weren't included by the Quick Mask tool. In the Output section, choose Selection from the Output To menu and click OK.

6. Save the selection as **cut out** and then deselect it. Choose Layer > New Fill Layer > Solid Color. In the dialog, name it **color** and click OK (**Figure 6.18**).

7. Now choose a color to add to the background. In this case, I set the following RGB values: R: 75; G: 96; B: 116. Click OK to close the Color Picker.

 NOTE *Because of the steps that follow and how they will affect this color, choose a color that's more desaturated than vibrant.*

8. Drag the color layer below the retouch copy layer (**Figure 6.19**).

9. Click the retouch copy layer so that it is active, then load the earlier selection. Choose Select > Load Selection, choose cut out from the Channel menu, and click OK.

10. With the selection (marching ants) visible, click the layer mask icon at the bottom of the Layers panel to reveal the new background around the model.

11. Click the color layer and change the blend mode from Normal to Color.

 You'll see that the cutout looks much more realistic because additional fine hairs are visible.

 NOTE *You may notice that some of the fine hair contains traces of the background color. This can be removed by going back into Refine Mask, but when we add the spotlight they will no longer be visible.*

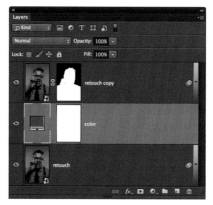

Figure 6.18

Figure 6.19

ADDING A SPOTLIGHT

Adding a spotlight in Photoshop means we can resize it, move it, make it harder/softer, or remove it with just a few clicks.

1. Change the background layer to a color layer, use the Elliptical Marquee tool while holding down the Shift key to drag a perfect circle over the model's face. The circle should be just wider than the face and not close to the edges of the picture (**Figure** 6.20).

2. Add a Levels adjustment layer, and drag the midtones point to the left to brighten the area of the background in the selection (**Figure** 6.21); I moved it to 1.70, but this can be adjusted later if necessary.

3. Choose Edit > Free Transform. Drag the ellipse so that a bright area appears above the model's head and out towards the edges of the picture.

4. Soften the edges of this bright selection, so that it looks more like a spotlight, by clicking the Mask icon in the Layers Adjustment properties and increasing Feather to 250px (**Figures** 6.22 and 6.23).

Figure 6.20

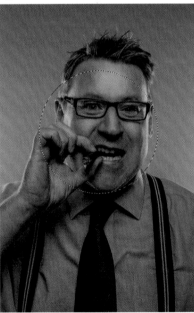

Figure 6.21

Figure 6.22

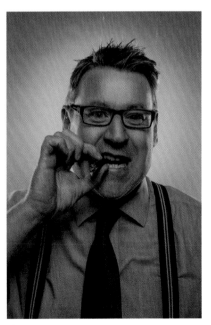

Figure 6.23

MATCHING BACKGROUND AND FOREGROUND COLOR

We now need to work on the color of the model. His skin tone is too warm compared to the blue background. In real life, had we photographed the model against a blue background, some of that color would have reflected back onto him.

1. Click the color layer. Create a copy of it by pressing Command/Ctrl-J. Drag the copy layer to the top of the layer stack, and change the opacity to 20%.

2. To make the model brighter, create a Curves adjustment layer, click the target adjustment icon in the Curves properties, click the model's nose, and drag upward (**Figures** 6.24 and **6.25**).

TIP *Renaming each layer so that you know what part it plays in the retouching process will save you time and frustration later should you need to make changes; this is especially true in pictures that require many layers and hours of work.*

Figure 6.24

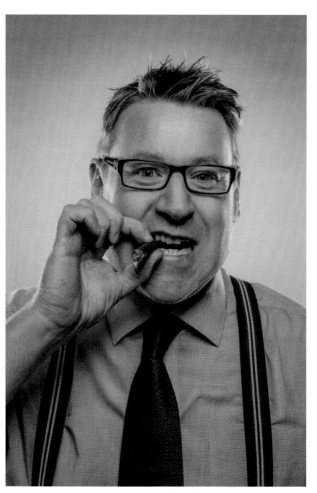

Figure 6.25

LIGHTING THE CIGAR

Here's how we can easily make the cigar appear alight using layer styles.

1. Click the retouch layer at the bottom layer of the layer stack, zoom in, and use the Lasso tool to draw a rough selection of the ash area of the cigar (**Figure 6.26**).

2. Copy this selection onto its own layer by pressing Command/Ctrl-J. Drag that layer to the top of the layer stack and name it **cigar**.

3. To make the ash look alight, we are going to apply three layer styles. Click the fx icon at the bottom of the layer stack, and choose Outer Glow from the menu. In the Structure section, change the blend mode to Overlay and increase Noise to 75%. Click the color swatch, choose black, and click OK.

4. Apply an Inner Glow layer style. In the Structure section, change the blend mode to Overlay, click the color swatch, and choose black. Click OK. In the Elements section, increase the Size to 25px.

5. Apply a Gradient Overlay layer style. Change the blend mode to Overlay, and click the Gradient bar to open the Gradient Editor. Choose the Black/White gradient (third from the left in the top row).

6. Click the white marker on the far right of the gradient. In the Gradient Editor, click the color swatch, choose red, click OK, and click OK again to close the Gradient Editor.

7. In the Gradient Overlay properties, reduce the opacity to 30% and click OK (**Figure 6.27**).

 NOTE *In the final image I added some smoke to the end of the cigar using a smoke effect brush; there are many available for free on the internet (**Figure 6.28**). Sometimes I'll do this by using a picture of smoke photographed against a black background. I then add this picture to the top of the layer stack and use the Screen blend mode to hide the black background, leaving just the smoke. Free Transform can then be used to resize the smoke, while the Move tool can be used to position it.*

Figure 6.26

Figure 6.27

Figure 6.28

THE PAINTERLY TEXTURED EFFECT

This painterly look is a finishing touch that I like to add to my pictures. The technique makes use of the Reduce Noise filter; it's best done at the very end of the retouching.

1. With the uppermost group active, add a merged layer to the top of the layer stack by choosing Select > All > Edit > Copy Merged > Paste. Rename this layer **painterly**, and create a copy of it by pressing Command/Ctrl-J. Rename this copy **sharpness**.

2. Turn off the sharpness layer by deselecting the layer's eye icon. Click the painterly layer and choose Filter > Noise > Reduce Noise.

3. In the Reduce Noise properties, set the Strength slider to 10 and all other sliders to 0%. Click OK (**Figure 6.29**).

4. To bring back some of the sharpness, click the sharpness layer and click its eye icon to make the layer visible. Choose Filter > Other > High Pass, and add a Radius of 1 pixel.

5. Click OK, and change the blend mode from Normal to Overlay.

Figure 6.29

Before

After

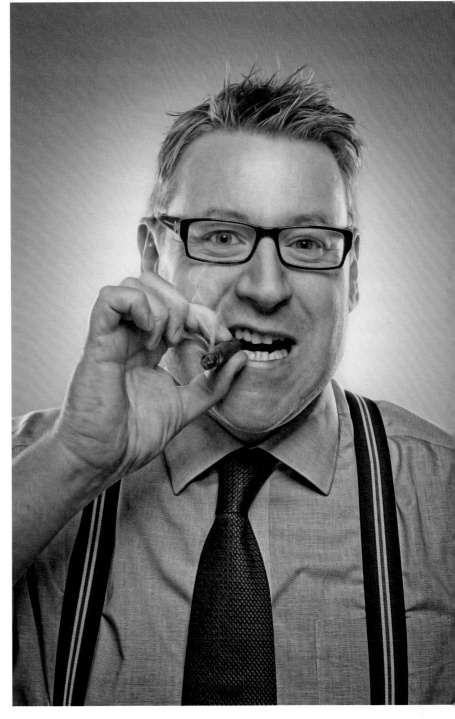

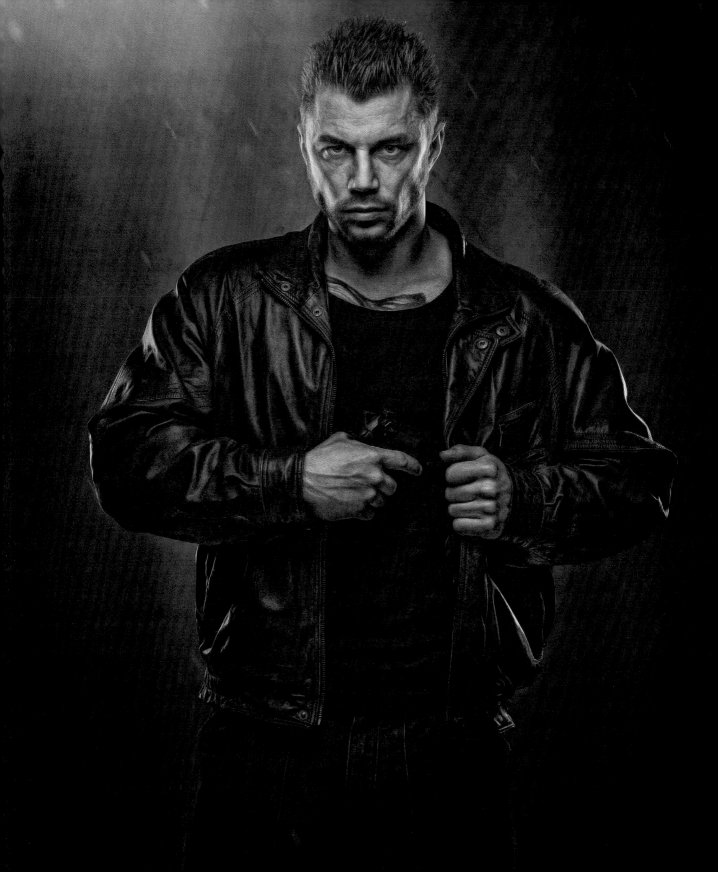

TOUGH GUY

Compositing is becoming increasingly popular among photographers and retouchers. The ability to combine images and create one final picture allows us to produce work that would once have been impossible.

Of course, to make it happen we need to grasp fundamental Photoshop skills, such as making selections and cutouts. But I also believe that we can learn much by simply observing. Taking the time to look around, and see how shadows and light behave in the real world, can remove the need for guesswork in Photoshop.

In this chapter, we'll create a composite by using blend modes. This technique was a game-changer for me—a way to create composites without spending most of my time making tricky selections and cutouts. This meant I could work on the more creative aspects, such as lighting effects, special effects, and so on.

RAW CONVERSION AND RETOUCH

Camera Raw is where every image retouch starts.

1. Open the raw file toughguy.dng in Camera Raw. With the Crop tool (making sure that the tool's settings are set to Normal in the menu), reduce the amount of background above the model's head and from the bottom—just above the curve in the seamless roll of gray paper. Press Return/Enter. (Don't worry about the area on the right side of the picture, because we'll be working on that later.)

2. The clothing our model is wearing is very dark, so we're going to bring out more detail. In the Basics tab, move the Blacks slider to +100 and the Shadows slider to +85. This reveals more details but has also brightened the highlights, so take the Highlights slider to −25 (**Figures 7.1** and **7.2**).

Figure 7.1

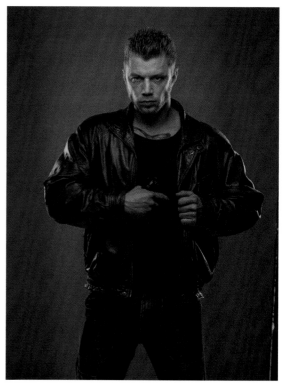

Figure 7.2

3. The model's hands look darker and cooler compared to the rest of his skin. To improve that, grab the Adjustment Brush and, making sure that all the adjustments are at zero, increase the Exposure to +10. Select the Auto Mask and Mask checkboxes, and paint over the hands so that they are covered in the red overlay. Deselect the Mask checkbox, and then increase Exposure to +0.55 and Temperature to +10.

4. Click the Adjustment Brush icon to exit, and then zoom in to the model's eyes. With an Adjustment Brush, select only the pupils and set the Exposure to +0.40, Clarity to +65, Sharpness to +35, and Temperature to –6.

5. Although we want a rugged, gritty feel, we will do a small amount of skin retouching, and Camera Raw is more than adequate for this. With the Spot Removal tool set to Heal, work around the model's face to remove any obvious blemishes or marks (**Figure** 7.3).

6. Click the Spot Removal icon to exit, and then go to the Details tab to add some sharpening. Since this is a portrait of a man, I tend to use quite a high amount of sharpening to add to the gritty, hard feel. Move the Sharpness slider to +85, and then restrict it to only the model by Alt/Option-dragging the Masking slider to 75 (**Figure** 7.4).

7. The last thing we'll do in Camera Raw before heading over to Photoshop is to improve the skin tone, as it looks a little too orange for my liking. Go to the HSL/Grayscale tab, and in Saturation drag the Oranges slider to –30.

Figure 7.3

Figure 7.4

NONDESTRUCTIVE RETOUCHING IN PHOTOSHOP

We're all done in Camera Raw for now, so next we'll take the photo to Photoshop as a Smart Object.

1. Hold down the Shift key and click Open Object.

2. To improve the composition and add to the canvas area we can use the Crop tool. Using the Crop tool, drag out the handle on the right side to roughly the same distance the background is from the model's arm on the left side, and press Return/Enter. Add a new blank layer to the top of the layer stack, and name it **composition** (Figure 7.5).

3. Fill in this transparent area with the Clone Stamp tool set to Current & Below (**Figure 7.6**), so that the result is an even amount of background on either side of the model. Don't worry about blending this area perfectly because we'll be adding textures; an uneven background will add to the final look.

4. The next step isn't an essential part of the retouch but rather personal taste; it uses the Color Efex Pro 4 plug-in to pull out detail—a look that I feel really suits this kind of picture. Click the bottom layer (the Smart Object), and choose Filter > Nik Collection > Color Efex Pro 4. Choose the Detail Extractor, and using nothing but the default settings, click OK. Back in Photoshop, click the layer mask that comes with the filter and go to Image > Adjustments > Invert. Then with a white, medium soft-edged brush, paint to reveal the effect only on the model (**Figure 7.7**).

5. We'll now add some dodging and burning. Add a new blank layer to the top of the layer stack, name it **dodge and burn**, fill it with 50% gray, and change the blend mode from Normal to Soft Light. Then with the Dodge tool set to an Exposure of 10%, dodge and burn the model's skin to enhance highlight and shadow areas, burning down the hairline and so on.

 TIP *Notice how the model's jacket looks like it's had dodging and burning already applied? This is because of the sheen on the jacket's material. When you're photographing models for themed shoots, give some thought to how the clothing will look under the light; it could save you lots of retouching time later.*

Figure 7.5

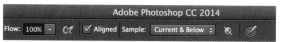

Figure 7.6

Figure 7.7

CREATING A NEW BACKGROUND USING TEXTURES

Now we're going to start adding the new background. Because our model is in front of a gray background, we'll use the blend mode compositing technique covered in Chapter 2.

I'm going to use the same texture several times, but you could use many different textures to build a completely unique look.

1. Go to File > Place Embedded (File > Place in earlier versions of Photoshop), locate the texture file to be added, and click OK. Resize the texture so that it fills the document by Option/Alt-Shift-dragging one of the corner transform handles. Press Return/Enter.

2. To add the texture onto the gray background, change the blend mode to either Soft Light or Overlay (depending on the amount of contrast you want in the background).

3. Add another texture, or duplicate the one we just added by pressing Command/Ctrl-J. Then choose Edit > Transform > Flip Horizontal. To avoid the sides of the background looking identical, add a layer mask and with a black brush paint away some of the repeating patterns or marks. Repeat this process until you get the look you're after (**Figure 7.8**).

4. With the uppermost texture layer active, Shift-click the first texture layer so that all are selected. Then go to Layer > New > Group from Layers, and name this group **Textures**.

5. To remove the texture from the model so that it appears only on the background, add a layer mask to the group and with a black medium soft-edged brush at 100% opacity paint directly over the model (**Figure 7.9**).

continues

Figure 7.8

Figure 7.9

TIP *You can check to see if you missed any areas by Option/Alt-clicking the layer mask in the Layers panel. Then simply paint in black or white to fill in any gaps. To return to the normal view, Option/Alt-click the layer mask again (**Figure 7.10**).*

6. Now we're going to add a vignette. With the Elliptical Marquee tool, drag out an ellipse in the center of the picture. Then add a Levels adjustment layer and move the midtones point to the right to darken it (**Figures 7.11** and **7.12**).

Figure 7.10

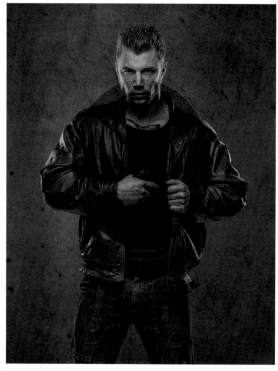

Figure 7.11

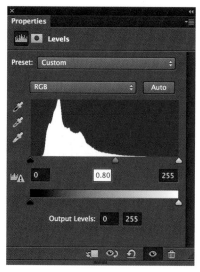

Figure 7.12

7. Click the Mask icon in the Levels properties, and click Invert. Soften the outside of the vignette by increasing Feather to 250 pixels (**Figure 7.13**).

8. Click the layer mask attached to the levels adjustment in the Layers panel, and go to Edit > Free Transform. Option/Alt-Shift-drag a corner transform handle outward to increase the size of the vignette so that it extends close to the edges of the picture.

 TIP *Creating a vignette in this way is nondestructive, and you can reposition it at any time. Simply click the levels adjustment layer mask in the Layers panel, and use the Move tool to drag the vignette.*

9. We're going to be adding more lighting effects in the upper corners, and it wouldn't look good to have dark areas there too. To remove them and leave the vignette only in the lower parts of the picture, click the layer mask and with a soft-edged black brush paint on the picture in the upper-left and upper-right areas.

Figure 7.13

ADDING SHADOWS

Adding shadows to the background is a great way to add drama.

1. Add a new blank layer to the top of the layer stack, and name it **shadows**. Press D to set the foreground and background to their default of black and white. Choose the Custom Shape tool from the toolbar, and choose the shape called Tile 2; it looks like a square with diagonal lines (**Figure 7.14**).

 continues

Figure 7.14

2. In the settings at the top of the screen, make sure that the custom shape is set to Pixels, Mode is Normal, Opacity is 100%, and the Anti Alias checkbox is selected (**Figure 7.15**). Then drag on the picture so that the shape fills the entire layer. Go to Filter > Convert for Smart Filters and then to Filter > Blur > Gaussian Blur and increase the Radius to approximately 200 pixels.

3. Remove the shadows from the model by adding a layer mask and then Command/Ctrl-clicking the layer mask that we added to the textures group. Go to Select > Inverse and then to Edit > Fill and choose Black from the Contents menu. Click OK and then reduce the opacity of the shadows layer to 65%.

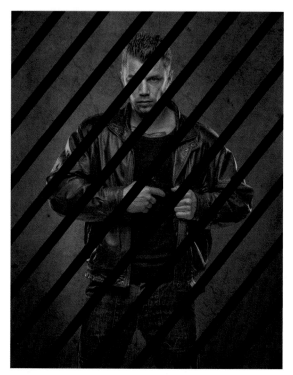

Figure 7.15

USING THE WORLD'S SIMPLEST LIGHTING EFFECT

Our model has highlights on either side of him, so we need to add light sources so that the highlights make sense.

1. Add a new blank layer, and choose a soft-edged white brush. Click in the center of the picture, go to Edit > Free Transform, Option/Alt-Shift-click a corner transform handle, and resize so that it goes way beyond the layer boundary. Press Return/Enter, and with the Move tool reposition so that just the soft, feathered edge is visible in the upper-left corner. Then add the same light source in the upper-right corner by pressing Command/Ctrl-J and repositioning with the Move tool.

 TIP *If you don't want the light source to be quite so bright, change the blend mode to Linear Dodge (Add) and adjust the Fill slider. It's a subtle difference, but using the layer's opacity tends to make the light source appear gray.*

2. Next we'll add some dust specks to the light sources using the thingys technique from Chapter 3. Choose File > Place Embedded (File > Place in earlier versions of Photoshop), locate the thingys file, and click OK. Option/Alt-Shift-drag a corner handle so that the file fills the entire layer. Press Return/Enter. Change the blend mode to Screen so that only the light parts of the layer are visible.

3. Go to Filter > Blur > Motion Blur. Change the Angle to −45 and the Distance to 70 and click OK (**Figure 7.16**).

4. The thingys/dust layer also brightens the image, which isn't what we want. To remove the lightening effect but keep most of the thingys/dust, add a levels adjustment layer, click the clipping mask icon, and drag the white output levels to 170 (**Figure 7.17**).

5. Now we'll desaturate the image by first adding a black and white conversion, using the gradient map method covered in Chapter 5. Press D to set the foreground and background colors to their default black and white. Add a Gradient Map adjustment layer, and then lower the opacity to 30%.

6. Add a Selective Color adjustment layer. In the properties, choose Neutrals from the Colors menu. Set the Cyan to +28, Magenta to +18, Yellow to +26, and Opacity to 60% (**Figure 7.18**).

7. Create a merged/combined layer at the top of the layer stack, and go to Edit > Free Transform. In the options at the top of the screen, make sure that the W (Width) and H (Height) are not linked by the padlock icon being de-pressed, and increase the width to 103%. This is just enough to make our tough guy appear broader without making it obvious that he has been retouched (**Figure 7.19**).

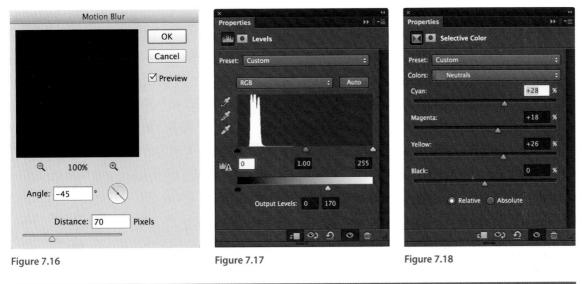

Figure 7.16 Figure 7.17 Figure 7.18

Figure 7.19

Before

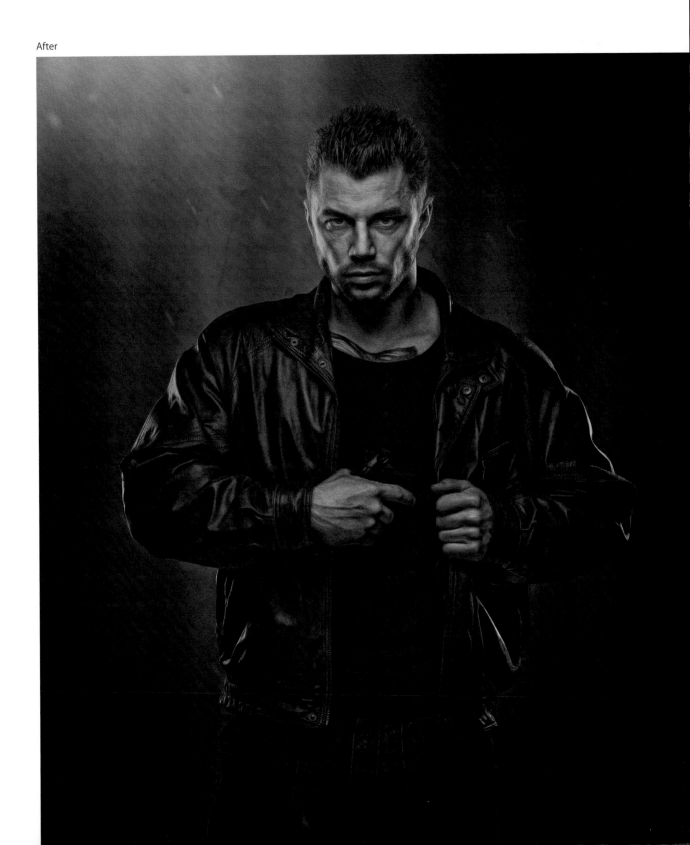

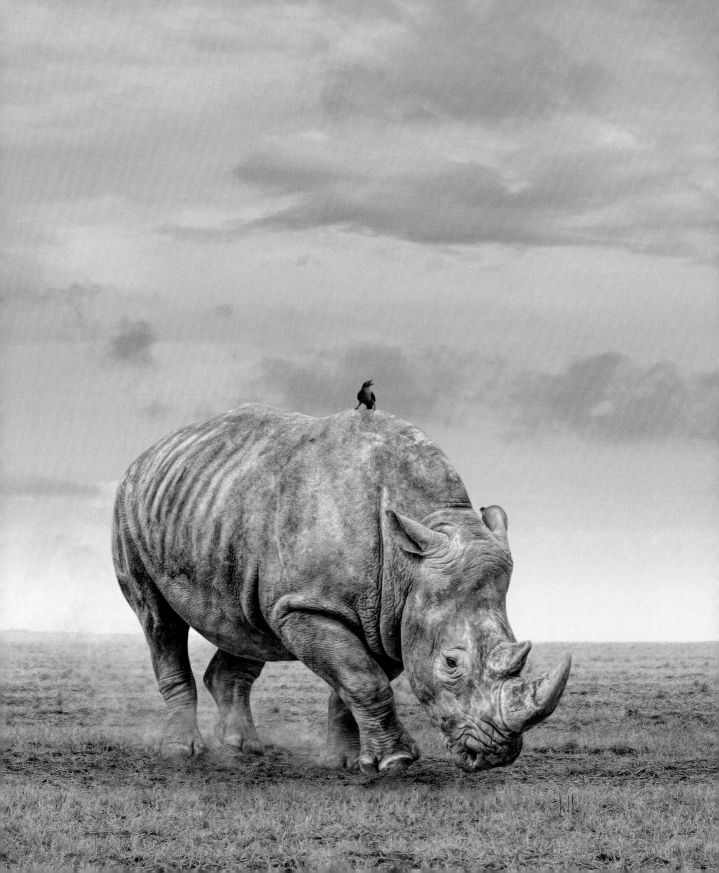

CHAPTER 8

RHINO COMPOSITE

I'm working on a personal project that involves photographing animals in captivity (zoos, wildlife parks, and so on) and then using Photoshop to set them free, making them appear to be in their natural habitat. This project has totally captivated me—I'm both an animal lover and a photographer, so combining the two seemed the perfect match.

Working on personal projects is one of the most important things you can do. It not only keeps you creating new images but can help you remain motivated and excited, pushing you to learn even more.

For this project we'll work through one of the composite images in this animal series, which I called "Wishing for Rain."

CREATING THE LANDSCAPE

First we'll use several photographs to create the landscape that the rhino will eventually be added into.

1. In Photoshop, go to File > Open and navigate to the field.dng raw file. Click OK to open the file in Camera Raw, and from within the Basic tab reduce Saturation to –5 (**Figure 8.1**).

2. Click the HSL/Grayscale tab, and under the Saturation tab reduce Oranges to –20, Yellows to –10, Greens to –65, and Aquas to –25 (**Figure 8.2**).

3. Reducing the saturation like this has given the landscape a much dryer and less alive feeling. To finish off in Camera Raw, we'll add a little overall sharpening. In the Detail tab, increase the Sharpening Amount to 50 and leave all other sliders at the defaults (**Figure 8.3**).

Figure 8.1

Figure 8.2

Figure 8.3

4. Choose the Straighten tool from the toolbar at the top of the screen (**Figure 8.4**). Click the far left of the top of the field, and drag a line to the right side of the picture (**Figure 8.5**). Press Return/Enter. Click Open Image to open the file in Photoshop.

 I want the ground to take up the bottom third of the final picture, so we'll use the Crop tool to change the composition and increase the width of the field for a wider landscape.

continues

Figure 8.4

Figure 8.5

5. With the Crop tool selected, ensure that the Delete Cropped Pixels checkbox is unselected, click the crop handle in the bottom middle of the grid, and drag upward so that the bottom third lines up along the top of the field. Then Option/Alt-click the crop handle on the middle left and drag left to increase the size of the canvas area (**Figure 8.6**). Click OK.

6. Go to Edit > Free Transform, Option/Alt-click, and drag the transform handle on the middle left until the field covers the entire canvas area (**Figure 8.7**). Exit Free Transform by pressing Return/Enter.

Figure 8.6

Figure 8.7

7. With the Pen tool, draw a path along the top of the field by putting down several points from just outside the left of the picture all the way across to just outside the right side of the picture (**Figure 8.8**). (Try not to make this a perfectly straight line; rather, add slight curves as you go from left to right. This will create a believable horizon line later.)

8. Leaving the path in place, go to File > Place Embedded (File > Place in earlier versions of Photoshop) and navigate to the sky.dng file. Click OK to open the file in Camera Raw. In the Basic tab, increase Clarity to +35 and Vibrance to +35. Click OK.

9. The sky.dng file will now be on top of our landscape picture but needs resizing. Shift-Option/Alt-click a transform handle in the top right or top left, and drag outward until the sky file completely covers the landscape as it resizes in the same proportions. Click OK. Using the path we created earlier as a guide, and with the Move tool (V) selected, Shift-click the up arrow key until the mountains in the distance are just above, as in **Figure 8.9**.

continues

Figure 8.8

Figure 8.9

10. Add a layer mask to the sky layer (**Figure 8.10**) by clicking the layer mask icon at the bottom of the Layers panel.

11. Choose the Brush tool (B), click the Brush Preset Picker, and choose number 134 (which looks like three blades of grass) (**Figure 8.11**). In the Brush panel, click Brush Tip Shape and set Size to 30px and Spacing to 5% (**Figure 8.12**). In Shape Dynamics, set Size Jitter to 0% and Angle Jitter to 3%. In Scattering, set Scatter to 10%, select the Both Axis checkbox, and set Count to 2. (No other settings should be active.)

Figure 8.10

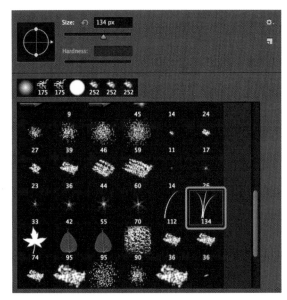

Figure 8.11

Figure 8.12

12. Click the Brush panel icon again to close the panel, set the foreground color to black, and then go to the Paths panel. With the Brush tool still selected, click the Stroke Path with Brush icon (**Figure 8.13**) at the bottom of the Paths panel to add our new horizon line (**Figure 8.14**). Click in the Paths panel to hide the path.

13. Go to the Layers panel, and with a normal medium soft-edged brush paint with the black foreground color below the horizon line to reveal the field below (**Figure 8.15**).

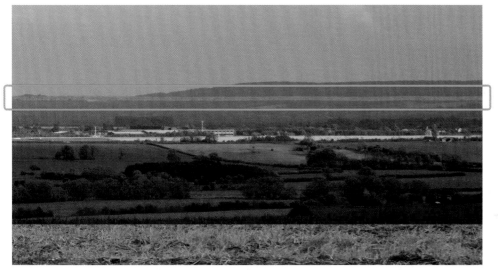

Figure 8.13

continues

Figure 8.14

Figure 8.15

14. We'll now add a little bit of haze in the distance by using a gradient, just as we did in Chapter 3. Add a blank layer and name it **haze**. Press D to set the foreground and background color to their default of black and white, and then press X to set the foreground color to white. Choose the Gradient tool (G), and in the options at the top of the screen choose the Foreground to Transparent gradient (**Figure 8.16**) and the Reflected gradient (**Figure 8.17**).

Figure 8.16

15. Shift-click the horizon line, drag upward to just above the distant hills, and release (**Figure 8.18**). Lower the opacity of the haze layer to 20%.

Figure 8.17

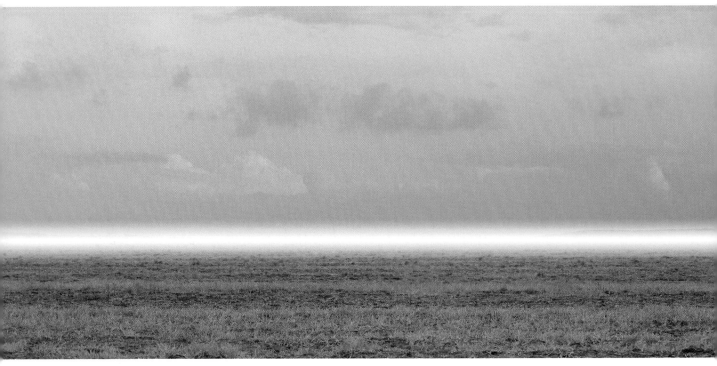

Figure 8.18

16. We'll now add an acacia tree to the landscape. Go to File > Open, navigate to the tree.jpg file, and click OK to open it. Go to Select > Color Range. Making sure that the Selection option is active, choose the middle sampler (it has the + symbol), and then click on and around the tree within the preview pane. Adjust the Fuzziness slider to add or take away from the selection (**Figure 8.19**). (Don't worry about the ground also being selected; we'll work on that next. The priority here is to isolate the tree from the sky.)

17. Click OK to close the Color Range properties and show the active selection on the tree image. Enter Quick Mask mode by clicking the Quick Mask icon in the toolbar or pressing the letter Q. If you've set up Quick Mask as I showed you in Chapter 1, the areas selected will now be covered with the red overlay (**Figure 8.20**). With a normal round medium soft-edged brush and a white foreground color, paint over the areas of the image where the red overlay is covering anything but the tree—that is, the ground and parts of the sky. Exit Quick Mask mode by clicking the Quick Mask icon in the toolbar or by pressing Q.

continues

Figure 8.19

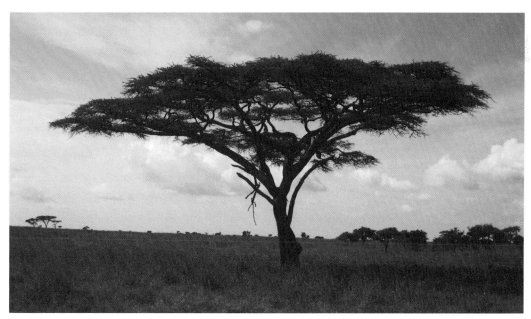

Figure 8.20

18. Add a layer mask by clicking the layer mask icon at the bottom of the Layers panel. Parts of the tree may appear transparent; to fill these areas and add more foliage, press Command/Ctrl+J three times. Then with the top copy highlighted, Shift-click the layer at the bottom of the Layers panel (**Figure 8.21**). Then go to Layer > Merge Visible.

19. Go to Select > All, and then to Edit > Copy. Go to the landscape picture, and then choose Edit > Paste to add the tree into the scene. Use Edit > Free Transform to resize the tree and use the Move tool to reposition (**Figure 8.22**).

When we add elements into a scene, we may also need to adjust the color, saturation, and contrast so that the elements blend in and look as though they were really there.

Figure 8.21

Figure 8.22

20. To lower the contrast of the tree, go to Image > Adjustments > Levels and change the black output level to 30 (**Figure 8.23**). Click OK. Reduce the saturation by going to Image > Adjustments > Hue/Saturation and reducing Saturation to –35. Click OK.

21. Rename this layer **tree**, add a layer mask, and press D to set the foreground and background colors to their default. Press X so that black is the foreground color. Choose the Brush tool (B), and from the Brush Preset Picker choose brush 134 (the three blades of grass). Go to the Brush panel and turn off all the settings (Shape Dynamics, Scattering, and so on). Zoom in, and with a brush size of 20px paint across the bottom of the tree to help it blend into the grass (**Figure 8.24**).

22. Add a new blank layer and name it **shadow**. Choose a normal soft-edged brush and paint a line underneath the tree. Go Filter > Blur > Gaussian Blur and add 10px of blur (**Figure 8.25**). Click OK and lower the opacity of the shadow layer to 15%.

Figure 8.23

Figure 8.24

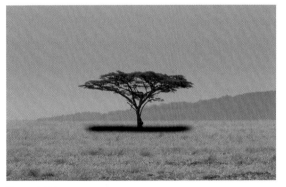

Figure 8.25

ADDING THE RHINO

Now that we've created the landscape, we can get to work on the rhino.

Figure 8.26 shows the picture we'll be using. I took it when I visited Whipsnade Zoo in the UK. With the two rhinos together, the mood of the picture is one of interaction and play. But selecting and cutting out the rhino on the left results in a completely different feel.

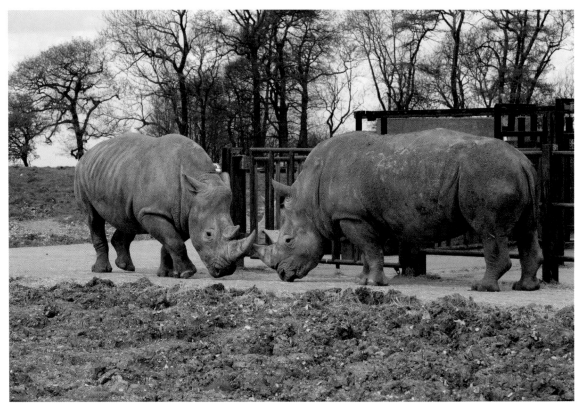

Figure 8.26

1. In Photoshop, go to File > Open, navigate to the rhino.
 dng raw file, and click OK to open it in Camera Raw.

2. In the Basic tab, increase Shadows to +60 to enhance
 the detail in the shadow areas, including the eye. Add
 some midtone contrast by increasing Clarity to +50
 (**Figure 8.27**).

3. Adding some sharpening at this stage will increase
 detail in the rhino's skin. In the Detail tab, increase
 Sharpness to 60 (there is no need to use the Masking
 slider because we're going to be cutting the rhino
 out). Shift-click Open Object in the bottom right of
 the screen to open the rhino file in Photoshop as a
 Smart Object.

4. Use the Pen tool (or whatever method you prefer) to
 select and cut out the rhino on the left. Go to Select >
 Save Selection, name it **rhino,** and click OK. Then with
 the selection still active, click the Layer Mask icon at the
 bottom of the Layers panel (**Figure 8.28**) to cut the rhino
 from the picture (**Figure 8.29**).

continues

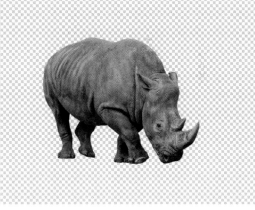

Figure 8.27

Figure 8.28

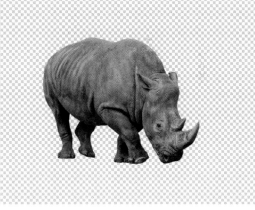

Figure 8.29

5. Drag the rhino into the landscape we created earlier by holding it temporarily on top of the tab for the landscape file until it opens. Then drag it into the scene, release, and with the Move tool reposition it (**Figure 8.30**).

6. To help the rhino blend into the scene, we need to soften it. Option/Alt-click the layer mask attached to the rhino layer to reveal it (**Figure 8.31**). Then go to Filter > Blur > Gaussian Blur, add 1px of blur, and click OK. You'll now see that the white part of the mask has been blurred slightly, which as a result has softened the outline. Option/Alt-click the layer mask to return to normal view.

Now that the rhino is in the landscape, we need to blend his hooves into the ground.

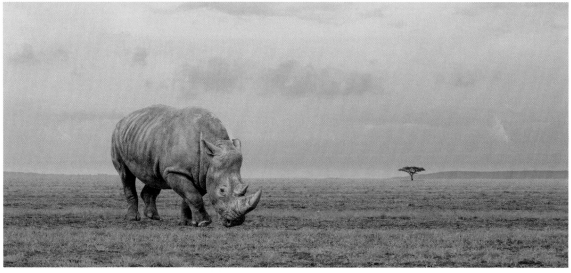

Figure 8.30

Figure 8.31

7. Click the bottom layer in the layer stack, which contains the original field. With the Lasso tool, draw a rough selection around the rhino's hooves (**Figure 8.32**). Then go to Layer > New > Layer via Copy. This creates a layer containing a copy of everything included within the selection. Double-click the name of the layer, and rename it **blend hooves** (**Figure 8.33**).

8. Drag the blend hooves layer to the top of the layer stack, so that it's above the rhino layer. Option/Alt-click the layer mask icon at the bottom of the Layers panel to add a black layer mask (**Figure 8.34**). This hides the contents of the blend hooves layer so that we may reveal it gradually in the next steps.

continues

Figure 8.32

Figure 8.33

Figure 8.34

9. Set the foreground color to white, choose a normal round soft-edged brush, and set the blend mode to Dissolve (**Figure 8.35**). Then paint around the hooves to reveal parts of the blend hooves layer. Once you've painted along the hooves where they touch the ground (**Figure 8.36**), go to Filter > Blur > Gaussian Blur, add 1px of blur, and click OK.

10. Although the lighting in the picture is overcast, we still need to add a shadow underneath the rhino. Add a new blank layer to the top of the layer stack, name it **rhino shadow**, and lower the opacity of the layer to 20%. Then with a normal soft-edged brush in the Normal blend mode, paint underneath the rhino an irregular shape that resembles a shadow. In this example I eventually lowered the opacity of the layer to 15% (**Figure 8.37**).

11. Click the rhino layer and lower the opacity to 90%.

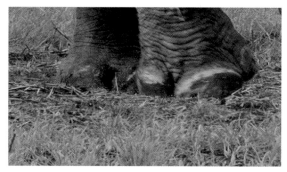

Figure 8.35

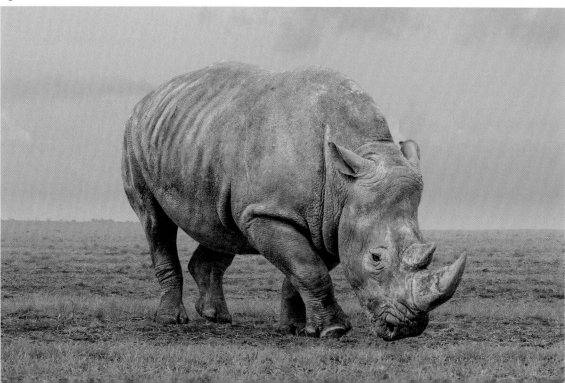

Figure 8.36

Figure 8.37

CREATING THE DUST

To make it look as though the ground was dry, we'll add some dust around the rhino's hooves.

There are many places online you can download smoke/dust effect brushes, but it's easy to create one by using a brush included in Photoshop and making a few simple adjustments in the Brush panel.

1. Choose the Brush tool (B), and from the Brush Preset picker choose brush 45 (**Figure 8.38**). Then click to open the Brush panel, and in the Brush Tip Shape properties change Spacing to 55%.

2. Turn on Shape Dynamics, and set Size Jitter to 100% and Angle Jitter to 100%. Turn on Scattering, and set Scatter to 0% and Count to 1.

3. Turn on Color Dynamics, select the Apply Per Tip checkbox, and set Foreground and Background Jitter to 50%. This will vary the color of the dust between the foreground and background colors we'll be setting in a moment.

4. Turn on Transfer, and set Opacity Jitter to 100%. No other settings should be applied. You can see in the preview box that this brush already looks like dust or smoke (**Figure 8.39**).

continues

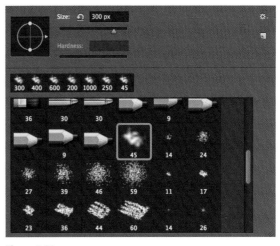

Figure 8.38

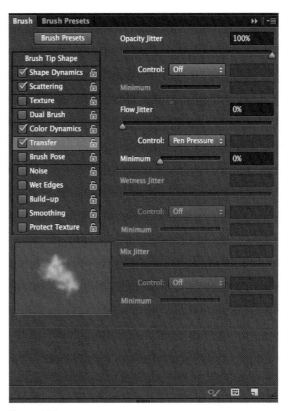

Figure 8.39

5. Close the Brush panel, and press D to set the foreground and background colors to their default of black and white. Then click the foreground color in the toolbar to open the Color Picker. Bring the color sampler/cursor into the image area, and click a light area of grass near the rhino's hooves. Click OK to close the Color Picker; the sampled color has now been set as the foreground color in the toolbar (**Figure 8.40**). The dust we paint in will vary between the foreground and background colors because we turned on Color Dynamics in step 3.

6. Lower the opacity of the brush to 50% in the options bar at the top of the screen, and then add a new blank layer to the top of the layer stack. Rename it **dust behind**, drag it beneath the rhino layer, and paint a few brush strokes around the rhino's hooves. Add another blank layer to the top of the layer stack, name it **dust front**, and paint a few more brush strokes to add dust around the rhino's hooves to give the look of dust being kicked up as he walks (**Figure 8.41**).

Figure 8.40

Figure 8.41

FINISHING TOUCHES

Now is where I start adding finishing touches—some using Photoshop and some using third-party plug-ins such as Nik Color Efex Pro from Google and Clarity from Topaz Labs.

To start with, I think more of the color needs to be removed to add impact to the overall mood, and we'll do that with a black and white conversion.

1. Click the uppermost layer in the layer stack, which should be labeled dust front. Then press D to set the foreground and background colors to their default of black and white. Click the Gradient Map Adjustment Layer icon (**Figure 8.42**), and create a black and white conversion using the method covered in Chapter 4.

2. Lower the opacity of the Gradient Map adjustment layer to 40%.

3. Double-click the rhino layer thumbnail, which will open the layer in Camera Raw. In Camera Raw, increase Clarity to +100 and increase Sharpening to 100. Click OK.

4. Click the uppermost layer in the layer stack. Go to Select > All, then to Edit > Copy Merged, and then to Edit > Paste to add a merged/combined layer at the top of the layer stack (or press Shift+Option/ Alt+Command/Ctrl+E). Double-click the layer name and rename it **FT** (for finishing touches) (**Figure 8.43**).

 > **NOTE** *This next step is purely optional, but at this stage I used the Nik Color Efex Pro plug-in from Google. When adding finishing touches, I don't use the plug-ins as Smart Filters but rather open them, experiment, and see what looks I can create.*

5. Go to Filter > Nik Collection > Color Efex Pro 4, and apply the Detail Enhancer preset with Effect Radius set to Normal. Click Add Filter. From the Presets menu, choose Cross Processing. In the Method menu, choose Y02, set Strength to 30%, and click OK. Go to Layer > Merge Down.

continues

Figure 8.42

Figure 8.43

6. To finish, we'll add the painterly effect covered in Chapter 4. Press Command/Ctrl+J twice. Rename the uppermost copy **sharpness** and click that layer's eye icon to turn it off. Then click the copy below and rename it **painterly** (Figure 8.44).

7. Go to Filer > Noise > Reduce Noise, and with all sliders at 0 increase Strength to 10 and click OK. Repeat this step, but set the Strength to 5 and click OK.

8. We need to bring back some of the sharpness, so click the sharpness layer, and click to reveal the eye icon and make the layer visible. Then go to Filter > Other > High Pass, add a Radius of 1px, and click OK. Change the blend mode of the sharpness layer to Overlay.

9. With the sharpness layer active, Shift-click the FT layer so that the top three layers are selected (**Figure 8.45**). Go to Layer > Merge Layers, and rename the uppermost layer **FT** to keep everything organized.

10. Finally, add some contrast using Unsharp Mask. Go to Filter > Sharpen > Unsharp Mask, and set Amount to 15, Radius to 15, and Threshold to 0. Click OK (**Figure 8.46**).

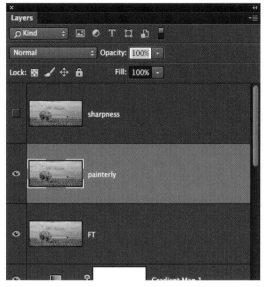

Figure 8.44

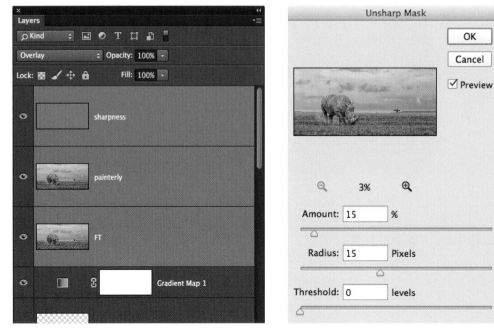

Figure 8.45

Figure 8.46

Before

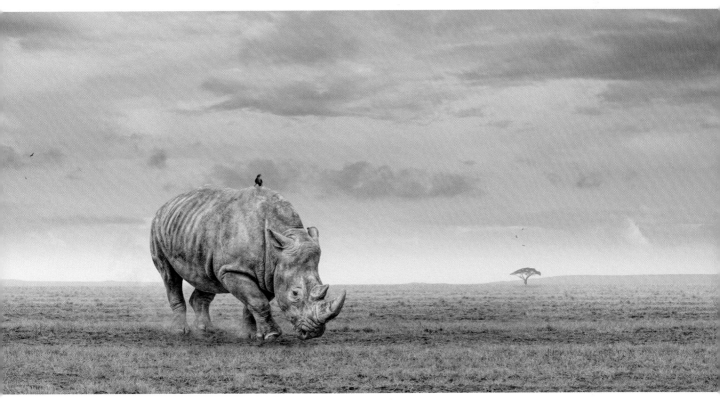

After

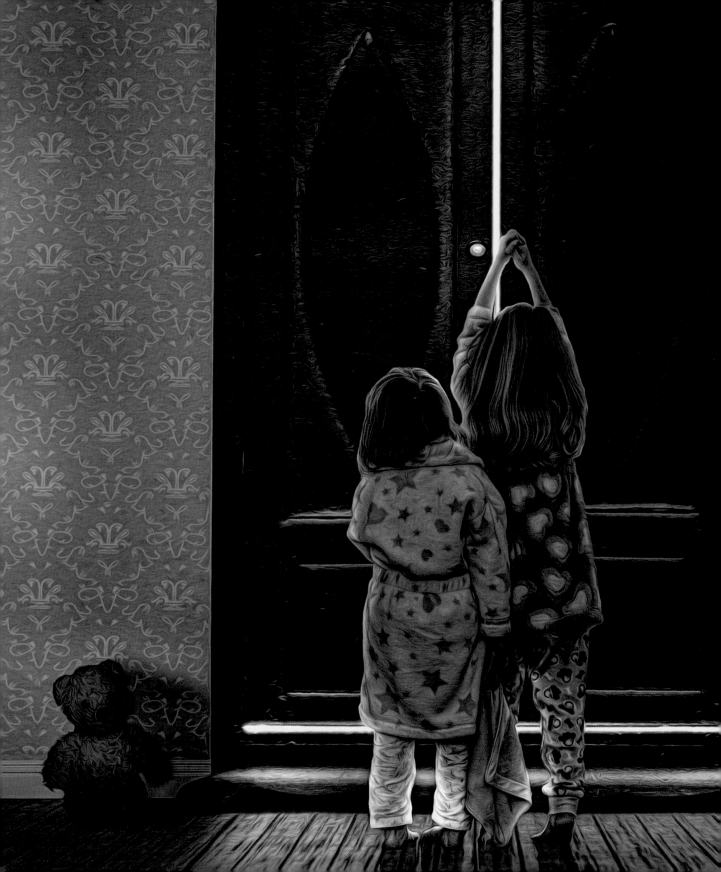

FAIRYTALE SCENE

When I was a very young boy, one of my favorite films was *The Lion, the Witch and the Wardrobe*. I was enthralled by C.S. Lewis's story of four children, billeted during World War 2, who discovered the magical world of Narnia through the doors of a large antique wardrobe.

I'd always planned to do a personal project inspired by the film, but it wasn't until I did a seminar in London with my friend Uli Staiger, an incredible digital artist from Berlin who specializes in 3D, that I put it into action. And when Uli showed me that he also builds actual miniature sets for his images, I was inspired.

In this chapter I take you step by step through the picture I created, "Mystical World." You'll see all the photographs that went into the picture, including the miniature scene, and then you'll see how the real-life children and toys were added, along with lighting effects, to create that fairytale feel.

BEHIND THE SCENES

Before we dive into Photoshop, here's a look at the individual photographs that went into making the final picture (**Figures 9.1–9.6**).

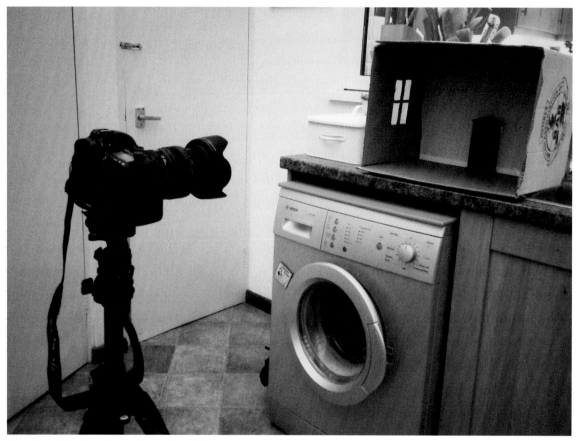

Figure 9.1 Cell phone picture showing how the miniature room was photographed in natural light.

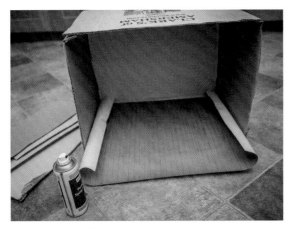

Figure 9.2 Assembling the miniature set

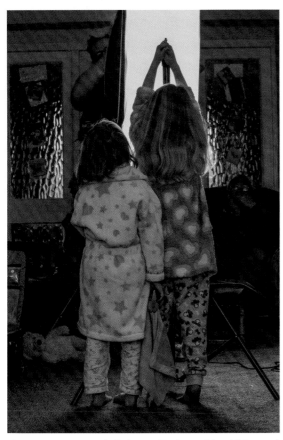

Figure 9.3 I positioned a light stand in front of the children and had them reach up to a point, which would be the wardrobe door handle in the final picture.

Figure 9.4

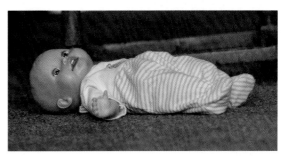

Figure 9.5

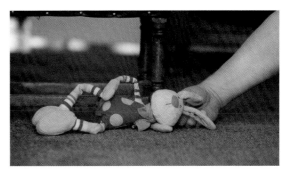

Figure 9.6

THE MINIATURE ROOM

We'll retouch the miniature room so that it appears life size, starting in Camera Raw and then moving to Photoshop.

1. Go to File > Open and choose the mystical_world.dng raw file. The file opens in Camera Raw. With the Crop tool, bring in all four sides (**Figure 9.7**).

2. Looking at the line of the skirting board against the back wall, we can see that the picture needs straightening. We can do this very quickly by double-clicking the Straighten tool while the crop is still visible (**Figure 9.8**).

3. If you're happy that the picture now looks straight, double-click the Hand tool to commit the crop. If not, drag up or down just outside the crop until it looks right.

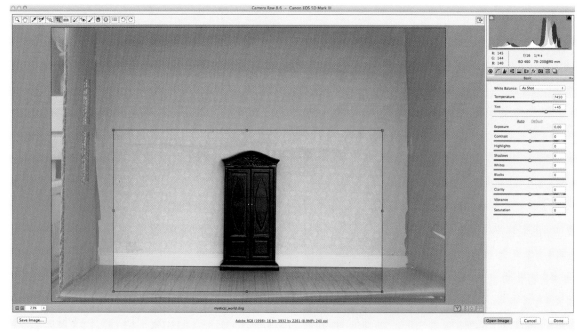

Figure 9.7

Figure 9.8

4. Most of the retouching for this picture will be completed in Photoshop, but before we do that we can quickly clean the image up by removing marks on the back wall and the floor with the Spot Removal tool set to Heal. There are also areas of the floor where the glue holding the paper down has lifted it slightly, causing a rippled effect; remove these using the Spot Removal tool (**Figure 9.9**).

 The Spot Removal tool is able to cover visible marks with matching areas of the pattern from elsewhere.

5. Shift-click Open Object, in the lower-right corner, to send the file to Photoshop as a Smart Object.

 At this stage it's obvious that we're working with miniature items, because in comparison to the size of the wardrobe, the wooden flooring and the skirting board (where the wall and floor join) look way too big.

6. We'll alter the perspective of the flooring because the angle the box was photographed at makes it look like it's sloping downward. With the Rectangular Marquee tool (M), make a selection of the floor (**Figure 9.10**). Go to Layer > New > Layer via Copy, or press Command/Ctrl+J. Name this new layer **floor**.

7. Go to Edit > Transform > Perspective, click either the lower-left or lower-right perspective handle, and drag outward (**Figure 9.11**). Press Return/Enter.

 continues

Figure 9.9

Figure 9.10

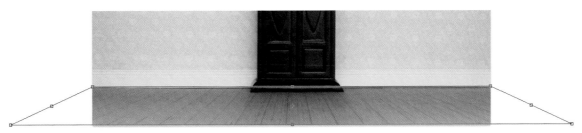

Figure 9.11

8. Now we'll shrink down the skirting board. Click the bottom layer (mystical_world) in the Layers panel and, with the Marquee tool, make a selection of the skirting board including some of the wall (**Figure 9.12**). Go to Layer > New > Layer via Copy (or press Command/Ctrl+J) to put this selection on its own layer. Name this new layer **skirting board**.

9. Go to Edit > Free Transform, and drag down the upper-middle transform handle to the point where the height of the skirting board is about half of what it was originally. Press Return/Enter (**Figure 9.13**).

10. To remove the piece of the original skirting board that's left at the top, we'll use the Clone Stamp tool. Add a new blank layer, and name it **clean up**. Then grab the Clone Stamp tool, and make sure in the options bar at the top of the screen that Sample is set to Current and Below, and that the Aligned checkbox is selected (**Figure 9.14**).

NOTE *Make sure that the Hardness setting of the Clone Stamp tool is at 0% so that the cloning blends seamlessly into the picture.*

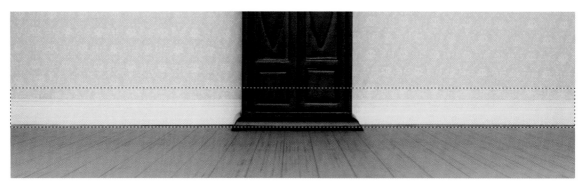

Figure 9.12

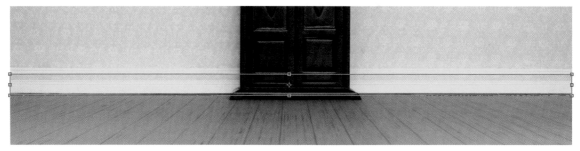

Figure 9.13

Figure 9.14

11. Switch to the Marquee tool, and select the top piece of skirting board. Go to Select > Modify > Feather, enter a Feather Radius of 2 pixels, and click OK. Switch back to the Clone Stamp Tool, and Option/Alt-click to select an area just above this selection to use as a clone source. Place the Clone tool inside the selection, and remove the skirting board (**Figure 9.15**).

> **TIP** *Using the Clone Stamp tool within a selection means we can clone over areas in proximity to other parts of a picture without affecting them. If you find the active selection (marching ants) distracting, press Command/Ctrl+H. The selection is still active but hides the outline. When you've finished cloning, remember to press Command/Ctrl+H to reveal it, and then choose Edit > Deselect.*

12. When we reduced the height of the skirting board, this also affected parts of the wardrobe. To correct this, add a layer mask to the skirting board layer, and with a black soft-edged brush paint over the bottom part of the wardrobe (**Figures 9.16** and **9.17**).

The flooring looks out of proportion because the fake individual boards are too wide in comparison to the wardrobe. There is no quick way to make these narrower, other than cloning a join between them and repeatedly adding to each board.

continues

Figure 9.15

Figure 9.16

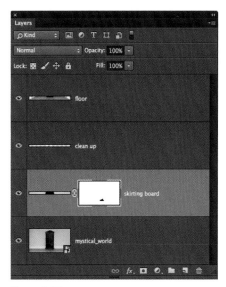

Figure 9.17

13. Add a new blank layer to the top of the layer stack, and name it **floor-boards**. Grab the Clone Stamp tool with the same settings as in step 10, Option/Alt-click, and clone one of the joins to the front of the wardrobe (**Figure 9.18**). (Don't worry about the angle as you clone, because we'll be correcting that in the next step.)

14. Go to Edit > Free Transform, and drag up or down outside the transform handles to alter the angle of this new joint (**Figure 9.19**). You can also resize it by Shift-Option/Alt-dragging any corner transform handle. Press Return/Enter.

This cloning process needs to be repeated across the whole of the floor, making sure to add a new layer for each joint line created. You may also find that you need to sample other joins as you move across the floor because of how the lighting changes. Don't worry about the ends of the joins (**Figure 9.20**), because we'll be cleaning those up in the next step.

15. Click the cloned floor-boards layer, Shift-click the first layer that we named floor-boards, and go to Layer > New > Group from Layers. Name the group **floor-boards** and click OK.

> **NOTE** *I also added a blank layer, named it "floor board gap-right," and used the Clone Stamp tool to fill in the gap along the right side of the picture where the floor and skirting board join.*

Figure 9.18

Figure 9.19

Figure 9.20

16. Add a layer mask to the **floor-boards** group and, with a black medium soft-edged brush, paint over the ends of the floor-board joins that need to be removed (**Figure 9.21**).

17. To keep all the parts of the retouching nicely organized so that we can find them quickly should we need to, let's now put all the layers that go into the background into a group. With the uppermost layer active, Shift-click the mystical_world layer so that all layers in the

Layers panel are highlighted (**Figure 9.22**). Go to Layer > New > Group from Layers, and name it **Room**.

18. In the film *The Lion, the Witch and the Wardrobe*, the wardrobe was much bigger. To increase the size of the wardrobe, go to Edit > Free Transform and in the options bar at the top of the screen (making sure the chain icon isn't active) change the Width (W) to 125% (**Figures 9.23** and **9.24**).

Figure 9.21

Figure 9.22

Figure 9.23

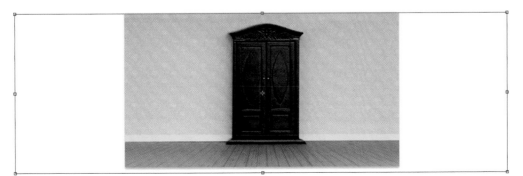

Figure 9.24

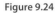

ADDING THE TOYS

We're now at the stage where we add the other elements, such as the toys and children. The techniques for selecting and cutting them from their original background are covered in Chapter 1.

1. Open the baby_doll file. Use the Pen tool to make a path around the doll (**Figure 9.25**), click the Load Path as a Selection icon in the Paths panel (**Figure 9.26**), and cut the doll from its original background by adding a layer mask.

2. To soften the outline of the cutout and help the doll blend in with the scene, press the Option/Alt key to reveal the layer mask, choose Filter > Blur > Gaussian Blur, and add a radius of 1 pixel of blur. To return to the picture of the baby doll, Option/Alt-click the layer mask.

3. Go to Layer > New > New Group from Layers, name the group **Baby Doll**, and click OK. Then do one of the following:

 With the Move tool (V), click the Baby Doll group and drag it on top of the Room tab. Wait for the Room file to become visible, then drag the Baby Doll group into the room.

 or

 Go to File > Save As, and save the baby doll as a Photoshop (.psd) file on your desktop. Go to the Room file, choose File > Place Embedded (File > Place in earlier versions of Photoshop), navigate to the baby doll file on the desktop, and click OK.

4. Go to Edit > Free Transform, and while holding down the Alt/Option and Shift keys, use the transform handles to resize the baby doll proportionally. Use the Move tool (V) to position it in the lower-left side of the scene (**Figure 9.27**). Press Return/Enter.

Figure 9.25

Figure 9.26

Figure 9.27

In total there are three toys to add to this picture: the baby doll, a teddy bear, and a rabbit. Using the steps above, open the Teddy Bear and Rabbit files, cut them from their original backgrounds using your preferred method (as covered in Chapter 1), place the cutout into a group, and add it into the room scene (Figures 9.28 and 9.29).

Figure 9.28 Layers panel with Room and Toys in individual groups

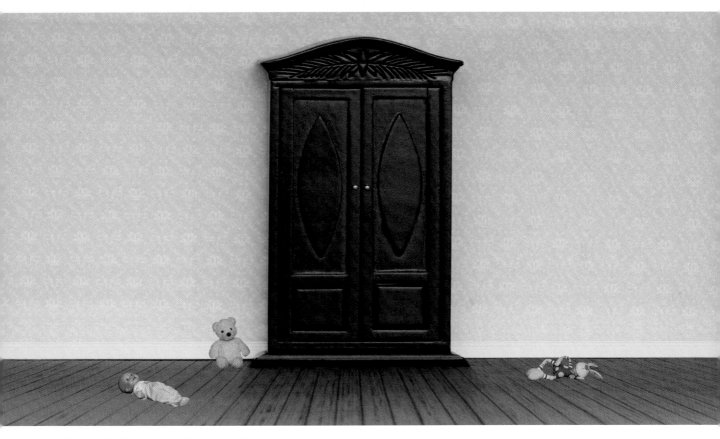

Figure 9.29 Room scene with toys added

ADDING THE SHADOWS

Now we'll add shadows to the room to give the feeling of nighttime.

First let's add the contact and shape shadows to each toy, using the technique we covered in Chapter 5.

1. Click the arrow next to the Rabbit group in the Layers panel, add a new blank layer below the rabbit layer, and name it **contact shadow**.

2. With a medium hard-edged brush at 100% opacity, paint the contact shadow along the length of the rabbit, where the toy is closest to the floor. Then add another blank layer, name it **shape shadow**, and with a soft-edged brush paint a shadow around the rabbit that would appear to have been cast by a light source coming from the left side of the picture (in this case, it would be moonlight) (**Figure 9.30**). Adjust the opacity of this shape shadow layer to control how dark it is. I found that 25% opacity worked well, but this can be changed later (**Figure 9.31**).

Continue by adding contact and shape shadows to the baby doll and teddy bear. Note that the shape shadow in **Figure 9.32** was added because the teddy bear is close to the wardrobe.

Now that we've added the contact and shape shadows for the toys, the floor looks too bright and lacking in contrast.

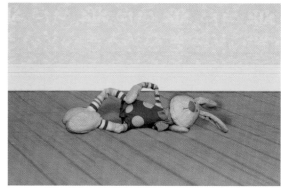

Figure 9.30

Figure 9.31

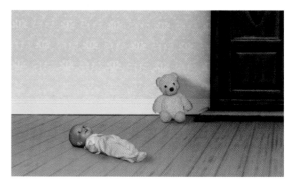

Figure 9.32

3. In the Layers panel, click the arrow to open the Room group so that we can see all the layers inside. Then click the uppermost layer in the group, hold down the Shift key, and click the floor layer (**Figure 9.33**). Then go to Layer > Smart Objects > Convert to Smart Object (**Figure 9.34**).

4. Go to Filter > Camera Raw Filter, change the Clarity to +65 and the Highlights to –40 (**Figure 9.35**), and click OK. This adds contrast to the floor and darkens it slightly.

Now we'll alter the overall lighting in the room and add shadows using the technique we covered in Chapter 3.

continues

Figure 9.33

Figure 9.34

Figure 9.35

5. Click the uppermost group in the layer stack (in my case it's the Rabbit group), and then add a Levels adjustment layer. Double-click the adjustment layer's name, and rename it **wardrobe shadow** (**Figure 9.36**). In the Levels adjustment properties, move the white output levels to 160 to darken the entire picture. To darken and add contrast in that area, move the Midtones slider to 0.60 (**Figure 9.37**).

6. Click the layer mask in the Levels adjustment layer, and go to Image > Adjustments > Invert to hide the darkening effect.

7. Go to View > New Guide, and with the Vertical checkbox selected enter **50%** in the Position field (**Figure 9.38**). Click OK. With the Move tool, drag the guide to the right side of the wardrobe—to a position about as far out as you want the shadow to appear (**Figure 9.39**).

8. With a hard-edged white brush, paint the right side of the wardrobe (to reveal the darkening effect from the Levels adjustment layer) in the shape of a shadow coming from a window on the left. (You can use the guide to create a straight line from top to bottom by clicking at the top, holding down the Shift key, and then clicking at the bottom near the skirting board.) When you've finished with the guide, go to View > Clear Guides.

 TIP *If the outline of the shadow appears too sharp, click the Mask icon in the Levels adjustment layer properties and move the Feather slider to the right.*

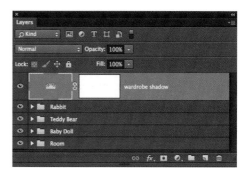

Figure 9.36

Figure 9.37

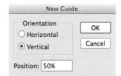

Figure 9.38

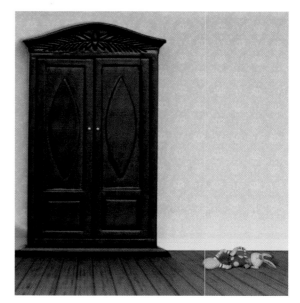

Figure 9.39

To see how this shadow would look in real life, when I was making the miniature room I cut out a window-shaped piece of the cardboard box and shined a flashlight through it. I took a picture of it and referred to it when doing the retouching. The importance of taking and using reference pictures is something I can't stress enough—seeing how things should be will save you hours of retouching time and frustration!

9. Darken the room by adding another Levels adjustment layer, naming it **darken room**, and moving the white Output Levels setting to 150 (**Figure 9.40**). With a large (around 1500px) soft-edged black brush, paint to remove the darkening effect on the left side of the picture (**Figure 9.41**).

We'll now create a shadow on the wall to the left side of the wardrobe, which will fake the look of light coming through the window panels.

continues

Figure 9.40

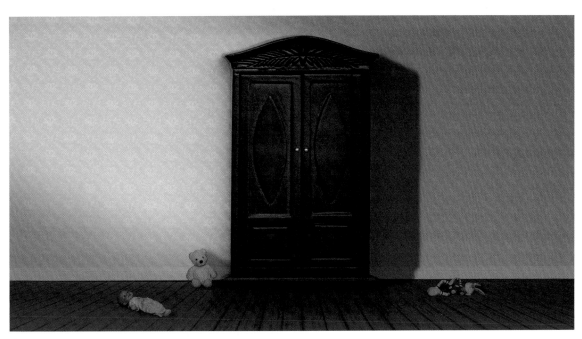

Figure 9.41

10. Add a new blank layer to the top of the layer stack, and name it **window**. Press D to set the foreground and background colors to their default of black and white (black being the foreground color), and choose the Custom Shape tool from the toolbar (**Figure** 9.42).

11. In the options at the top of the screen, choose Pixels from the menu on the far left. In the Custom Shape menu, choose the 3x3 grid (**Figure** 9.43).

12. Drag the grid onto the left side of the picture, and then go to Edit > Transform > Perspective. Click the lower-left transform handle, drag upward (**Figure** 9.44), and press Return/Enter.

Figure 9.42

Figure 9.43

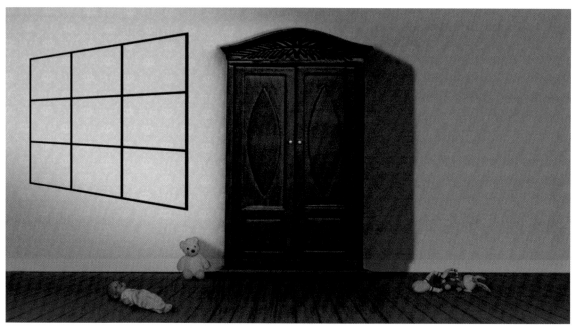

Figure 9.44

13. Click the **window** layer in the layer stack, go to Filter > Convert for Smart Filters. Then go to Filter > Blur > Gaussian Blur, add a Radius of 75 pixels, and click OK.

Before we add the children to the scene, let's darken the toys because at the moment they look too bright to fit into this darkened scene.

14. Open the Rabbit group, and click the thumbnail of the rabbit in the layer stack. Then add a Levels adjustment layer, click the Clipping Mask icon so that only the rabbit layer is affected, and drag the white Output Levels slider to 140 (**Figures 9.45** and **9.46**).

15. Repeat this process to darken the baby doll and the teddy bear. Because the top of the teddy bear is in the bright part of the scene, add a layer mask and with a black medium soft-edged brush, paint away the darkening effect from the top half of the teddy bear (**Figure 9.47**).

Figure 9.45

Figure 9.46 Toy rabbit darkened

Figure 9.47 The teddy bear is darkened, but the top portion of the head is left at the original brightness.

ADDING THE CHILDREN

With the miniature room prepared and the toys added, we can now bring the children into the scene.

1. Open the children file, make a selection, and cut them from their original background using a layer mask. Add them into the room scene using the same technique as you used for the toys. Resize them using Edit > Free Transform, and move them to the front of the wardrobe using the Move tool (**Figure 9.48**).

2. Darken the children so they fit in with the lighting of the room: add a Levels adjustment layer, click the clipping mask icon (so that the adjustment affects only the children), and then move the white Output Levels slider to 200 (**Figure 9.49**). Rename this adjustment layer **darken children**.

Figure 9.48

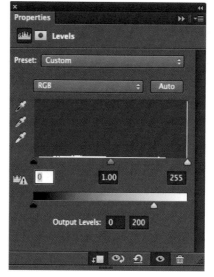

Figure 9.49

3. Add a new blank layer below the children layer, name it **contact shadow**, and paint in the shadow where the children's feet meet the floor. Add another new layer, name it **shape shadow**, and then paint in a shadow coming from both children to the bottom of the picture (**Figures 9.50** and **9.51**). (I lowered the opacity of the shape shadow layer to 20%.)

Now we'll add rim lighting to the children. This will later look as though it was caused by light coming from inside the wardrobe.

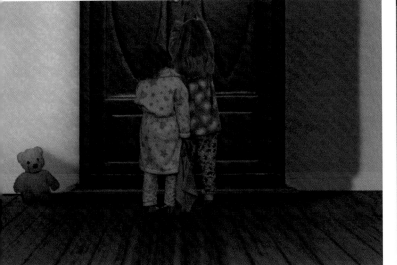

Figure 9.50

Figure 9.51 The contact shadow and shape shadow layers shown below the children layer in the layer stack

4. Click the children layer, click the fx icon at the bottom of the Layers panel, and choose Inner Glow (**Figure 9.52**). In the Structure section, change the blend mode to Color Dodge. In the Elements section, increase Choke to 10% and Size to 60px (**Figure 9.53**).

5. Click the color swatch in the Structure section, and in the Color Picker set R to 130, G to 105, and B to 3 (**Figure 9.54**). Click OK to close the Color Picker, and click OK again to close the Layer Style properties.

6. We need the Inner Glow layer style to show only in certain areas. Go to Layer > Layer Style > Create Layer, and then drag this new layer to the top of the layer stack (if you don't it will appear darker because it would be below the Levels adjustment layer that we used to darken the children).

Figure 9.52

Figure 9.53

Figure 9.54

7. Add a black layer mask by Option/Alt-clicking the layer mask icon at the bottom of the Layers panel. Then with a white soft-edged brush, paint to reveal the Inner Glow effect in areas where you think it would be—assuming that the glow had been cast by light coming through the gap in the wardrobe door (**Figures 9.55** and **9.56**).

8. To organize the Layers panel, place all the layers that correspond to the children into a group and name it **children**, then place all the layers corresponding to the window into a group and name it **window**.

A picture like this can have many layers, and keeping them organized in groups (**Figure 9.57**) makes it much easier to find them should we need to make changes.

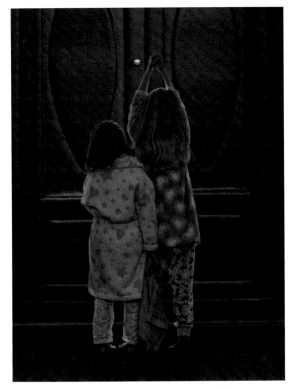

Figure 9.55 The Inner Glow effect around the children

Figure 9.56 The Inner Glow layer style as a layer in the layer stack

Figure 9.57 Keeping layers organized in groups helps us find them much more quickly.

TURNING DAY INTO NIGHT

We'll use the same technique as we did in Chapter 4 to change the scene from day to night nondestructively.

1. Open the children group, and Command/Ctrl-click the layer mask attached to the children layer (**Figures 9.58** and **9.59**). Go to Select > Save Selection, name the selection **children cut out**, and click OK. Go to Select > Deselect to remove the selection outline.

NOTE *Saving the selection of the children means we will easily be able to remove any of the lighting effects (which we'll be adding later) that spill over onto them.*

Figure 9.58

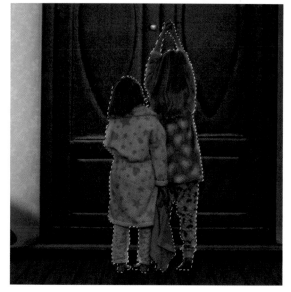

Figure 9.59

2. Click the children group, and Shift-click the Room group at the bottom of the layer stack. Then go to Layer > Smart Objects > Convert to Smart Object, double-click the layer name in the Layers panel, and name the layer **night** (**Figure 9.60**).

This places all the groups of layers we've created so far into one Smart Object. This means we will always have access to the layers within it, but we can also continue retouching and using a filter without making a merged layer.

NOTE *If you're using a version of Photoshop earlier than Photoshop CC, you'll need to create a merged layer at the top of the layer stack by clicking the uppermost group (children), choosing Select > All, choosing Edit > Copy Merged, and then choosing Edit > Paste. Name this layer night, and then go to Layer > Smart Objects > Convert to Smart Object.*

3. We'll use the Camera Raw filter for the night effect, so choose Filter > Camera Raw Filter. In the Basics tab, move the Temperature slider to –45, set Exposure to –1.40, and set Clarity to +50 (**Figure 9.61**). Click OK to go back into Photoshop.

Figure 9.60

Figure 9.61

THE WARDROBE LIGHT

The light coming from the wardrobe is applied using the same technique we used to add the reflected light on the superhero in Chapter 3.

1. Add a new blank layer to the top of the layer stack, and name it **glow middle**. Then click the foreground color in the toolbar, set R to 101, G to 74 and B to 0, and click OK. With a soft-edged brush, paint a line down the join between the two doors (**Figure 9.62**).

2. Change the blend mode of the glow middle layer to Color Dodge, and create multiple copies by pressing Command/Ctrl+J six times, which brightens the light considerably. Click the uppermost layer, Shift-click the first glow middle layer, and go to Layer > New > Group from Layers. Rename this group **glow middle**.

3. Add a glow light to the bottom of the wardrobe doors: create a new blank layer, name it **glow bottom**, and paint a line across the join at the bottom (**Figure 9.63**).

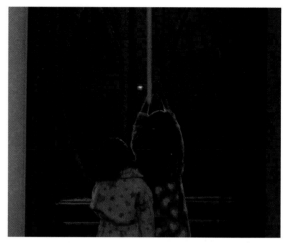

Figure 9.62

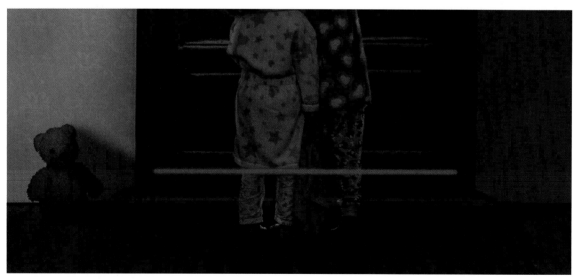

Figure 9.63

4. Change the blend mode of the glow bottom layer to Color Dodge, and create multiple copies to brighten the light by pressing Command/Ctrl+J six times. Click the uppermost layer, Shift-click the first glow bottom layer, go to Layer > New > Group from Layers, and name it **glow bottom**.

 NOTE *Creating six copies isn't the magic number of times to brighten the light; it's just what's needed to brighten it in this particular picture. You may find that you need to create more or fewer copies to achieve the desired effect.*

5. Next we'll add reflected light onto the wardrobe and the floor. Add a new blank layer, and name it **reflected light - wardrobe**. Change the blend mode of this layer to Color Dodge, and with the same foreground color as before (R: 101, G: 74, B: 0), paint a few dabs of light onto the wardrobe with a soft-edged brush (**Figure 9.64**).

6. Duplicate this layer and brighten the reflected light by pressing Command/Ctrl+J. Put both of these layers into their own group and name it **reflected light – wardrobe** (**Figure 9.65**).

7. The last bit of light we'll paint is where it's spilling onto the floor. Add another blank layer, name it **light spill**, and change the blend mode to Color Dodge.

continues

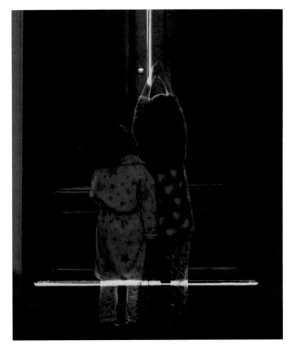

Figure 9.64

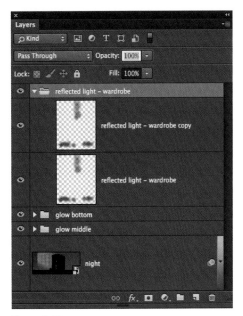

Figure 9.65

8. With a soft-edged brush (using the same foreground color as before), paint along the floor in front of the wardrobe and behind the children. Duplicate this layer by pressing Command/Ctrl+J three times (**Figure** 9.66).

9. Put all the light spill layers into their own group, and name the group **light spill**. Then click the light spill group to make it active, Shift-click the glow middle group layer (**Figure** 9.67), go to Layer > New > Group from Layers (**Figure** 9.68), name it **light**, and click OK.

Now you'll see why we saved the selection of the children earlier—we can use it to remove the light from them very quickly.

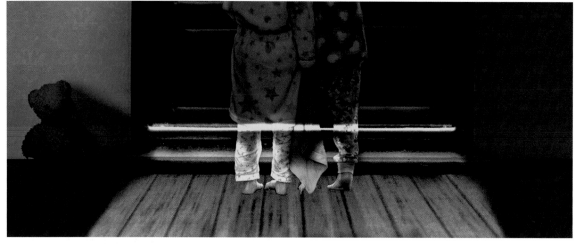

Figure 9.66

Figure 9.67 The groups used to make the wardrobe light

Figure 9.68

10. Go to Select > Load Selection, choose children cut out from the Channel menu (**Figure 9.69**), and click OK.

11. With the selection around the children now visible, Option/Alt-click the layer mask icon at the bottom of the Layers panel. This adds a layer mask and also fills the selection area of the children with black; the result is that the light effect is no longer visible on the children (**Figure 9.70**).

12. Press D to reset the foreground and background colors in the toolbar to their default, and then press X so that black becomes the foreground color. Making sure the mask is still selected in the Layers panel, use a black soft-edged brush to paint over areas of the floor to remove any extra light. This ensures that the light spill looks realistic and brings back the shape shadow at the back of the children (**Figure 9.71**).

The rim light we added around the children earlier has lost its impact because we changed the scene from day to night, so we'll improve this.

continues

Figure 9.69

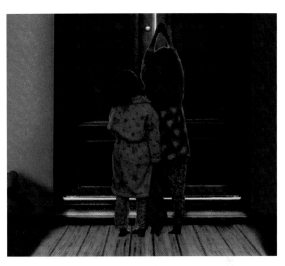

Figure 9.70

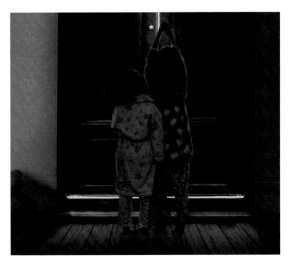

Figure 9.71

13. Now with the Brush Tool and using the same foreground color as before, add a blank layer to the top of the layer stack, and name it **rim light**. Change the blend mode of this layer to Color Dodge and paint around the children in the areas where the rim light was originally added, and then duplicate this layer to brighten it (**Figure 9.72**).

> **NOTE** *Don't worry about painting too far onto the wardrobe, as we can use the saved selection of the children to remove that very easily.*

14. With the uppermost layer selected, Shift-click the layer directly below it so that both rim light layers are highlighted. Place them into a group by going to Layer > New > Group from Layers. Name this group **rim light**. Then go to Select > Load Selection, choose children cut out from the Channel menu, and click OK.

15. With the children selection active, click the layer mask icon at the bottom of the Layers panel. This adds a black layer mask but fills the selection of the children in white. The result is that the rim light we just painted is visible only within the children (**Figure 9.73**).

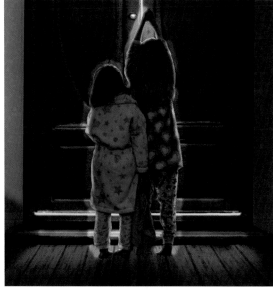

Figure 9.72

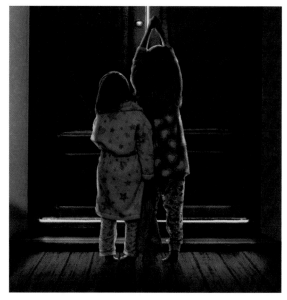

Figure 9.73

FINISHING TOUCHES

At this stage the picture is complete, apart from a few finishing touches. Ordinarily I would now save the image and come back to it later.

By doing this, the next time I look at the picture will be with fresh eyes and I'll be able to see right away if anything needs altering or adding to. If all looks good, then I'll add the finishing touches.

When I originally made this picture, I experimented with plug-ins to see if I could add to the final look.

1. To add a merged layer, go to Select > All, then to Edit > Copy Merged, and then to Edit > Paste (or press Shift+Option/Alt+ Command/Ctrl+E). (This adds to the top of the layer stack a single layer that is a combination of everything below it.) Name the layer **FT** (for "finishing touches").

2. One of the plug-ins I turned to was Color Efex Pro 4, from the Nik Collection by Google. The Detail Extractor preset did a great job of enhancing overall detail in the picture, especially in the children's hair and clothing, and the patterned wallpaper. Each time I used a plug-in, I merged that layer down so I was still left with the FT layer at the top of the layer stack. Do this by using the Merge Down command in the Layers panel menu (located in the upper-right corner) (**Figure 9.74**).

 I then added the painterly look I covered in Chapter 4.

3. Create two copies of the FT layer by pressing Command/Ctrl+J twice. Rename the top layer **sharpness**, and the layer below it **look**.

4. Turn off the sharpness layer by clicking the eye icon to the left of the layer thumbnail. Click the look layer, and go to Filter > Noise > Reduce Noise. Set Strength to 10 and all other sliders to 0. Click OK.

5. Turn on the sharpness layer by clicking the box to the left of the layer thumbnail, turning on the eye icon. Then go to Filter > Other High Pass, add a 1px Radius, and click OK. Change the blend mode of the sharpness layer to Overlay. This step brings back some sharpness.

6. Add one final merged layer to the top of the layer stack by going to Select > All, then to Edit > Copy Merged, and then to Edit > Paste. Add punch to the final image without adding unwanted halos, or affecting the colors, by choosing Filter > Sharpen > Unsharp Mask. Set the Amount to 25%, the Radius to 25 pixels, and the Threshold to 0. Click OK.

The picture is now complete.

Figure 9.74

Before

After

RETOUCHING A LANDSCAPE

There was a time not that long ago when I used Camera Raw purely as a necessary part of the process of opening raw files before I took them into Photoshop for the serious stuff. That's pretty much how I worked with Lightroom too, other than using it as an expensive image catalog.

However, I'm now able to do retouching and corrections in Camera Raw that before would have been challenging, to say the least. This is because of the continual updates and enhancements that Adobe releases via Creative Cloud. I'm adapting the same techniques that I used only in Photoshop and discovering ways I can re-create the same effect using Camera Raw or Lightroom.

A perfect example is the landscape shot at the start of this chapter, which I took while away for a short break on the coast in Devon, England, at a friend's cottage. I don't typically photograph landscapes, but the cottage is near a lake on the grounds of the farm, a beautiful location that I just had to get a picture of—even if it did mean setting the alarm for 4 a.m. to catch the sunrise.

USING CAMERA RAW

Let's take a look at what we can do in Camera Raw to retouch this image.

You'll notice that the raw (out-of-camera) file is underexposed (**Figure 10.1**). This is something I do when photographing landscapes because I prefer to use the available dynamic range rather than shooting for HDR or using a neutral density filter. I generally underexpose landscape images by two to three stops.

1. Open the spillers_before.dng raw file from within Photoshop.

2. First we'll make use of the dynamic range and bring out detail from the darker areas of the picture.

3. In Camera Raw, under the Basic tab, move the Shadows slider all the way to the right (+100). And because we want more detail visible, also move the Blacks slider all the way to the right (+100) (**Figure 10.2**).

4. After moving the Shadows and Black sliders, we need to adjust the Highlights slider, as the highlights can sometimes appear a little on the bright side. Set it to –100 and by doing so you'll see that most of the adjustment occurs within the sky, which is great because it adds even more detail and interest to those clouds (**Figure 10.3**).

Figure 10.1 Our raw image

Figure 10.2

Figure 10.3

5. Next we'll enhance the colors to what they looked like to me when I was taking the original photograph early in the morning. Use the Vibrance slider because it's a more subtle tool than the Saturation slider and enhances only those colors that are lagging behind (the Saturation slider would increase all the colors in the picture). Move the Vibrance slider to +100 (**Figure 10.4**). The difference is significant and in keeping with what the scene looked like when I took the photograph (**Figure 10.5**).

continues

Figure 10.4

Figure 10.5 The result of increasing the colors using the Vibrance slider

6. Choose the Graduated Filter (**Figure 10.6**), and drag the control point from about a third of the way into the sky to just below the line of the distant hills. Reset all the adjustment sliders by double-clicking on each of the pointers and then move Temperature to +10 to warm the sky up a little, and then move Tint to +5 to add more magenta (**Figure 10.7**).

Figure 10.6

> **TIP** *When dragging straight lines with the Graduated Filter, you can hold down the Shift key while dragging for much more control.*

7. Still making adjustments to the Graduated Filter, move the Clarity slider to +100 and then the Contrast slider to +25; this adds impact to the clouds and makes them a little more dramatic (**Figure 10.9**).

Figure 10.7

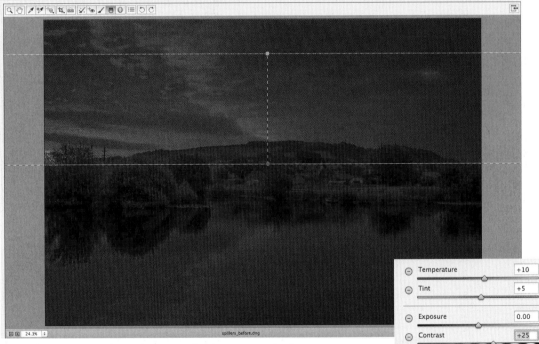

Figure 10.8 Using the Graduated Filter to make adjustments to the sky

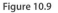

Figure 10.9

8. To add more impact to the lake, first select the Adjustment Brush (**Figure 10.10**). Make sure that the Mask option is selected and that Feather is set to around 50. Place the brush over the lake. If the red mask appears on too much of the bushes and riverbanks, simply click Erase and paint it away. Now that the lake has been selected, deselect the Mask option so you can see the effect of the adjustments you'll make. Move Clarity to +70 and Contrast to +20 (**Figure 10.11**).

Figure 10.10

Figure 10.11

continues

Figure 10.12 The red overlay indicates the area that will be affected by the adjustments.

9. Let's now enhance the color in the lake, which is reflecting the sky above, by adding some blue. Move the Temperature slider to –10, and then add more magenta by moving Tint to +8 (**Figure 10.13**).

Figure 10.13

Figure 10.14

10. I now want to draw more attention across the middle area of the picture, which is where the farmhouse, buildings, boat, field, and bushes are. We'll do this using the Adjustment Brush. Click the New option, on the right side of the screen, and reset all the adjustment sliders by double-clicking each of them in the panel. Select the Mask option, and also make sure that Auto Mask is selected (**Figure 10.14**), and then with the Adjustment Brush paint over the middle area of the picture, taking care not to go too much into the lake and the sky. The Auto Mask option does a great job keeping the mask within the trees and hills.

11. Deselect the Mask option so you can see the area you're adjusting, and move Shadows to +100 and Exposure to +0.50. Add a little magenta from the sky by moving Tint to +5 (**Figure 10.15**).

Figure 10.15

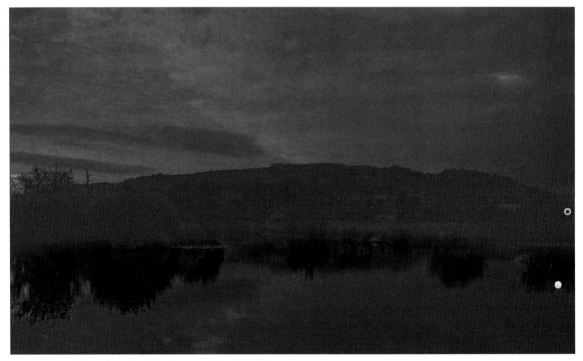

Figure 10.16 Red overlay indicating the area to be adjusted

12. Next we're going to sharpen the image. First, exit the Adjustment Brush by clicking on its icon and then click the Detail tab. Move the Amount slider to +80. I tend to sharpen landscape images more because of all the detail, but I don't want to sharpen the sky in this image too much because it will make any noise there much more obvious. So hold down the Option/Alt key and move the Masking slider to 75 (**Figure 10.17**).

Holding down Option/Alt while moving the Masking slider will temporarily show your image in black and white. The white areas are where sharpening is being applied; the black areas are where no sharpening is being applied. The more you increase the Masking slider, the more black you introduce. +75 is just enough to take the sharpening away from the sky and apply it only where we want it (**Figure 10.18**).

13. Ordinarily when we retouch images that are underexposed, the areas that were originally dark will contain quite a bit of noise. This is when you'd use the Noise Reduction panel, also found in the Detail tab, but since this image contains negligible noise we don't need to do much here. For now, move the Luminance slider to +15 and leave the remaining sliders at their defaults (**Figure 10.19**).

continues

Figure 10.17

Figure 10.18

Figure 10.19

14. Next we'll check the image for any dust or marks that may have been on the camera lens or sensor when the photograph was taken. Click the Spot Removal tool (**Figure 10.20**), and set the Type menu to Heal (**Figure 10.21**). With Feather at about 50%, simply paint over any obvious dust or marks you see. It helps to make the head of the Spot Removal tool barely bigger than the mark.

Figure 10.20

Figure 10.21

Figure 10.22 Using small brush strokes to remove or heal areas

15. The last thing we'll do in Camera Raw is add a subtle vignette so as to guide the viewer's eye into the middle of the picture. Click the Radial Filter panel (**Figure 10.23**), make sure all the adjustment sliders are at their defaults, and make sure Effect (at the bottom of the Radial Filter properties) is set to Outside. Drag from the center of the picture to a corner of the image or until the desired vinette shape is achieved, and then move the Exposure slider to –0.50 (**Figure 10.24**).

continues

Figure 10.23

Figure 10.24

Figure 10.25 The Radial Filter boundary is positioned to adjust only the outer areas.

16. I guess you could now call it a day and say the retouching on this image is finished, but I'd like to remove the electric wires running across the width of the picture. We could make use of the Spot Removal tool here, but my choice would be to send the image to Photoshop. As we're always looking to work nondestructively and smart, we'll open the image in Photoshop as a Smart Object. Hold down the Shift key and click Open Object (**Figure 10.26**).

> **NOTE** *Whenever I work on a raw image file in Camera Raw or Lightroom and need to take it into Photoshop, 99.9% of the time I'll open it as a Smart Object. That way, the adjustments I've made will always be available to me so that I can alter them if need be. If I take the image files into Photoshop without doing so, then what I've done to that point is set in stone, so if I want to change anything I'll have to start from scratch.*

17. We're going to use a combination of the Spot Healing Brush and the Clone Stamp tool, so start off by adding a new blank layer to the top of the layer stack and renaming it **wires**. Then choose the Spot Healing Brush tool (**Figure 10.27**), and in the options at the top of the screen, make sure that Content Aware is active and that Sample All Layers is selected. Starting from the right side of the picture and with a small brush head (**Figure 10.28**), paint over the overhead wires. (I find that shorter rather than longer brush strokes work best.) Don't go over the wires that are too close to anything else, like a bush or a hill, as you'll find you may get a smudge effect; we'll sort out those areas using the Clone Stamp tool.

Figure 10.26

Figure 10.27

Figure 10.28 Painting over the overhead wires

18. Once you've done as much as you can with the Spot Healing Brush, choose the Clone Stamp tool. In the options at the top of the screen, select Aligned and choose Current & Below in the Sample drop-down menu (**Figure 10.29**). Then Option-click/Alt-click to sample areas on either side of the remaining wire and remove it (**Figure 10.30**). Then use the Clone Stamp tool to remove the telegraph pole on the left side of the picture.

19. All that remains now is to crop the image, so from within Photoshop choose the Crop tool. Make sure that Delete Cropped Pixels is unselected (**Figure 10.31**) so that you're working nondestructively, and drag the crop boundary where you'd like it to be (**Figure 10.32**).

Figure 10.29 The Clone Stamp tool and its settings

Figure 10.30 Using the Clone Stamp tool near adjoining areas

Figure 10.31 To crop nondestructively, deselect the Delete Cropped Pixels check box.

Figure 10.32 Cropping the image by moving the crop boundary

Before

After

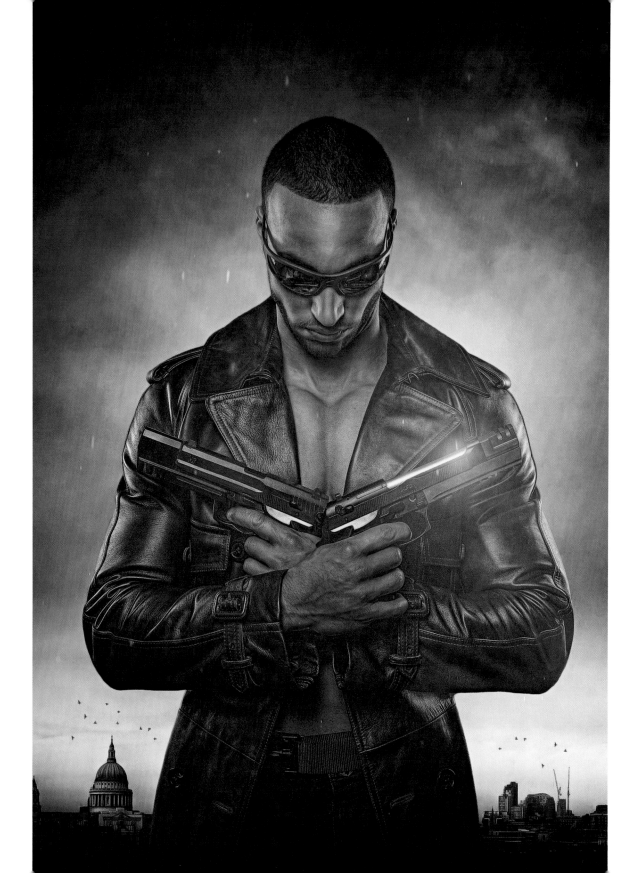

ASSASSIN

In this final chapter I take you through all the retouching from start to finish for a picture I call "Assassin."

This is a themed composite image that was originally shot against a gray seamless background, with the intention that in the retouching I would use textures to create a wall behind the model.

The out-of-camera file with the best pose from the shoot was underexposed, but thanks to Camera Raw and all the information held in the file, a lot more detail was recovered. This meant that what was originally a throwaway image became a keeper with a new background composited behind.

In this tutorial I'll cover techniques shown throughout the book but also show you some new ones, such as a moveable vignette, and an alternative way to create lens flares and reflections.

LIGHTING SETUP

Here's a quick look at the studio lighting setup used for this picture.

Because the model was going to have a background added behind him with a light source on it, I used a three-light setup consisting of two gridded strip boxes on either side of the model. This was to mimic the highlights that would be caused by a light coming from behind the model. To the front was a medium octabox, also with a grid (**Figure 11.1**). Grids gave more control over the direction of the light and reduced spill. I shot at f/11 so that the model was in focus from front to back.

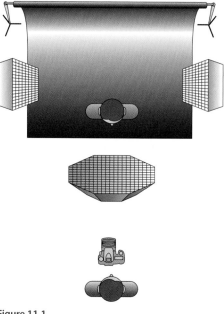

Figure 11.1

CAMERA RAW

As always we'll start the retouch in Camera Raw and then send the file into Photoshop as a Smart Object, so that we maintain a nondestructive workflow.

1. Go to File > Open and navigate to the assassin.dng raw file. Click OK to open the file in Camera Raw.

2. To enhance the detail in the raw file, in the Basic section tab, set Exposure to +1.60, Highlights to –100, Shadows to +50, and Blacks to +10 (**Figure 11.2**).

Figure 11.2

3. Because the image has an orange color cast, correct the white balance by choosing the White Balance tool (**Figure 11.3**) and clicking the background area to the side of the model's head (**Figure 11.4**).

4. The model's hands look too dark in comparison to the rest of his skin, so choose the Adjustment Brush (**Figure 11.5**), and reset all the sliders to their defaults by double-clicking their slider markers. Select the Mask checkbox, and paint over the model's hands so that they are covered in the red overlay (**Figure 11.6**).

continues

Figure 11.3

Figure 11.4 Click with the White Balance tool on the background.

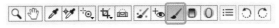

Figure 11.5

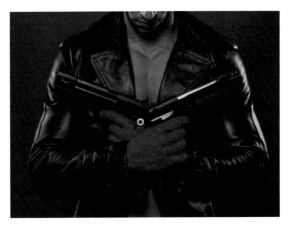

Figure 11.6 Red mask overlay indicating that only the model's hands will be affected by the adjustments

5. Deselect the Mask checkbox (**Figure 11.7**) to hide the red overlay, then adjust the hands by setting Temperature to +5, Tint to −20, and Exposure to +0.50 (**Figure 11.8**). Exit the Adjustment Brush by clicking the Hand tool (H) in the toolbar.

6. In the HSL/Grayscale section under the Saturation tab, with all the adjustment sliders at 0, set Oranges to −20 (**Figure 11.9**) to reduce the orange cast on the model's skin.

7. In the Detail section tab, increase Sharpening Amount to 85 and Masking to 62 (**Figure 11.10**). As the final picture is going to have a hard/gritty feel to it, we can afford to add a high amount of sharpening.

Figure 11.7

Figure 11.8

Figure 11.9

Figure 11.10

8. On the model's pants the button is visible underneath his belt. Zoom in with the Zoom tool (Z). Choose the Spot Removal tool (**Figure 11.11**), and with Type set to Clone and the Show Overlay checkbox selected (**Figure 11.12**), brush over the button to hide it (**Figure 11.13**).

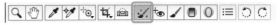

Figure 11.11

> **TIP** *When you use the Spot Removal in Camera Raw with Type set to Clone or Heal, a red pin indicates the area you brush over and a green pin indicates the source chosen by Camera Raw to cover it with. If necessary, drag the green pin for a better result.*

Figure 11.12

Figure 11.13

COMPOSITION

We've retouched the file in Camera Raw and now we'll move it to Photoshop to create the composite image.

1. Now that we are finished in Camera Raw, Shift-click Open Object in the lower-right corner to open the image in Photoshop as a Smart Object.

 To improve the composition and overall balance of the image, we'll move the model into the center of the frame and widen his stance.

2. Go to Edit > Free Transform. In the options at the top of the screen, ensure that the chain icon isn't depressed, and then increase the width (W) to 103% (**Figure 11.14**). Then press the left arrow key on your keyboard eight times so that the model is shifted to the left and is now central in the frame. Press Return/Enter.

Figure 11.14

SELECTING THE MODEL

I photographed the model against gray seamless paper with the intention of using the blend mode compositing technique to add a new background. But we'll be adding a scene as opposed to a solid background, so we cannot use that technique and will need to make a selection.

For an image like this, with dark clothing against a fairly dark background, my choice is to use the Pen tool on the body and then Refine Edge on the hair.

1. With the Pen tool (P), and the options at the top of the screen set to Path, draw out a path around the model's body but leave out the top of his head and hair (**Figure 11.15**).

2. In the Paths panel, click the Load Path as a Selection icon (**Figure 11.16**). Now that we have a visible selection indicated by the marching ants (**Figure 11.17**), click the Layers panel and choose Select > Save Selection.

Figure 11.16

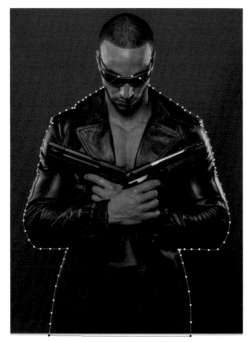

Figure 11.15 Draw out a path around the model, but leave out the top of the head.

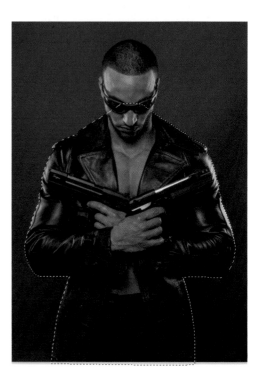

Figure 11.17

3. In the Save Selection properties, name the selection **body** and click OK, leaving all other settings as they are (**Figure 11.18**). Then go to Select > Deselect.

4. Choose the Quick Selection tool (W) and drag inside the image area on top of the model to select the head. Check the selection by entering Quick Mask mode by pressing Q, or clicking the Quick Mask icon in the toolbar. To finesse the mask, paint with a brush in black or white to add to or remove from the selection.

 The head should now be covered in a red overlay, indicating that it is selected (**Figure 11.19**).

5. Exit Quick Mask by pressing Q, and then choose the Quick Selection tool (W). From the options bar at the top of the screen, choose Refine Edge. Select the Smart Radius checkbox, and increase Radius to 2.5px (**Figure 11.20**). Set Output To to Selection, and click OK.

 continues

Figure 11.18

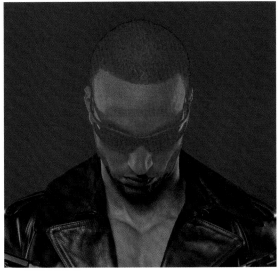

Figure 11.19

Figure 11.20

6. Go to Select > Save Selection. Name the selection **head**, leave all settings at their default (**Figure 11.21**), and click OK. Then go to Select > Deselect.

7. Click the Channels tab, and then click once on the thumbnail of the body channel (**Figure 11.22**).

8. Command/Ctrl-click once on the thumbnail of the head channel to load it as a selection (**Figure 11.23**). Fill this area with white by going to Edit > Fill > Contents > White, and click OK. Then go Select > Deselect to cancel the active selection.

9. Click the head channel in the Channels panel, and drag it into the trash as we no longer need it. Double-click the word body in the body channel, and rename it **cutout**. Click the thumbnail of the RGB to return to the full-color view of the model (**Figure 11.24**).

Ordinarily at this stage I would enhance the image details by converting it to a Smart Object, and then using a third-party plug in such as Detail Enhancer in Nik Color Efex Pro 4, as covered in Chapter 4. But for this image I will enhance details using the Photoshop technique, and because this is a destructive process I will wait until later in the retouch.

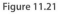
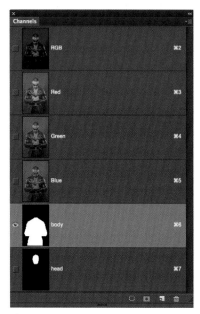

Figure 11.21

Figure 11.23

Figure 11.22

Figure 11.24

DODGING AND BURNING

Using the dodging and burning technique covered in Chapter 2, we'll now add depth and dimension to the model.

1. Click the Layers panel tab, and then add a new 50% gray layer by going to Layer > New > Layer. Name this layer **dodge and burn**, change Mode to Soft Light, and select the Fill with Soft-Light-neutral color (50% Gray) checkbox (**Figure 11.25**). Click OK.

2. Choose the Dodge tool from the toolbar, and in the options at the top of the screen set Range to Midtones and Exposure to 10%. Select the Protect Tones checkbox (**Figure 11.26**).

 The material of the model's coat means it needs little dodging and burning to add to the depth and dimension, so the main areas to work on are the chest, hands, and head.

3. The highlights on the left arm are not quite as bright as the right arm. So with the Dodge tool, brush several times over the highlight area running down the left arm to brighten it up (**Figure 11.27**).

 continues

Figure 11.25

Figure 11.26

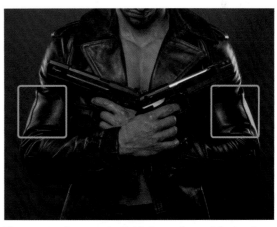

Figure 11.27 Even out the highlights on the model using the Dodge tool.

4. Option/Alt-click on or underneath the eye icon for the dodge and burn layer in the Layers panel to show just the 50% gray layer (**Figure 11.28**). Then with the Lasso tool, select any areas that have very defined dodging and burning (**Figure 11.29**).

5. Go to Filter > Blur > Gaussian Blur, and add 6 pixels of blur (**Figure 11.30**) so that the highlight and shadow areas blend together. Click OK. Go to Select > Delselect, then Option/Alt-click to turn on the eye icon for the dodge and burn layer, and return to the picture of the model.

Figure 11.28

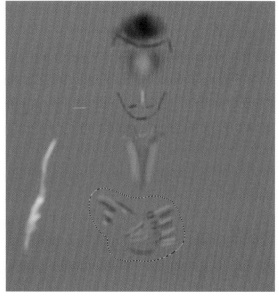

Figure 11.29

Figure 11.30

RETOUCHING THE JACKET

Ideally our model would have been wearing a black jacket rather than brown. But it's quick and easy to change the jacket to black using a simple black and white gradient map.

1. Press D to set the foreground and background colors to their default of black and white, and then click the Gradient Map Adjustment layer icon (**Figure 11.31**).

 This immediately gives a great black and white conversion, but there are certain areas that need to be addressed. The highlights on the right side have lost detail, and the shadow areas have become too dark.

2. Click the gradient bar (**Figure 11.32**) in the Gradient Map properties to open the Gradient Editor, and then click the white point marker (**Figure 11.33**). This enables us to set the color that we want white to be represented by in the gradient; since pure white is too bright, we can set it to gray.

 continues

Figure 11.31

Figure 11.32

Figure 11.33

3. Click the white color swatch (**Figure 11.34**) to open the Color Picker, change Brightness to 85 (**Figure 11.35**), and click OK.

4. Brighten the shadow areas by dragging the midtone point (**Figure 11.36**) to the left. I found that dragging to 40% brightened the shadow areas sufficiently.

5. Click OK to close the Gradient Editor, then click the layer mask attached to the Gradient Map adjustment layer (**Figure 11.37**). Go to Image > Adjustments > Invert to change the layer mask to black, and conceal the black and white conversion.

Figure 11.34

Figure 11.35

Figure 11.36

Figure 11.37

6. With white as your foreground color, choose a medium soft-edged brush. With the Gradient Map adjustment layer active, paint on top of the image area to reveal the black and white conversion all over the model's jacket (**Figure 11.38**).

 NOTE *There is no need to be too accurate when painting in the black and white conversion on the model's jacket, because we will perfect it using a selection in the following steps.*

7. Quickly remove any areas where you've revealed the black and white conversion outside of the model by going to Select > Load Selection > Channel, choosing cutout, and clicking OK. This loads the selection of the model we made earlier. Now go to Select > Inverse, and then to Edit > Fill > Contents and Black. Click OK. Go to Select > Deselect to remove the selection.

8. To remove any areas where the black and white conversion has gone onto the model's chest, choose the Quick Selection tool and, in the options at the top of the screen, select the Sample All Layers checkbox (**Figure 11.39**). Then drag to make a selection of the model's chest (**Figure 11.40**).

9. If needed, hold down the Shift key and drag to include the visible part of the model's stomach and hands in the selection. Go to Edit > Fill > Contents and Black, and click OK. Go to Select > Deselect to remove the selection.

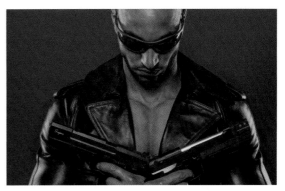

Figure 11.38

Figure 11.39

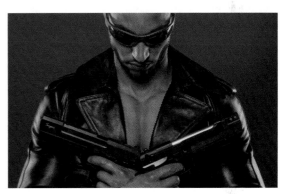

Figure 11.40

ADDING THE BACKGROUND

Now we'll prepare the background and add it into place. We'll be using the london.jpg file, and although it's not a raw file we'll retouch it in Camera Raw.

1. Go to File > Open, navigate to the london.jpg file, and in the Format menu choose Camera Raw (**Figure 11.41**).

2. In the Basic tab, set Shadows to +100, Clarity to +75, and Saturation to –100 (**Figure 11.42**).

3. Straighten the image by double-clicking the Straighten tool (**Figure 11.43**). Press Return/Enter, and click Open Image.

4. Go to Select > All, and then to Edit > Copy. Click back on the model picture, and go to Edit > Paste to add the London picture. Rename this layer **London**.

5. The London layer should be at the top of the layer stack. Lower its opacity to 50% so that you can see the model through it (**Figure 11.44**), then go to Edit > Free Transform and resize the London layer so that it fills the image area, and press Return/Enter. Press 0 to set the opacity of the layer to 100%, and use the Move tool (V) to drag the layer into place.

Figure 11.41

Figure 11.42

Figure 11.43

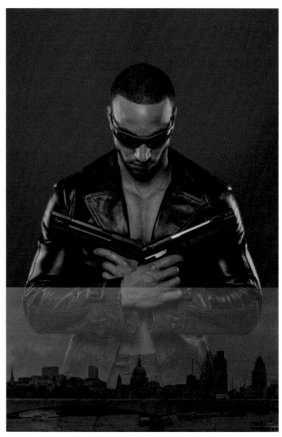

Figure 11.44 Lower the opacity to help with positioning the London layer.

London photograph by Dave Clayton

6. Add a new blank layer to the top of the layer stack, and press D to set the foreground and background colors to their default of black and white. Go to Filter > Render > Clouds, and use the Rectangular Marquee tool to drag out a selection in the center of the image area (**Figure 11.45**).

7. Press Command/Ctrl+J to copy this selected area onto its own layer. Then go to Edit > Free Transform, and Shift-Option/Alt-drag a corner transform handle to resize this layer outside the image boundary (**Figure 11.46**). Press Return/Enter, and rename this layer **clouds**.

continues

Figure 11.45

Figure 11.46 Drag the transform handles outside the image area to enlarge the layer.

8. Click the original render clouds layer below and drag it to the trash, and then drag the London layer to the top of the layer stack. Click the layer mask icon to add a white layer mask to the London layer (**Figure 11.47**).

9. With a black foreground color, choose the Gradient tool with Foreground set to Transparent and a Linear gradient (**Figure 11.48**). Click the layer mask attached to the London layer, and then drag a gradient to blend the clouds and London layers together (**Figure 11.49**). (Note: You may need to apply several strokes with the Gradient tool.)

Figure 11.47

Figure 11.48

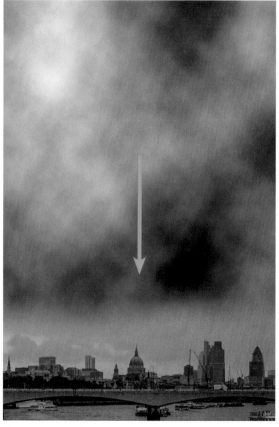

Figure 11.49 Apply a gradient to a layer mask to blend layers together.

10. Click the clouds layer and lower the opacity to 70%. Shift-click the London layer so that both are selected, and then go to Layer > New > Group from Layers, rename it **background scene**, and click OK.

11. Go to Select > Load Selection > Channel > Cutout and click OK. Option/Alt-click the layer mask icon at the bottom of the Layers panel (**Figure 11.50**) to reveal the model (**Figure 11.51**).

12. Click the assassin layer at the very bottom of the layer stack, and then add a Hue/Saturation adjustment layer. Lower Saturation to –85 so that the model matches the background more closely.

NOTE *The assassin layer is a Smart Object, so we could lower the saturation of the model by double-clicking the thumbnail and going into the Camera Raw filter. We used a Hue/Saturation adjustment instead so that it would be easier to judge how much the saturation needed to be lowered. I did not want to remove the color completely.*

Figure 11.50

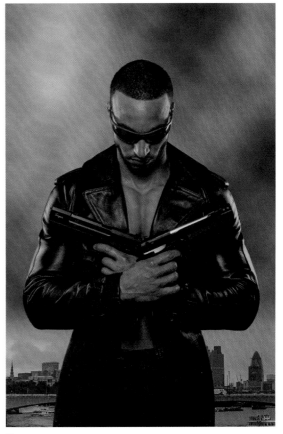

Figure 11.51

ADD A MOVEABLE VIGNETTE

Now we'll darken the area around the model with a vignette. This technique creates a moveable vignette that we can reposition at any stage.

1. Click the background scene group at the top of the layer stack, and add a Levels adjustment layer. Drag the midtone point to 0.30 (**Figure 11.52**) so that the entire image is darkened.

2. Click the layer mask for the Levels adjustment, then with a black foreground color, choose a normal soft-edged brush and click once in the center of the image (**Figure 11.53**). Then go to Edit > Free Transform, and Shift-Option/ Alt-drag any outer transform handle outward to increase the size of the vignette (**Figure 11.54**). Press Return/Enter, and rename this adjustment layer **vignette**.

 TIP *To reposition the vignette, use the Move tool (V). With the layer mask attached to the Levels adjustment layer active, drag in the image area.*

3. Add a new blank layer to the top of the layer stack, name it **darken bottom**, and with the black soft-edged brush paint across the very bottom of the image to darken it further.

Figure 11.52

Figure 11.53

Figure 11.54

THE GLASSES

To add a little more interest to the picture we'll add a reflection on the glasses. The reflection won't be entirely accurate because it won't contain the model's hands and guns, but just adding something is enough to sell the fake.

1. Go to the london.jpg file. (If it's not open go to File > Open, navigate to the file and click OK.) Go to Select > All, and then to Edit > Copy.

2. Click back on our model picture, and then make a selection of the lenses in the glasses using whichever tool you prefer (**Figure 11.55**).

3. With the selection of the lenses visible, go to Edit > Paste Special > Paste Into and add the London file. Go to Edit > Free Transform to resize the layer, and drag to reposition the pasted image to avoid having the same parts visible that appear in the background scene group (**Figure 11.56**). Press Return/Enter to lock in the transformation.

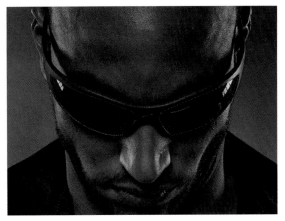

Figure 11.55

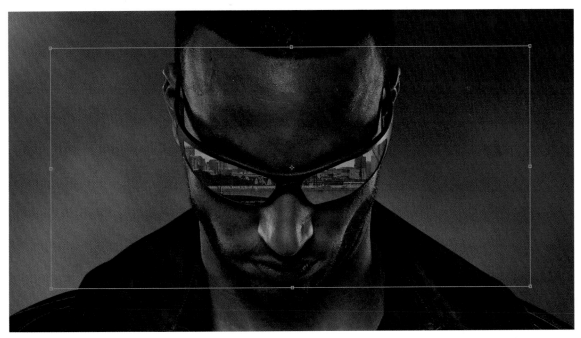

Figure 11.56

4. To add a slight distortion to the layer because of the shape of the lenses, go to Filter > Distort > Pinch. Add an Amount of –4 and click OK (**Figure 11.57**). Rename this layer **reflection** and lower the opacity to 50%.

5. Now we'll darken the outer portions of the lenses. Go to Layer > New > Layer, name it **darken lenses**, change Mode to Soft Light, select the Fill with Soft-Light-Neutral-Color (50% gray) checkbox, and click OK.

6. Grab the Burn tool, and in the options at the top of the screen set Midtones and Exposure at 30%. With the darken lenses layer selected, go to Layer > Create Clipping Mask to restrict the burning to the lenses (**Figure 11.58**). Now darken the outer areas of the lenses using the Burn tool.

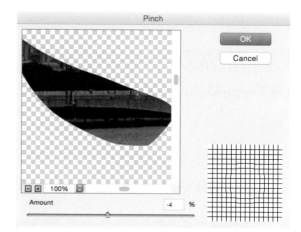

Figure 11.57

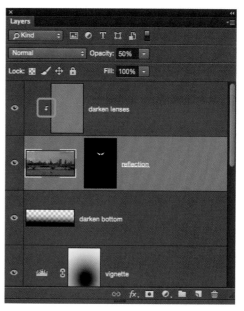

Figure 11.58

FINISHING TOUCHES

With the composite elements in place, now is the time that I would step away from the image and return later with fresh eyes to add finishing touches.

Regularly stepping away from the image you're retouching enables you to view things more clearly when you return, and see if anything you've done needs to be altered.

Enhancing the Details

1. Add a merged/stamp layer to the top of the layer by Select > All, then Edit > Copy Merged, and then Edit > Paste (or press Shift+Option/Alt+Command/Ctrl+E).

2. Press Command/Ctrl+J to create a copy of this layer. Shift-click the layer below so that both layers are selected, go to Layer > New > Group from Layers, name the group **details**, and click OK. Change the blend mode of the group to Soft Light.

3. Click the triangle icon for this group to open it and reveal the two layers inside. Change the blend mode of the uppermost layer in the group to Vivid Light (**Figure 11.59**).

4. On the same layer, go to Image > Adjustments > Invert, which restores the picture to how it originally appeared; however, the image has now been set up to enhance details.

5. Convert the layer to a Smart Object by going to Filter > Convert for Smart Filters. To add the details, go to Filter > Blur > Surface Blur and set Radius to 10 and Threshold to 10 (**Figure 11.60**). Click OK.

6. To restrict the details so that they are affecting only the model and not the background, first close the group by clicking the triangle icon. Then go to Select > Load Selection > Channel and choose cutout from the menu. Click OK to load the cutout selection, and add a layer mask by clicking the layer mask icon at the bottom of the Layers panel (**Figure 11.61**).

Figure 11.59

Figure 11.60

Figure 11.61

Lens Flare

In Chapter 2, I showed you how to add lens flares using a 50% gray layer and the Lens Flare filter.

Here's another way to add lens flares, using a brush and a blend mode.

1. Add a new blank layer to the top of the layer stack, name it **center glow**, and change the blend mode to Linear Dodge (Add). Then with a white foreground color and a normal soft-edged brush at 100 pixels, click the shiny metal part of the gun (**Figure 11.62**).

2. Press Command/Ctrl+J to create a copy of layer. Change the name of the layer to **outer glow**. Go to Edit > Free Transform, Shift-Option/Alt-click a corner transform handle, and drag outward to resize it (**Figure 11.63**). Press Return/Enter.

3. Lower the Fill of the outer glow layer to 60% (**Figure 11.64**). This makes the flare less bright and allows darker areas of the image to show through. Lower the fill of the center glow layer to 55% (**Figure 11.65**).

Figure 11.62

Figure 11.63

Figure 11.64

Figure 11.65

Coloring / Toning

1. Create a group at the top of the layer stack, containing both of the lens flare layers, by clicking the outer glow layer and Shift-clicking the inner glow layer so that they are both selected. Then go to Layer > New > Group from Layers and name the group **lens flare**. Then go to File > Place Embedded (File > Place in earlier versions of Photoshop), navigate to the thingys.jpg image file, and click OK (**Figure 11.66**).

2. If necessary, resize the thingys file to fill the layer by adjusting the transform handles, then click OK. Rename this layer **thingys**.

3. To hide the darker parts of the layer and leave the brighter parts visible, change the blend mode of the thingys layer to Screen. To add some movement to the thingys, go to Filter > Blur > Motion Blur. Set Angle to –45 and Distance to 35 (**Figure 11.67**) and click OK. Lower the opacity of the thingys layer to 80%.

continues

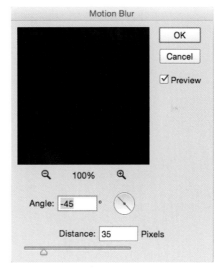

Figure 11.66

Figure 11.67

4. Add a Selective Color adjustment Layer (**Figure 11.68**). In the Selective Color properties, from the Colors menu choose Neutrals. Set Cyan to +14, Magenta to –6, Yellow to –11, and Black to 0 (**Figure 11.69**).

5. From the Colors menu, choose Blacks. Increase the contrast in the image by adjusting Black to +20 (**Figure 11.70**). Lower the opacity of the Selective Color adjustment layer to 80%.

Figure 11.68

Figure 11.69

Figure 11.70

The Cartoon or Painterly Effect

To finish, we'll add the cartoon/painterly effect that I use on a lot of my images.

6. Add a merged/stamped layer to the top of the layer stack by going to Select > All, then to Edit > Copy Merged, and then to Edit > Paste. Press Command/Ctrl+J to create a copy.

7. Click the eye icon of the uppermost layer to turn it off, and then click the layer beneath (**Figure 11.71**). Go to Filter > Noise > Reduce Noise, and set Strength to 10 and all other sliders to 0 (**Figure 11.72**). Click OK.

8. Click the uppermost layer in the layer stack and turn it on (make it visible) by clicking to reveal the eye icon. Then go to Filter > Other > High Pass, add in 1 pixel (**Figure 11.73**), and click OK. Change the blend mode of the layer to Overlay.

Figure 11.71

Figure 11.72

Figure 11.73

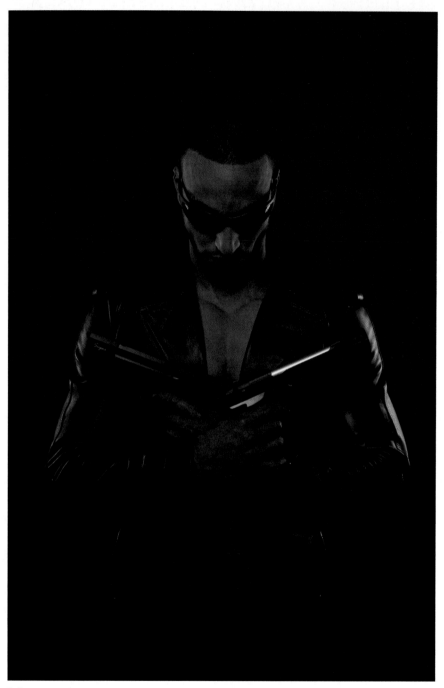

Before

After, when I created this picture, I also added some flying birds to the scene and experimented with the Cross Process presets in Nik Color Efex Pro 4 to get the final look.

INDEX